MW01088998

"*Gently Awakened* is Sara Joseph's story, but it is also truth for you as an artist to read, consider, and then act on yourself. Sara shares personal experiences and challenges as a professional artist, yet relates them directly to scripture. Her poetry, painting, and sculpture will challenge the reader. This makes a fun, yet challenging, read. I read this with a pencil in hand, marking spots of insights for me to stop, ponder, pray and act on myself.

Joseph has challenged me to reexamine my spiritual growth and stagnation—to break through the things of the world for the things God has set aside for me to do. I will read this book again for further insight into God, the Holy Spirit, the Bible, and me as an artist and as a Believer."

—**John S. Freeman,** founder and executive director,
The MasterClass Academy

"Sara Joseph has captured the struggle and answer for the journey of every creative person. With her own struggle, she brings to life what is both unique and similar for every artist. She does not dodge the deep questions of purpose, money, and fear. She reveals the answers by lavishing us with her own gift of creative writing and, especially, her poetry. Travel along her journey with tears, laughter, and admiration. Your resolve will be strengthened to rely on the Creator of our gifts, and to use those gifts for the benefit of all."

—**Dr. Pete Deison,** founder, Park Cities Presbyterian Art Festival

"*Gently Awakened* converts the hearts of readers as it covers deep terrain of faith, theology, salvation, beauty, and creativity in an engaging and personal way. Sara Joseph makes a full-frontal assault on obstacles to art and creativity—overcoming fear, discouragement, criticism, and lack, through sound biblical means and examples from her personal path to professional artist.

She skillfully stitches the exotic threads of an Indian childhood into a

compelling life story that reaches into America and invites us to follow her adventures as a Christian artist here.

Making profound and wonderful connections between her faith and art as a glorious and unashamed calling, Joseph edifies, counsels, encourages, and exhorts the disheartened, and brings hope that art can and should thrive in the Christian life and Church. This is a book that needed to be written and should be widely read."

—**Marisa Martin,** columnist, *World Net Daily*; visual artist

gently awakened

THE INFLUENCE OF FAITH ON YOUR ARTISTIC JOURNEY

SARA JOSEPH

Gently Awakened
© 2013 Sara Joseph

All Scripture quotations are taken from the Holy Bible, King James Version, public domain.

Published by
Deep River Books
Sisters, Oregon
www.deepriverbooks.com

ISBN - 13: 9781937756871
ISBN - 10: 1937756874
Library of Congress: 2013936927

Printed in the USA
Cover design by Connie Gabbert
Cover art by Sara Joseph www.christian-artist-resource.com
Interior design by Robin Black, www.blackbirdcreative.biz

This book is dedicated
to my parents,
Abraham and Sarasu Thomas,
for their unconditional love, inspiration, and care.

The Seeker and the Sought

I sought as one upon a mission
I sought Him with a stubborn passion
When closed the gap of my pursuit
I grasped in wonder this simple truth
Snatched from death and dearly bought
He was the Seeker and I much sought

Contents

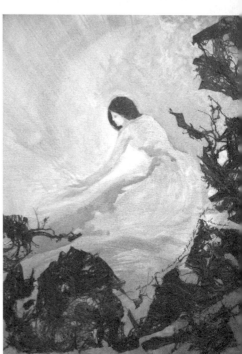

Make It Plain

"And the LORD answered me, and said, Write the vision,
and make it plain upon tables that he may run that readeth it."

—HABAKKUK 2:2

"COME, COME," URGES THE SHOPKEEPER waving me into the store, his toothy grin a startling white in contrast to his blue-black skin. Books are stacked in precarious columns, squeezed into every available nook and cranny, grudgingly vacating a narrow path into the literary maze that is the Christian Literature Society bookstore. My trips back to India in summer never feel complete without a visit to this store, tucked away among many similarly overstuffed stores hawking a variety of goods on Evening Bazaar Road in Chennai. "What can I get you? Some Bibles? A songbook? What?" he asks, scurrying ahead of me into the store, allowing me barely enough access through the tight space between hard and softcover paper walls. Breathing in the familiar musty odor of dry paper, I follow him.

I know just what I am looking for—true stories by little-known authors, printed on obsolete printing presses funded by small church societies. Fending off the zealous shopkeeper with a promise to buy as soon as I find what I am looking for, I embark on a treasure hunt. Within minutes I strike gold. *Sushila's God,* I gather from the back cover, is the true story of a simple village girl who once fearfully worshiped snakes before she learned about Jesus. The shopkeeper would much rather see me leave with a stack of new Bibles, yet this unlikely story of transformation is precisely the treasure I came for. Wincing at the gaudy cover, I flip through a few pages to read Sushila's first prayer: "God who made the world," she scarcely breathed the

words out loud, "I have nothing to give you. There is just me. Please take me, and oh, please don't let my parents marry me to an old man."

I am sold!

There is something inherently authoritative in the story of someone this vulnerable, uneducated, and inconsequential in her rural Hindu community being wooed by a God who responded to the yearning of her heart. It thrills me to read how He blessed her beyond her wildest dreams. Stories like hers convince me that the events that began in the book of Acts continue even today, forming chapters too numerous to include in our already voluminous Bible!

The shopkeeper is, however, unimpressed with my selection, which in his estimation is nothing more than a worthless booklet. "See madam, this is better. Fine new sermons from a famous preacher in America!" Little does he realize that Sushila's story will travel with me to America to touch the lives of others far removed from her humble home in the mist-wreathed hills of Chandighat. Authentic stories of those Jesus rescued from hopeless lives in Hinduism, Islam, or the innumerable other beliefs that form the spiritual landscape of India are inspiring. No sermon can match the searing power of the changed narrative of a reborn life.

Collecting Christian testimonies from all over the world like others collect fine wine or art is a passion of mine. True life stories made dynamic in Christ stimulate and instruct me. The story of Bilquis Sheik, a Muslim woman, of *I Dared to Call Him Father* is a treasured book in my prized collection. I am awed by accounts from the past like that of Fanny Crosby's lifetime contribution of over two thousand now familiar and beloved hymns, a creative output that was clearly supernatural, relayed in the book *Fanny Crosby, The Hymn Writer*. George Mueller, who cared for 10,024 orphans before concluding his time on earth without resorting to manipulative funding schemes, teaches me in the pages of *Young Rebel in Bristol* that God can be trusted to provide material resources when depended upon in faith. Dodie Osteen's jubilant account *Healed of Cancer*, written about her healing after being sent home to die, strengthens my resolve to believe God's promises for health despite medical reports to the contrary. God always has the last word in a human life, whenever He is permitted to.

"Behold, I stand at the door and knock; if any man hear my voice, and open the door, I will come in to him, and will sup with him and he with me."—REVELATION 3:20

Sushila did not get married to an old man. Instead, God brought a young teacher into her life who loved, cherished, and grew in faith with her. Together they were blessed with healthy children and a wonderful home. The threats she faced at the time of her prayer were real; other young girls in her community were forced into marriage by parents who only considered the financial status of the future groom. They faced endless years of loveless unions and abuse by husbands who were old enough to be their fathers.

Stories that unashamedly testify to the transformation of lives when hearts are opened to Jesus are fuel for my aspirations, since I learned early that God is impartial. What He did for another He promises to do for me if I can simply believe it. Each personal testimony is raw potential for my future.

Can I see myself blessed and anointed with vigor not my own, tackling challenges that would overwhelm anyone who does not know Christ? Dare I believe that I could be endowed with power to overcome, power that is clearly supernatural? Could I see myself alone yet cared for, assaulted yet jubilant, troubled yet filled with peace?

My imagination is captured by exciting possibilities, and the incurable romantic in me dreams of extraordinary adventures unfettered by theology, doctrine, or the heavy stuff of formal churchgoing. Each supernatural account that I digest thrills, encourages, and spurs me on.

My collection of testimonies is, however, noticeably deficient in one aspect. Where are the stories of contemporary painters, sculptors, and mixed-media artists who are also Christians? Why do my fellow artists not tell rousing stories of protection, provision, and inspiration? There are many artists today who are Christians, yet I rarely read supernatural stories from them similar to the testimonies of the past—stories of transformation, trials, and triumph.

As an artist myself, I yearn to read about creative lives that bear the unmistakable stamp of God's presence in paint, clay, and stone. To glean from other contemporary artists who find power in God's Word to impel their creativity, reaching for extraordinary excellence in art, would be more

than inspiring. However, my search proves to be an exercise in futility. I find none. Perhaps life is so challenging that their passions are poured into their art, leaving little energy for recording their journey of faith.

I am enthralled and stimulated by the making of art. There is no dearth of information on the technical aspects of any artistic media. Books of instruction on drawing, painting, and sculpture abound. Yet creativity is also spiritual, perhaps more so than any other endeavor. That being true, the lack of information on developing as an artist in Christ is glaring.

In my own journey with Jesus, He teaches me that my passion for technical excellence in art is to be second only to a life lived as a Christian. I learn that in the practical living of this new life with Him, which I enter into by choice like countless others before me, a treasure trove of wisdom, insight, and power is there for the taking, continuing to transform my art and myself. God's marvelous grace helps me live out such a life even while I first dabble in art and then gradually grow in skill as an artist.

One day, quite unexpectedly, I sense His unmistakable nudge to write about it. I do so hesitantly, in the hope that from my story others might draw some fragment or spark to trust God with their own artistic destinies.

Although I was born into a Christian family, I understood nothing about faith until I became an adult. I then developed an insatiable appetite for studying the Bible. The resulting transformation in my life even now fills me with awe, because I bear witness to changes that no one but God could have worked in me. Once blithely ignorant of my need to change, I was also powerless to effect those changes without Him. Who I am today is far removed from who I used to be. My tomorrows with Jesus fill me with irrepressible joy, as I am certain that they will bear little resemblance to today! So I toy with the idea that perhaps lessons I've learned may be instructive to another.

When I began this journey as an artist, I did not dream of someday seeing my thoughts in print. My only prior experience in writing was in response to the clever ploy of my mother to redirect my restless, moody adolescent energy into the harmless activity of keeping a journal. Thankfully, all my prolific, rambling writing as an exuberant teenager remains safely confined to a dusty cardboard box in the attic.

Playing with words still intrigues me, just as much as playing with line, shape, and color. I rearrange words on my computer until they satisfactorily capture the thoughts floating elusively in my head. I seek not to impress, but to express. I prefer to be accused of simplicity than pomposity. Compare me, if you will, to an unsupervised child with a blank wall and a new box of crayons!

Curious about whether my story would strike a chord with other artists, I cautiously put it to the test. Christian Artist Resource, a website in which I described a few of the lessons I learned as a Christian artist, was timidly launched—some five years ago now. In a language alien to me I wrote, anonymously at first, page after page of lessons from the heart. Clumsily I shared my experiences, sheepishly recounted mistakes made, and hesitantly uploaded my art—watercolors, oil and acrylic paintings, ink sketches, polymer clay sculptures . . .

The response I receive even today from these fledgling efforts is both illuminating and gratifying. It confirms my suspicion that contemporary testimonies of Christian artists are desired in the public sphere. Other artists worldwide grapple with the same issues I struggle with.

How does the Christian faith affect the artistic journey of today's painter, sculptor, poet, or anyone creative? Will I be able to adequately express the mammoth role my faith plays in my life? Will I find apt words and a sure voice in paint, clay, or other media? Dare I hope that my work may intrigue those who don't yet know Christ?

I am aware that I inhabit a world contemptuous of piety of any sort. Being an artist with an ardent faith arouses as much interest as a blurb for cremation services on the back page of a neighborhood mailer. Yet I determine not to let that deter me. The human heart yearns for the authentic; of that I am convinced. My life in Christ is that and more.

Like the collection of testimonies in my personal library, my testimony describes truths about God that may seem self-evident to some, yet are unique to the artist. For others, I pray that this account may well up in hope for their specific challenges, perhaps even unrelated to the making of art. May the anointing of the Holy Spirit use my account to either reinforce a timeless truth or expose it to you afresh.

Every book that shares Jesus, and all that He means to the author, does

so differently. Yet if it tells the truth with veracity, it has within its pages the power to transform lives in unpredictable ways. That is my prayer. Perhaps my inspiration can become yours, and my conviction kindling for you to step into tomorrow with confidence as a Christian artist. If you can be spared from making mistakes that I made on this journey, I will be grateful.

Since I began to share my journey, numerous others have also done the same, discussing their art and stories on the Internet. Like the swell of a massive, growing wave, I realize that a dynamic resurgence of creative expression uniquely described by the Christian artist is being orchestrated by God. I am merely a drop in this choreographed sweep of froth and joy flooding the shores, drenching other Christian artists who may stand timidly by, drawing them also into its delightful wake. Some will only be splashed and entertained; others, I pray, will be sufficiently doused to live out their own calling.

This book is for you. In it, I address squarely the questions that I now know are universal, although they are rarely examined or debated. Lessons from my experience are only tools to illustrate truths pertinent to every artist. Apply them diligently, and you will weave your own powerful testimony to share with others, in words, art, or your very life itself. Mull over my story and then swirl it into the palette of your life with its unique and dynamic colors. May it enhance your understanding and art. None of us have all the answers, but we do know the One who does.

Are you a skeptic or just one idly curious? Then I nurture the hope that the thoughts in this book will get under your skin like the grain of sand in an oyster that eventually irritates the production of a priceless pearl. I don't mind if I irk you into trying a few of your own experiments with God.

Consider the brilliant colors of a sunset. The hot pink hues are stunning only because of the uniform, dull grayish-purple of the surroundings. I am nothing special. My ordinariness is the almost anonymous foil for Someone extraordinary. Less my account, this is more the story of an extraordinary God. May His character shimmer through my words, art, and verse.

"But the path of the just is as the shining light, that shineth more and more unto the perfect day."—PROVERBS 4:18

Dawn

Faint blush of salmon stains the sky
Inky night bids a swift good-bye
Color spilled, relentless flow
The dawn of day a forceful glow

No man can bottle this fuchsia hue
Day once begun will stride on through
Dimming darkness and gaining strength
The day must live its destined length

Quiet whisper bids me learn
A lesson from the gleam of dawn,
"You walk a path, O Righteous One,
Which like first radiant beam of sun

"Dispels darkness and welcomes Me
Though faint at first, with little to see
Shining brighter till full force of day
Destined for glory though fashioned of clay."

What joy to know that once begun
No turning back the blazing sun
My way will march the way of dawn
Until my time on earth is done

Brighter, sharper, erasing night
No taint of ink, no dimming sight
From glory to glory, ever bold
From blush to fuchsia and then to gold.

Come Out from Among Them

"Wherefore come out from among them, and be ye separate,
saith the Lord, and touch not the unclean thing; and I will receive you,
and will be a Father unto you, and ye shall be my sons and daughters,
saith the Lord Almighty."

—2 CORINTHIANS 6:17–18

MUFFLED NOISE, WHICH IS AS CLOSE TO TRUE SILENCE as I've ever experienced, is a priceless, often elusive gift. I seek it out as often as I can, conscious that it confers an acute awareness of my humanity and spirituality. I grew up comfortable with noise, simply because it was inescapable. For one accustomed to clamor, finding myself in a quiet place is an unforgettable memory, one that will not dissolve over time.

Growing up in the coastal city of Chennai, India, once known as Madras, my childhood is happy and uncomplicated. I dote on my father, admire my mother, and bicker good-naturedly with my younger brother, whom I love dearly. Then there are my grandparents, aunts, uncles, cousins . . . I am fortunate to live a life well populated by loved ones.

Like most cities in India, Chennai is crowded and noisy, although I think nothing of it at the time. School is a couple of miles away; a kindly old man, hired by my parents, usually drives me there by car. It is a treat when, on rare occasions, my mother allows me to walk to school alone. The streets are always crowded with cars, auto rickshaws, bicycles, bullock carts, and pedestrians, all crammed together in a happy jumble of noise and activity.

On those infrequent walks, I absently navigate my way around stray dogs, cats, street vendors selling flowers, and the occasional cow on the

pavement, distancing myself as best I can from speeding buses careening madly around corners. I walk oblivious to it all. Colored by the places and characters of the latest book I've read, I dwell almost exclusively in my imagination. On one day I'm delicately sipping tea in a beautiful English manor, and on another I'm struggling to live at the bottom of a slave ship, braving storms and on my way to the New World. My ever-pragmatic mother endeavors often to bring me back to the reality of the present, but I happily evade it, choosing instead the romance and adventures of my mind.

The lazy Cooum, a sluggish river, meanders through the city, green and seething with unappealing mystery. There is a brick and concrete bridge across it, narrow and inadequate for the teeming masses of humanity jostling their way over it at all times of the day and night. School is about a mile or so on the other side. That bridge is a bottleneck for traffic, squeezing the surging throng within its poorly designed confines and then coughing them up on the other side. The noise, which is already deafening, grows even more insistent on the bridge itself, issuing a shrill complaint of protest. Horns honk in every conceivable pitch and timber, voices are raised in annoyance, crows caw, and all of it is accompanied by the ridiculous tinkling of bicycle bells.

Once, on my trek to school I happen to notice a little dirt path by the side of the brick bridge, sloping downward, leading closer to the water. Were I older and wiser, I would not take that path; but I am neither—just a curious little girl, yielding predictably to the impulse. The crude dirt path proves to be irresistible. Tightly gripping my heavy school bag, I take jerky steps down to the water's edge to discover a simple, narrow wooden bridge below the main one, floating a couple of feet above the water, just wide enough for two to walk abreast. I glance behind me to be sure that no one has spotted me venturing this far off the main path. Just ahead, the wooden bridge beckons me. No one else is on it, so I hesitantly walk over it and stop abruptly in the middle.

There, suspended a few feet over the river, I stand stunned by the sudden absence of rude noise. Above me the roar is muffled. I am engulfed in a quiet unlike anything I've ever experienced before, thrown into sharp contrast by the chaos that I've just stepped away from. I seem to inhabit an

alien world, calm and removed; a part of, yet separate from, humanity, held in a surreal space of near silence. The water below ripples lazily, stirred by a breeze I could not have sensed above. In that moment of stillness on that rickety bridge, I become conscious for the first time of both the simplicity and the complexity of being. I am apart from, and yet a part of, the world. It is a strange feeling, making an indelible mark upon me as something to be savored. God is far from my mind, but the stillness gives me pause. I am left with a nagging sense that there is so much more to living than I am able to grasp with my childish imagination.

God's call to "come out from among them" takes on new meaning when years later I search out still places, places of near silence, places that suddenly throw into crisp contrast the roar of countless other noises that distract, babble, cry, taunt, intrigue, or amuse. Only in the stillness does He call us quietly to become His sons and daughters. Perhaps it is only in that quiet that we can truly hear Him.

How easy it is to miss His whisper amid the clamorous ruckus of daily life! It took traveling halfway around the world before I finally learned to hear His voice with clarity in moments that I now seek out with deliberate purpose. The separation the Scripture talks of is only to bestow upon us the marvelous rights of adoption. Once made irrevocably His children, we are sent right back "among them," conscious of and careful to maintain our separateness while equally sensitive to belonging to those from whom we have come away. They are beloved members of our families, friends, neighbors, coworkers, those we distantly know as acquaintances, and others God directs into our lives. We are instructed to live distinctly different lives from them, secure in the love of our Father, leaning on His wisdom and drawing from His unlimited resources. We are called to find abhorrent what He declares impure and to cherish and pursue what He esteems highly. Instruction pertinent to that journey is anticipated and provided for in the pages of the Bible. Together with Him, we now endeavor, with every means made available to us, to include them in the same family of God, in order that they too may share that joyous, mysterious belonging and separateness. It becomes a partnership—His labor of love as well as ours.

Blessed Assurance

THE SWING'S SQUEAK IS IN PERFECT HARMONY with a young, haunting voice singing a hymn: "Blessed Assurance, Jesus is mine. Oh, what a foretaste of glory divine."[1] The swing is an innovative contraption made out of a narrow coconut branch, hanging by a rope looped through the rafters of the verandah, just wide enough for a child's bottom. The porch with its deep maroon floor, facing an expanse of sandy land bordered with scarlet hibiscus bushes, jackfruit and mango trees, is a favorite place to play. My brother and I, along with cousins, are sent every year from different cities to my widowed grandmother's home in Kerala, India, as soon as school closes for the summer. Often there are ten or eleven of us spending the holidays with her.

Ammachy has help looking after this motley group of energetic children who are released from their parents' clutches for a few brief weeks: two other families living on her property care for her needs, her rice paddy fields, and us. We keep them busy. They cook for us, pick up after us, and care for the cows, dogs, cats, chickens, and fields. We wander all over the farm, carefree under their watchful care. The men are field hands, the women oversee the kitchen, and their many children play with us. Familiar with the land, they teach us, city dwellers, how to clamber up trees to eat the sweet fruit that hangs heavily within easy reach. We play games with ingenious toys they create with twigs and leaves from the abundance of tropical flora and fauna all around us. They build a little hut out of woven coconut branches for us to play in. Crawling into it, we girls spend hours concocting "meals" of rice, weaving garlands of jasmine, and brewing "shampoo" out of orange hibiscus flowers. We then "sell" the nasty stuff to my brother and

1 Francis J. Crosby, "Blessed Assurance," 1873. Hymn based on Hebrews 10:22.

another cousin, the only two boys among many bossy little girls. While we play house, they build roads in the dirt and play with toy cars.

Ammachy presides graciously over it all. At mealtimes we gather around her table, hungrily devouring huge quantities of steaming hot, delicious food: rice, kachia moru, mounds of crispy fried mathi, all sorts of curries, swimming in spices and coconut milk, mango and lime pickles . . . we are indulged and too busy to know it.

I marvel today at her patience and love. Only much later did I come to understand that she was a woman of steadfast, enduring faith. Although she was widowed early, I witnessed no outward signs of the grief that my father said once gripped her. I knew her only by her happy smile, her warm, enveloping hugs, her unfailing forgiveness of our many childish misdemeanors, and her fervent prayers to a God I was as yet unfamiliar with. She was also generous, comfortable with hosting and feeding large numbers of relatives and household help. My father told me that he remembers when, among other dishes, two hundred slices of French toast were once served for breakfast!

Her sprawling, tile-roofed home was embraced by wide porches, cheerily crowded with mossy potted plants and festooned with hanging baskets in a riotous blaze of color and texture. Papery white and fuchsia bougainvillea climbers scrambled vigorously over most of the roof. Once a beloved home for many, it enjoys a cherished place in our memories.

On that ordinary afternoon long ago, I am drawn, as if by an irresistible power, to the source of the singing. Its melody is carried smoothly in the still, jasmine-scented air. He is strange—just a youth, ungainly and absurdly large for the swing he sits on, singing and rocking back and forth on the front porch.

"Well, are you coming or not?" asks one of my cousins impatiently from the dining room. Lunch is over, and the others have already headed out to play by the pond. The dishes clatter noisily as they are cleared away, intruding on the sound I am most curious about. "I'll be there in a few minutes," I tell her, watching as she runs off after her sister. Walking as quietly as I can in the opposite direction, I head into the cool, dimly lit living room and peer from behind the half-opened door, careful not to be seen. I am

alone; the faint sounds of others in the distance already arguing about what to play reach me. He seems very grown up; I am only a little girl.

He sings in a clear, sweet voice, his face upturned, his expression pure. What do the words mean? They sound so beautiful. I search desperately for understanding, but my vocabulary comes up short. *Foretaste. Glory divine. Heir of salvation. Purchase of God* . . . My young mind soaks in the words uncomprehendingly, yet somehow conscious of their import. Dreamily swinging back and forth, he finishes his song and sits silently still.

Perfect submission, all is at rest,
I in my Savior am happy and blest,
watching and waiting, looking above,
Filled with His goodness, lost in His love.

He is unaware of my guilty presence; I am conscious of intruding. He does not know that he has moved me with his song of worship. Intrigued by the mysterious words and the lilting melody, I stand there silently absorbing with reverence something elusive, mysteries hovering just outside the fringes of my grasp. Only when I eventually become the "purchase of God" will I understand some of the implications of those words. Even now, I still only know in part.

When that divine transaction is sealed between God and man, as it was for me years later, moments like these sparkle, beckoning "the bought" to trace a gracious path back to the first timid beginning of a remarkable journey. He was a seminary student, I found out later, just visiting my grandmother for a couple of hours, lost in God's love in that quiet, shady porch, unaware that he was sowing early seeds of eternity in my young life.

Later that day as the shadows lengthen, other music, grating and harsh, accompanied by the frenzied beating of drums, blares from the loudspeakers of the Hindu temple down the street. It is so unlike what I heard earlier in the day.

We are sent off to bathe and get into our nightdresses before dinner, after which we, her numerous grandchildren, gather around Ammachy's chair in the living room. The stars and fireflies twinkle outside. The last

sounds of each summer day, after some Bible reading and hymn singing, are those of her lengthy, heartfelt prayers to God.

These are the faint, first embers of my life, destined to be fanned into flame in the ensuing years.

This is my story, this is my song,
Praising my Savior all the day long.

The Way, the Truth, and the Life

ONE ORDINARY NIGHT YEARS LATER, far from my happy childhood in India, my husband BJ makes me aware of my need for a Savior. We are just a couple of years into our marriage. Everything is still vaguely unfamiliar, even America, the country where we are growing into a new life together. That unfamiliarity is the fodder for my exploring of spiritual realities that I've never considered before. An inordinate amount of questioning and latent stubbornness precedes my accepting Jesus and His claims. Is He the answer to my every yearning? Can I believe that He really did die for me or that He is the Son of God?

I have questions—so many of them. Why would God work this way, through a man who was fully God and yet a man? Why did He willingly accept punishment for my sin? Was there no other way to satisfy the demands of perfect justice?

If Jesus is the Son of God, I learn that only one response is expected of me: to believe that it is true. I must act then upon that belief, I am told, by trusting that Jesus's sacrificial death on the cross is sufficient atonement for my own sin. It is to be a secret transaction between God and me—that act of trusting. Exercising faith in this central truth of Christianity is, I gather, somehow essential for the start of an intimate friendship with God, whom I can then call my Father. I do not doubt there is much in my life that a holy God would consider sin. It would be a relief to wipe the slate clean and begin anew. I hesitantly entertain that possibility.

It seems too absurdly easy that such an elementary faith will magically launch a new life, suggesting exciting possibilities so unlike my own rather ordinary life. I shy away. My questions are too many.

An impossibly simple suggestion by BJ brings to a halt my circular arguments. "Why not surrender first and trust Him to answer your many questions later?" he asks.

How like BJ to simply cut to the chase! If I'd had my way, I might still be pondering questions that I felt demanded answers while blithely avoiding the glaring need to first acknowledge my own sinfulness before a holy God and my desperate need for a Savior!

My questions, although many, are now not compelling enough to restrain me from the alluring possibility of something magical happening upon my trust, although I am uncertain about what that is to be. I lay aside my doubts and uncertainties and embrace the ambiguity of perhaps not ever understanding it all. I surrender in exchange for the hope of a relationship with Jesus. If He is who He says He is, then surely by committing my life to Him, I've begun a journey of infinite worth? It seems like an unusual transaction: my willingness in exchange for a strange new life, holding much promise—*zoe,* in Greek, the very life of God. The more I consider it, the more my frantic mental scurrying is gently stilled. Some questions suddenly seem arrogant to even ask. Others are answered over time. Still others don't matter any more.

Nothing dramatic happens when I give in; there is no flash of glorious light, no booming, deep voice of God commending my decision. The night is quiet as we pray together, giving no indication of the remarkable transformation that has begun and is yet to come. The mundane gives way to the extraordinary; my life is now permanently infused with the supernatural life force of God. *Zoe.* There are no outward signs betraying anything unusual. However, Jesus now has a home in me, and I find my safe haven in Him.

Years later, I discover that my new life is in answer to the prayers of my Christian ancestors generations earlier. Nothing happens without prayer, and none of us will ever comprehend the impact of prayer in its totality until we enter eternity. The prayers of my Christian grandparents in the overwhelmingly Hindu country of India found their fruit in me. My great-grandfather's words of uncompromising faith still speak to me from the faded pages of a battered leather journal I now own. His entry on Sunday, January 1, 1939, reads, "'Bless the Lord, Oh my soul, and forget not all His benefits.' May we realize His presence more and more . . ." The fleeting

memory of my grandmother's prayers returns through the blurry fog of my childhood, reminding me that who I am today is no accident.

My surrender, borne on the winds of the past, carries with it the seeds of a future that is hazy yet promising. Strangely enough, it happens without fanfare. But what becomes undeniable in the years that follow is its sweeping impact on my life and the lives of countless others through me.

If you are an artist who has yet to begin this journey with Jesus, before you read any further, this—this surrender, this belief—is the required, unavoidable first step. Without this, your artistic aspirations will amount to nothing of eternal value or significance. Find a Bible in any bookstore, or you may already have one gathering dust somewhere. Treat yourself to a reading of the book of John. It won't take you long. Then flip back about seven hundred and fifty years in time and read Isaiah 53. All of it is true, written about before it ever happened, deliberate and necessary, and only waiting for a response from each human heart. Think seriously about all you've read. Read some more if necessary. Then quick, make your decision! Step unreservedly into a life with Jesus, a life unlike anything you've ever experienced before! It is a simple decision of the heart with fabulous immediate and eternal consequences.

Of the many books that teach on practically every aspect of the artist's life, this one may seem quaintly different. I am not trying to be contrarian; I have merely learned unexpected lessons in my journey with Jesus. These have given me a startlingly different perspective on being a contemporary artist who is also a Christian.

Your artistic talent is a gift from God. It will not be withdrawn if you do not choose Jesus, but all that is intended for its use will remain only a vague mystery without this surrender to the Giver. What is popularly considered artistic success will not be denied you if you strive for it. However, apart from Him, its reward and glory will prove strangely bland and empty.

Attempting to understand the rest of this book without this essential first step will be like looking into a turbulent, foaming pool, expecting to see yourself reflected with crystal clarity. Nothing will be revealed. Instead, all the shifting and churning water will only leave you with a profound

sense of disquiet. I would not be surprised if you abandoned this book in disgust, claiming it to be so much mumbo jumbo. The template for beginning is vitally important. Jesus is, as He claimed, "The way, the truth, and the life" (John 14:6). He is the Son of God. Without Him we are lost, understand nothing of our purpose, and are destined to a life of no more significance than a clanging cymbal among countless other noisemakers.

With Him life becomes abundant, and our tomorrows stretch into an intriguing eternity filled with promise. The *zoe* life of God at work in a yielded human heart has unfathomable potential. If you are already a Christian, this is still pertinent to you: we have yet to witness all that *zoe* can be, simply because we yield ourselves conditionally, often reserving parts of our lives because of ignorance, fear, lack of faith, or persistent sin. The Bible encourages us with plenty of role models to emulate while warning us with detailed accounts of others who came up short. Our reservations about partnering with Jesus will hinder us; surrender, continual and full, will free us into experiencing various measures of this marvelous life.

The *zoe* life of God, though eternal in substance, is tasted and savored first here upon this dusty, sinful earth and brought to fullness where time is swallowed up in eternity. I, in my spiritual infancy, had no way of grasping the thrilling adventures ahead, which is perhaps just as well. God does not choose to confer with us as He works out His purposes for our lives, which, although they are always good, are wrought through circumstances that are not often effortless or comfortable for us.

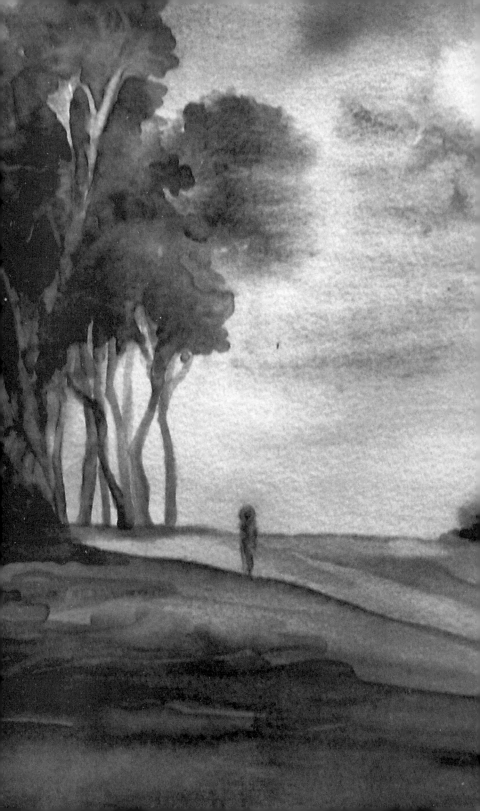

A Different Decision

THE DOOR SLAMS SHUT. I AM FINALLY ALONE. The hum of the refrigerator seems annoyingly loud. I have to think, to sift through thoughts, to make decisions. Not many decisions—just one. One overwhelming decision that looms large in my mind with murky consequences.

Nothing in my experience as a mother has prepared me for these tumultuous teenage years with my older son, Johann. This season draws reserves of energy that I had no idea I possessed. This decision, however, does not involve him.

Insistent tapping on the window distracts me. The Texas sun glares mercilessly. The light, bouncing off the water in the pool, sparkles like a million diamonds. On the other side of the pane stands my younger son, Reuben, just five, sporting a crooked grin, with a fat toad clutched in his hand. He will need braces soon. I smile and wave at him.

Reuben knows nothing of the decision I must make soon. He lives in an uncomplicated world in which others make decisions for him. Turning away, satisfied that I've shared in his delightful discovery, he runs off with the wriggling creature in his clenched fist. His world is safe for his boundless inquisitiveness. My curiosity, by contrast, has little room to breathe, explore, or stretch.

My husband has nothing to do with this decision either. An expert time manager and a diligent entrepreneur, BJ lives by a schedule carefully mapped out on whichever electronic device currently holds the most favored status in his estimation. We are different, he and I. He encourages me to make lists. I promptly lose them. His dogged attempts to clone me into a more organized version of himself are most often met with frustration rather than success. Enjoying with impish delight the unplanned moments of my day, I despise following anything precisely, even recipes. Hopelessly incapable of

duplicating anything, I tackle each experience with gusto as if it is my first time. BJ is fond of reminding me that I'm far less efficient than he is. I also make more mistakes than he does. But he is an engineer, and I am an artist.

Well, almost.

And that is the decision I have to make. Thus far a rather unpopular vocation, if it can be called that, defines me. I am a stay-at-home mom, comfortable among my like-minded church friends but without an acceptable defense elsewhere for my existence. "What do you do?" is the inevitable question I face at parties, which, when answered, is met with a glazed look of utter, pained boredom. It bothers me only occasionally. I enjoy being a mother, and my family is pampered by my constant presence and undivided attention. All that is soon to change.

I am about to trade one unpopular role for another. This one is vague, faintly romantic but largely undefined. Born into an affluent family of engineers, doctors, architects, and entrepreneurs, my decision to spend the rest of my adult life as an artist makes little sense even to me. Staying at home to be available to my young children is certainly a whole lot more socially acceptable. There is a collective unspoken consensus on careers of real worth, and pursuing art does not make the list.

"You are what?" I imagine being asked while I mumble, "An artist." I wince, knowing well that the only familiar adjective forever married to *artist* is, of course, *starving!* I am to discover otherwise. Over the ensuing years, I grow into an abundant life as an artist in His service, abandoning so many preconceived notions which I once had, yet still conscious of possessing only a partial understanding of all that this life and work can be.

But even in the beginning, it is inescapable. I've always mentally sketched people's faces while talking to them, absorbing subtleties of color in their skin, eyes, and hair even when I have no way of recording my observations. I lose myself in the glossy pages of art magazines, dreaming and reading about the magical world of creativity. How thrilling to absorb beauty and then interpret it through the clever use of line, shape, and color! While waiting outside the children's piano, tennis, and gymnastics lessons, I devour every book I can find on any kind of art that interests me.

Late at night while everyone sleeps, I stay up painting watercolors and listening to desperate people discussing their hopeless situations on the radio. The host quietly leads them in prayer, soothing music plays in the background, and I struggle to stay awake to paint. With bleary eyes, I distractedly slosh the brush in my cup of coffee, dismayed when, with a stroke of fragrant, muddy color, I ruin an otherwise transparent watercolor. Yet not even that deters me. Those quiet hours of painting bring me as much joy as days I've spent listening to imaginative stories of childish adventures, cleaning diapered bottoms, and kissing sticky cheeks.

Eventually I make my decision. It seems enormously impractical, yet it makes all the sense in the world. I add the new role of artist to my happy yet otherwise unremarkable life. I have only the foggiest notion of what that might entail. Even fuzzier is my understanding of what it might mean to be an artist who is also a Christian.

So begins an adventure: unpredictable, often confounding, and yet filled with unexpected surprises. From now on, art will take on a larger role in my life, becoming more than a satisfying pastime.

My telling you of this decision at what must seem like an unlikely juncture in my story may be unsettling, rather like stumbling late into a movie after the opening credits and the first scene has gripped the audience. Yet I know that I have caught you in the middle of your life story as well. None of us are really at the very beginning of anything, but rather smack in the grit of life itself. God alone knows how He has steered us to what we consider monumental decisions in our lives. He was there before and will be there after.

As a wife and mother, I live in little pockets of time. Wiping noses and ironing shirts are often unexpectedly interrupted with the quiet of a stolen hour of art. Art becomes, in such stark contrast, of grave import—to simply walk away because the timing is not ideal is not an option. Who cares if no one thinks that I can one day accomplish anything of value with my sketching and painting? For now, the moment is to be savored, sacred, and holy. But it is brief. A moment later Johann announces that Reuben has crawled into the dryer and is waiting for me to "find" him! Another

precious interruption. Time moves on in staccato rhythms. And from the gleanings of those priceless moments of import interspersed with equally dear trivia, I choose to write.

Acutely aware that my decision is propelling me into an unknown future, I deprive myself of an easy escape route. It may seem like a trivial matter to you, but I assure you that at the time, it was far from it: I eventually sign a lease on a studio, beginning a season of spending more time than ever away from my excessively dependent family in the pursuit of God's will for me as an artist. It comes at a time when we as a family are facing some financial struggles. It is a stretch of faith for me to obey. The timing is far from perfect. It would be no exaggeration to say that to all outward appearances, this seemed a downright foolhardy decision to make. I try desperately not to view it as a luxury which must be justified by creating meaningful work. Every separated moment spent there is costly. I am overwhelmingly conscious of the expense, and it is oppressive. Yet I know God is calling me to this.

Despite a fair measure of butterflies in my stomach, I find comfort in knowing that I have clearly heard from God. My act of reasonable service is to step out in faith and obey Him.

Over time, I learn about the tentacles that money wraps around the artist, choking all life. As my story continues, I'll tell you how I broke loose from those fetters and am now free. Staying free, I have learned, although not as effortless as the initial break, is also possible. In the laboratory of my experience I'll share biblical truths that I've proved are just as powerful today as when they were first written. What you choose to do with my account is entirely your call.

In hindsight, I see each step I took, no matter how trivial, as an act of faith moving me gently and firmly toward my destiny and calling. Had I shied away from these steps, I might never have tasted the life I now live as a Christian artist. In the immeasurable love and grace of Jesus, it is likely He would have granted me other opportunities to follow Him. I would, however, have lost precious time.

The clock is ticking, and time is running out for each of us. Dare we squander it in hesitating? Can we not instead muster the courage to seize

every precious second, making it supernaturally productive? Why not trust Him to guide and direct us into paths of His choosing, living lives that are joyful, satisfying, salty, and irresistible to a tired and cynical world?

> *"And Jesus said unto him, No man, having put his hand to the plough, and looking back, is fit for the kingdom of God."*
>
> —LUKE 9:62

The Twinkle

Who are you, and just what do you do?
Answer well, or they'll look through you
With firm handshakes at every party
And eyes full of this imperious query

Have you accomplished work of import?
Do you, with flair, play a worthy sport?
Surely you lead a conglomerate or two
There's got to be something superb about you

No one asks if maybe you're just a hand
Or if, perchance, a foot on which to stand
If we are the body, with Christ as the head
Do we clamor to be worthy of Him, instead?

If asked of me, here's my imagined reply
"I may be a twinkle in His clear, smiling eyes
Reflecting azure skies and verdant fields
The glory of the lily and the humble weed.

"I may be the twinkle that delights to mirror
Love eternal for the prince and the pauper
Sometimes dulled is this luminous shine
When reflecting His sorrow, as if it were mine

"His ingenuity with simple effect
As an eager artist do I merely reflect
Mirrorlike, I must smudge-free remain
Lest I sully His beauty with ugly stain."

Honoring the Master

"Whoso keepeth the fig tree shall eat the fruit thereof: so he that waiteth on his master shall be honoured."

—PROVERBS 27:18

OUTSIDE MY WINDOW THE RAIN FALLS SILENTLY. It is a gentle Texas summer shower, nothing like the drenching tropical downpours of my childhood. I grew up familiar with monsoon rains which pounded on tiled roofs. In the summer, I sometimes watched little rivulets of rain tracing complex paths like chaotic highways while I sat in my grandmother's porch. The mind-numbing quality of pelting rain expelled all coherent thought. There was a fascinating ferocity in the streams rushing busily, joining each other to come crashing off the roof, through magenta bougainvillea into a puddle inches from where I sat, dry and removed. Much like the frenetic busyness of life, from which God calls me away today to sit still and removed. Rain is now soft and silent, not deafening and hypnotic; my view is glass paned and temperate.

Many sultry summers were once spent squabbling with cousins, climbing mango trees, roasting cashew nuts, and enjoying an enormous variety of succulent tropical fruits. But I was completely unfamiliar with the fig—the fruit of a common Mediterranean tree richly symbolic in Scripture and, now, in my artistic life. I could only imagine what a fleshy, ripe fig might taste like. When I eventually tasted one as an adult, its sweetness took me by surprise. It tasted nothing like the flattened, dried figs from the eastern grocery store. Those look like something accidentally discovered with disgust on the bottom of your shoe, flattened as they are in an unappetizing tan stack!

I read somewhere that dried figs are good for you, so despite their dismal appearance, they often find their way into my pantry. A fresh, sweet fig comfortably meets its match in the juicy, honeyed sweetness of the mango or the custard-like syrupy flavor of the *chikoo*, two of my childhood favorites.

I am intrigued by the unlikelihood of my now writing about this fruit that was once so unfamiliar to me. This incongruity is consistent with the ambiguous tasks of writing this book or living as a contemporary Christian artist. Contrary to popular advice to stick with the familiar, I find that exploring the exotic is exciting. Who knows what unexpected treasure I may unearth?

The characteristics of the fig tree—its leaves, its fruit, its seasons and fruitfulness—are used symbolically in the Bible more than once, illustrating richly complex truths that are consistent, interconnected, and relevant. Its various subtle meanings help me as an artist. I trust that they will help you too.

The tending of the fig tree described in Proverbs 27 is an analogy that has taken me years to absorb. While that is an indictment on the slow pace of my learning, it is also a reflection of the marvelous complexity of God's Word. Despite the apparent clarity of the analogy, the infinite nuances of relevant application will take my lifetime to unravel. It is a common difficulty of all spiritual lessons. Spiritual truths are spiritually discerned, and we dwell almost exclusively in the realm of the material. Quickly reading something in the Bible, it is easy to assume that it is plain to understand. However, that understanding is no match for what happens when the Holy Spirit illuminates a truth and then seals it with an experience. Then my heart is seared; truth is now rich and multidimensional, spilling over into areas of life that I never considered before. Such illumination births in me a certain knowing that is impossible to erase.

The unique role of the Holy Spirit as a teacher, revealing the hidden to give us knowledge of all issues, biblical and otherwise, deserves attention. I honor Him by respectfully submitting my human intellect to receive what can only be spiritually discerned. He promises to guide me into "all truth" (John 16:3). He holds the keys; I reverentially stand aside for the door to

be opened, ever mindful that presumption or arrogance will keep the door barred and the key out of reach.

I strive to describe lessons learned slowly, because they defy common wisdom. These are lessons so subtle that sometimes I fear that unless I tell them quickly, I may forget them myself. Retrieving them from memory, despite reliving them many times over, I still have no mastery over them. Knowing the truth is easy; it's letting it govern my life that is elusive. Like trying to grasp and contain oil in my fingers, these lessons tend to slip furtively away, because they are contrary to my every instinct.

Yet over time my instincts are changing, and I discover the sweet familiarity of His life lived in, and through, me.

Lessons of the Fig

BEGINNINGS ARE IMPORTANT. You have, now, a partial glimpse of mine.

In the Old Testament, the first creative project fallen man tackles, after the devastating sin of disobedience, is sewing fig leaves together. The absurdity of this project apparently bypasses Adam and Eve completely. They merely respond to the horrifying awareness of their nakedness.

> *And the eyes of them both were opened, and they knew that they were naked; and they sewed fig leaves together, and made themselves aprons.*—GENESIS 3:7

Acutely aware of their loss, they feel shamefully exposed, not only physically but down to the very fiber of their beings. They sense the profound loss of the mysterious, God-endowed covering which once clothed them with royal dignity and authority. It was on them, it was about them, and it flowed through them to affect their world—powerful, glorious, and more than adequate. Forming the very substance of their being, it was their most precious possession; they squandered it by grasping for and consuming that which was forbidden. Their first creative act is conceived in fear and is an expression of their perceived independence from God. They attempt to mask their lack using resources immediately available to them. However, they do so in secret, apart from the vital union they once enjoyed with the One who endowed them with the very creativity that sought a solution to their problem.

Their endeavor gives a clue to our intrinsic predisposition, inherited from them. Adam and Eve do not turn to God but attempt to resolve their dilemma themselves. A rebellious will, independent of God, is now etched into their very being—and eventually into ours. Excluding God and partially empowered in

47

our creativity, we become demigods attempting to shape our world. Those who do not share the same gifts praise our creativity. However, whenever we do not acknowledge God's empowering role, such praise only stokes our false sense of independence. It is suspiciously like receiving undeserved worship. Usurping His role, we feebly play at mimicking His creativity, arrogantly unaware that we are only impersonators. Creativity without God may seem adequate but will come woefully short of what God intends for us.

God offers Adam and Eve a temporary solution in the covering of animals. He does this not simply because of the ridiculous inadequacy of fig leaves as a covering for their nakedness, but to teach them an important principle, repeated over eons of time. He deems it necessary that the shedding of blood be the only sufficient atonement for the sin of rebellion. Why? Perhaps because of the high cost—the stuff of life itself is found in the blood of the created being. Their disobedience leads to a severing of their relationship with God and the loss of a free and joyful life as they knew it.

Once fearless, enjoying God's company and living vibrant, lavishly fulfilled lives, humanity is now stripped naked of authority and power. They become cowering, peevish, and selfish. Their creativity, first expressed in the sewing of fig leaves, is now more often than not an exercise in meaninglessness and futility. Yet that is a lesson that they never seem to grasp—until Jesus rescues and restores humanity. The restoration of every aspect and nuance of man's loss is what Jesus accomplished on the cross! To grasp this marvelous truth and to live out its potential, in all of its magnitude, has been the quest of Christians since the cross.

We do not understand it all, yet with the little that we do grasp, such power is released to us! Our meager lives now sparkle with possibilities that are known only to God and are limited, or unleashed, exclusively by our faith.

The sin of self-sufficiency is well masked today. For you to see it at work in your life, through the mists of excuses and justification, will be the work of the Holy Spirit. It was in mine. My role is to write what I've learned. My prayer is not simply for you to read it and walk away, but for the Holy Spirit to guide and direct you to create with the full understanding of who you are in Christ.

Therefore if any man be in Christ, he is a new creature: old things are passed away; behold, all things are become new.

—2 CORINTHIANS 5:17

You are made new and sufficient only in Christ. In Christ, you are complete and abundantly creative. This, I have discovered, is not a grandiose claim that is of no use to a beginner artist. If a novice artist like I once was exercises the requisite amount of faith, a lifetime of boundless creativity will become his or hers to enjoy. God is the author of all ability, including creativity. Could He perhaps have a plan and purpose for it?

The analogy of the fig tree is rich in symbolism, teaching lessons pertinent to every Christian who either aspires to be an artist or already is one. There is far more to it than the now infamous enormous leaves which formed man's first clothing!

An even more intriguing analogy is apparent in the way a fig tree grows—and the purpose for its growing. The fig tree has precise seasons: a season to be planted, tended, and pruned, followed by a season to blossom and finally to bear rich, sweet fruit. There is a certain timeliness expressed in its every aspect, from its origin to its growth and even its longevity. In the Old Testament, the symbol of the fig tree is used frequently as representative of God's provision and care of each Israelite in a covenant relationship with Him. Intended to be a resource and a blessing, the fig tree was to be nurtured with the express purpose of harvesting fruit repeatedly.

And Judah and Israel dwelt safely, every man under his vine and under his fig tree, from Dan even to Beersheba, all the days of Solomon.—1 KINGS 4:25

Numerous biblical references to the fig tree imply that to profit from it, close attention is required. Tend the fig tree with diligence, and it produces fruit. Neglect it and either miss out on the harvest or worse, end up with unpalatable fruit! The children of God are expected to honor and revere the Provider of the fig tree as much as they respect the potential of the tree.

When they honor God, the land enjoys peace and the trees yield fruit. When they dishonor God, they frustrate His intent of abundant provision for them. The best expression of honoring God in the Old Testament was by obeying Him. Joy and satisfaction were a predictable result of obedience. When the people wandered away from the covenant, the result was dismal.

> *The vine is dried up, and the fig tree languisheth; the pomegranate tree, the palm tree also, and the apple tree, even all the trees of the field, are withered: because joy is withered away from the sons of men.*—JOEL 2:22

If you agree to trust God as your source of provision and supply, and you purpose to tend the fig tree of your life diligently, shouldn't the fruit be guaranteed? Unfortunately, it is not. Satan, an enemy of your mission, works actively against you to undermine your productivity. He seeks your very soul. Granted a temporary lease on the world by Adam's sin, he is limited in power and only effective with Christians who do not grasp the terms of the lease or comprehend the authority that has been restored to them by Jesus on the cross. Not particularly creative, Satan employs the same tricks over and over again, out of a tired repertoire of successful ruses—but they can effectively cripple you if you permit it. He will stop at nothing within the limited realm of his power to destroy you and stifle God's purposes for your life. Understanding his wiles and your authority in Christ will render him useless. Quickly recognizing his hand will keep him from undermining your fruitfulness.

Often, the enemy offers the insidious suggestion that you ignore God completely and take instead some other easy provision which he will readily supply. Take, for example, the case of the Israelites faced with the potential of starvation and an endless siege in a battle against the Assyrians. The king of Assyria made the following offer:

> *For thus saith the king of Assyria, make an agreement with me by a present, and come out to me, and then eat ye every man of*

his own vine, and every one of his fig tree, and drink ye every
one the waters of his cistern.—2 KINGS 18:31

This undisguised example of compromise by joining the enemy, presented to the covenant children of God, is no different from what Satan will present to you and me, with some minor variations over the millennia. I often marvel at descriptions of the pomp and splendor of the invading Assyrians. The Bible details the Assyrian hierarchy of power, mentioning various officials besides the immensely ruthless king. Artifacts dating from that time abound in museums, giving us a terrifying picture of what the hapless Israelites were facing. This deadly force, known for its cruelty and brutality, was now camped at their very gates, proudly confident in its string of prior victories. The entrances to Assyrian cities boasted of their might, adorned as they were with the grisly sight of the impaled bodies of their enemies.

Under these circumstances, is it any wonder that it was challenging to trust God? It was far easier to agree to form a covenant with the king of Assyria. The king exuded power, wealth, and influence. In all his pomp, he appeared to have the upper hand over an unseen God. Death by torture and starvation were pressing realities for the Israelites. Did they dare to choose the intangible, the words of their prophets reminding them of their covenant with God, over that which tormented their physical senses? The choice before us is no different today. We are constantly tempted to choose that which our senses assure us is best over that which God teaches us is more perfectly suited for us in ways we cannot even imagine. Take the counsel of the prevailing culture or the words of an ancient book claiming to be the very words of God—that is the choice before us. Common sense or supernatural, godly wisdom—which will it be?

This historical event or others like it, now ancient words in the Bible, are relevant to us because of their exquisite symbolism. Like the offer of the Assyrians, easy options are still available in the choices you face today. Could the fig tree be symbolic of all aspects of your gifted life demanding persistence, diligence and faith in the Provider for fruitfulness without

compromise? Symbols occur with breathtaking consistency in the Bible. Its sixty-six books, although penned by forty authors of unusually different professions, from shepherds to kings, over thousands of years, are consistent in every nuance and symbol. It is that very quality that points to the true author as God. The improbability of orchestrating such cohesion of text and theme, symbols and metaphors, ideology and history, prophecy and fulfillment over so many millennia demonstrates that the Book is beyond the scope of human machinations. The symbol of the fig is one such example, and it grows even more meaningful later in biblical history.

In fact, the fig tree is enormously pertinent to us as artists. During the Babylonian exile, history records that the first wave of Jewish exiles marched from Jerusalem were princes *and* those with creative ability and skill—the carpenters and craftsmen, the artisans, smiths, and engravers (2 Kings 24:14, Jeremiah 24:1, 29:2). Historians estimate that they probably numbered at least a thousand. Their artistic talents and consummate skills were prized and feared by their captors. In Babylon these elite exiles had the potential to become valuable members of society and arbiters of culture, while left behind in Israel, their creativity posed the threat of orchestrating a successful rebellion against their captors. How they responded to their circumstances in the choices they made affected their future, just like ours do today. God chose an unusual symbol to refer to them. In a prophetic vision given to Jeremiah, He called them the "the ripe figs"!

In Jeremiah 24, Jeremiah saw a basket of ripe and unripe figs in front of God's temple. God showed him that the ripe figs were symbolic of those who, in obedience to the command of the prophets of God, remained in the land despite their overwhelming inclination to flee in terror. When they were told to trust God and submit to their captors, despite the fact that they would become exiles, they listened. Generations of disobedience as a nation had brought them to this unfortunate moment in history. God had warned them that their national security was based on their honoring Him. Repeatedly disregarding His commands brought about the strengthening of their enemies and their present predicament. Young and old, ungodly and devout were all eventually taken captive to Babylon. Many who struggled to believe

God in this horrendous turn of events lost their lives. However, to those with hearts to hear and obey, He sent the assurance that He would care for them even in the land of their captivity if they would comply with His command to surrender willingly and not resist the enforcing of His will.

Some, unfortunately, chose to trust in what their senses told them was a dreadful situation, and they rushed to form alliances with Egypt. They fled the land desperately looking for aid from everyone but God. They are called "the evil figs," vividly portraying the danger of assessing the future through the prism of our own perceptions. Although the circumstances were trying, God still promised Jeremiah that He would watch over the now captive "good" figs. He would place in them what they were incapable of stirring up in themselves—the heart and desire to know Him.

His promise to them is found in Jeremiah 24:7:

And I will give them a heart to know me, that I am the Lord:
and they shall be my people, and I will be their God: for they
shall return unto me with their whole heart.

This elite group of princely and creative Israelites were promised blessing and prosperity in the land of their captivity: they were ripe, sweet figs. They unflinchingly faced their fears in a pagan land and overcame. Despite this tremendous reversal of their circumstances, they stubbornly refused to serve any but the one true God. Is it any wonder that their savor extended into the land of their captivity? God used them to penetrate Babylonian society, bringing His wisdom and presence into places that had thus far been impervious to Him.

Is He perhaps calling you to the same? Could you, through your art, bring His presence into physical domains simply because of your allegiance to Him? There is no way of knowing unless you step out and choose to do His bidding, trusting in the same unseen God to lead and guide you.

Walking into one of the galleries where I exhibit my art, a new painting catches my attention. It mocks Christianity in a tasteless and blatant manner. There is a canned image of Jesus, scored out, with bright red signs

stamped on it declaring "For Sale," "Marked Down," "Out of Date." Has Jesus become so irrelevant—a symbol to be discarded in the landfills of society? This artist seems to think so. A smattering of other familiar Christian symbols are haphazardly scattered across the canvas, reiterating the same sentiment. Momentarily taken aback by the content, I then find it amusing. Apparently the presence of my art, which I had thus far considered rather innocuous and certainly not overtly Christian, evoked a passionate, albeit negative, response from another artist with a strongly opposing view whose work hangs in the same gallery. Besides being vocally resentful of the content of my art, this visual statement is his hostile response. My art is communicating in the nonverbal language of faith with an effectiveness that startles even me. I seem to have ruffled a few feathers simply by sharing the same space!

Remember Proverbs 27:18: "Whoso keepeth [guards, watches over] the fig tree shall eat the fruit thereof: so he that waiteth [gives heed] on his master shall be honoured." When I consider that the fig tree may be symbolic of whatever creative ability I have been gifted with, it follows that I must wait on the Master for his counsel even as I tend it. I feel a little like the Hebrew captives in a foreign land. Everything is unfamiliar. The Jews looked alien to everyone they met. Their faces, clothes, habits, and customs were drastically different from those in the strange new land where they found themselves. Yet they were commanded to continue to seek and serve their God in much the same way as before.

Comfortable as I am creating art in worship of God in the privacy of my home, openly displaying its content in public is terrifyingly uncomfortable. In venues where art is described in the familiar language of design, color, shape, and texture, I am now venturing to converse in the language of praise, worship, prayer, and faith. I feel like a captive, shackled by expectations of my own as well as those of others. But am I really in a land of captivity, or is it only one of my own making? What if Christian artists are intended by God to be true arbiters of culture and art, creatively unshackled and proclaiming His excellence? What if my relationship with God makes me privy to the most potent language of art? Perhaps, like the Jews

in ancient Babylon, God intends our presence, in vital union with Him, to flavor and season society. Perhaps the salt of our work will trigger in others an insatiable thirst which only God can quench. These possibilities dawn rather slowly upon me.

Many years after the Babylonian captivity, in the New Testament, Jesus expressed His frustration with a fig tree that did not produce fruit, although in its outward appearance it was full and verdant. Appearances, which are everything in our superficial culture, are meaningless to Jesus. His aversion to them is expressed in His impatience with the tree's fruitless existence and command for its speedy removal. He expects prodigious fruitfulness.

And when he saw a fig tree in the way, he came to it, and found nothing thereon, but leaves only, and said unto it, let no fruit grow on thee henceforward forever.—MATTHEW 21:19

A certain man had a fig tree planted in his vineyard; and he came and sought fruit thereon, and found none. Then said he unto the dresser of his vineyard, Behold, these three years I come seeking fruit on this fig tree, and find none: cut it down; why cumbereth it the ground?—LUKE 13:6-7

As artists, we are blessed with varying abilities and skill. If our talent is part of what is represented by the fig tree, then some of us are the recipients of saplings while others delight in the gift of sturdy trees. However, skill and talent play only a small part in determining the worth of our tree or the sweetness of our fruit. Our fig tree will reflect either careful tending or callous neglect. That fruit is expected of us is an indubitable fact. The quality and quantity of fruit is all that ultimately matters.

We can nurture the soil that anchors the tree by feeding it with the riches of God's Word. On the other hand, our neglect or apathy can cause it to wilt in worthless, arid soil. We live in a hotly contested environment where it is imperative to vigorously weed even well-prepared soil. There is no other way to rid our turf of the profusion of unwanted nutrient thieves

which will continuously rear their ugly heads. And even having done so, the battle is not over.

I choose to be sensitive to God's light, straining as all plants naturally do to its presence and growing lushly in response to it. Then, as I burst forth in vitality, I also purpose to willingly submit to the Master for pruning. Resolve with me to allow Him to snip off leggy and undisciplined growth from our lives, even if it is uncomfortable.

Surely now it is time to burst forth in fruit? Not quite yet.

Instead there follows a season of waiting, when every fiber of my being screams for the visible signs of fruit. I determine to be unwavering in purpose and to wait. You must too. Wait even when it seems futile to do so. Wait when others demand an immediate harvest. Wait when it seems as if no possible good can be achieved by waiting. Patience must complete its work in us before we'll enjoy His promise of sweet, rich, and abundant fruit. That tortuously long wait, endured patiently and expectantly, honors God. In all its quiet emptiness, when there are no outward signs of comeliness or productivity, to wait with eager expectation indicates faith in Him.

Someday, in His timing, we'll bear fruit: sweet, rich and sumptuous fruit—not just one, but many. Each fig hides seeds in its sweet flesh with the power to multiply, to produce more fruit, until there is an abundant harvest. Our reward is not a single event, but continual seasons; greening up, flowering, forming fruit. Our tree will one day be mighty, established, anchored where it has been planted, and a joy to behold.

The act of creating art is ultimately an act of faith. Like precious seeds in the weary, soil-stained hands of a desperately poor farmer, the gift of art appears inconsequential. It does not betray even an inkling of its true potential. Rather, it almost seems to work furiously to disguise its worth. Its riches will only be revealed to the highest bidder, the most passionate investor, the most deeply dedicated gardener. Cultivated carefully, your calling as an artist has the potential to infuse your life with purpose, passion, and an unshakable sense of destiny. It has the potential to make you wealthy in the richest sense, enriching not only yourself but the Babylon around you with the presence of God.

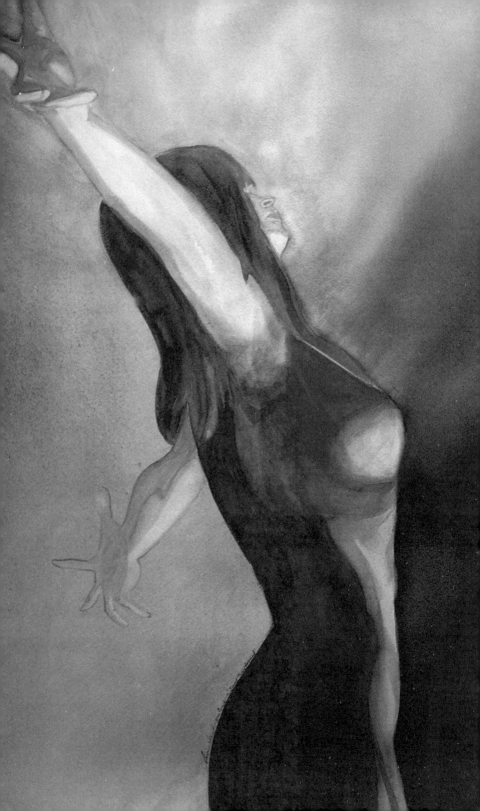

Nursemaid's Elbow

CHRISTIANS WITH ARTISTIC SENSITIVITIES OFTEN SINCERELY WONDER if their creativity is intertwined with their calling. If you are called to missions or a position in a recognized organization of the church, the import of your calling is unquestioned. Missionary friends of mine recall a specific moment when they knew they were called to take the gospel to Zaire or Lebanon. Invariably others, like pastors or deacons, confirm such calls. The church then offers support in prayer, encouragement, training, and funds. No one questions the gravity or worth of a missionary calling in response to Jesus's command to go into all the world to preach the gospel to all nations, to teach and to make disciples.

It is rare to find churches today that treat with equal gravity the mission of one called to be an artist. Since launching the website to address this void, I have become aware that there are several contemporary churches stepping up to remedy this unfortunate situation. Chances are, however, that where you live today, you do not yet have the privilege of belonging to a church that actively supports your destiny as an artist. So what can you do? How can you know if you are called to this task of artistically expressing the good news using the nonverbal language of art? If you do acknowledge such a call, do you know how to fulfill it successfully?

I realized early that I love to be creative. To shape things of beauty with my hands gives me an inordinate sense of joy and satisfaction. Have you have ever felt the thrill of making something beautiful with ordinary materials? Have you experienced surprise at its ability to take your breath away? Did you ever think with wonder, "Did I really do that?"

And if so, so what? Does feeling this way mean that you have a calling to be an artist?

Predispositions and sensitivities are gifts from God. Things that delight one can bore another to tears. The sheer variety of our personalities and quirks are as astounding as the diversity among creatures within just one group.

A recent visit to the Insectarium to view the display of bugs and other creepy crawlies astounded me. The sheer variety of butterflies in every hue and color took my breath away. I'd love for passionate adherents of the theory of evolution to explain the reason for such variety. What useful function can all that shimmering color and beauty serve? Why did extravagant color not fade away to a practical value study of black and white, like some organs that experts claim became vestigial?

Standing before extensive wall displays, I close my eyes and think, "Surely there aren't any pink butterflies, are there?" Opening them again, I eagerly scan the glass cases for what I think must surely be an improbable insect. I do not have to search too far, for there before me, in the most elegant shade of pink, peach, and buttery cream, is an exquisite butterfly, skewered in a display case for all to see! I see no purpose for its existence other than to delight me. Its presence serves to increase my awe of God, who like me, appears to create for the sheer joy of it!

Do you not see it in all creation? Comical creatures like the emu and ostrich, exquisitely beautiful peacocks, delicate translucent jellyfish, flamboyantly colorful tropical fish in every conceivable hue . . . all reflect God's personality as surely as your artwork reflects you.

If you have enjoyed that thrill of creativity even once, here is something to consider: God Himself placed that feeling of exultation in you. Your emotional response to the act of creation is not without purpose. Don't let anyone else, or any circumstance, marginalize His purposeful plan for it. Understanding this is not just a matter of mentally consenting to it, but something far more necessary. It is a vital step in embracing your role as a Christian artist. It is important to do more than just acknowledge the source of these feelings as God with a cursory nod. This truth has to enter into every fiber of your being for some very specific reasons.

Yours is the wonderful gift of freedom, the liberty to cooperate with His plan or to do nothing further with it. If you creatively engage sporadically

over the ensuing years and enjoy the process, but abandon it never to explore it any further, that is your choice. However, according to Luke 13:6–7, if you do so, you will use up the soil that God intended for you to thrive in. More than likely, others will try to talk you out of developing your gift. We encourage children to color and paint to their hearts' content, but when they reach the higher grades, the same activities are considered a frivolity or an indulgence. (Funnily enough, the world is full of retirees, in their golden years, coloring and painting again to their hearts' content!) The accepted paradigm is that of the starving artist: misunderstood, passionate, hopeless, destitute, and quite frankly, a deluded misfit in society. Well-meaning family and friends will steer you toward a more lucrative career. They will assure you that if you can pay your bills, you can create all the art you desire in your "spare" time.

The pressure remains even for those who have some support in their artistic endeavors. Should you be fortunate enough to study art in college, there is always the temptation to gravitate toward forms of artistic expression that are more commercially profitable. Fine artists are only commended when they acquire the requisite fame, often for their eccentricities rather than ability, to command high prices for their work.

In ages past, when the church sponsored the creation of art to ornament the great cathedrals, being an artist was considered a noble profession. Royal families, often hand in glove with the papacy, vied for the favor of artists in order to entice them into tackling mammoth commissions. Their contributions in drawings, paintings, and sculpture still define our popular understanding of what Christian art is. However, none of that is useful for you. Revisiting history will not help you handle the issues of your time and circumstances. The wealthiest sponsors of contemporary art used to be the big corporations, but with all that has happened in the global economy in the last couple of years, even their benevolence for the arts is either reserved for a privileged few, most of whom express a vastly different worldview from ours as Christians, or it has faded like a distant memory into the fabric of history.

What should you do, then, if you delight in the simple act of creativity? How will you find an audience, pay for supplies, show your work, and

contribute to society? Is that even possible today? Perhaps you think it is easier to enjoy art as a hobby whenever time allows and focus on the all-consuming task of making a living, paying endless bills, chasing elusive wealth, or getting ahead. That choice is completely yours, and I would not dare venture to make it for you. However, I do hope to present some compelling arguments for why you must not walk away from your God-endowed creativity.

There is usually just one reason for abandoning the gift for more "worthy" pursuits. Value is tied to one currency alone—money. But what if you choose to esteem another currency, one that God calls infinitely more valuable than even fine gold—the currency of faith? What if that currency offered rewards far greater than much coveted wealth, without excluding it? Currency is used to trade. We exchange something we value for something of even greater perceived value. Only a fool would give away valued currency in exchange for something of lesser value. God states that the currency of faith has such inherent value that every act of esteeming, honoring, and growing it allows us to benefit from trades of far greater value than any earthly currency can match. That being so, should not our pursuits be directed toward its accumulation so that we can trade up and become wealthy the way God intended us to be? But do we really believe that? Perhaps few are engaged in this pursuit simply because we do not believe it to be true. The currency we pursue reflects with astonishing accuracy what we truly believe. I suspect that most believe money gives us the power to trade up, while faith does not!

I cannot claim to fully grasp all the implications of such a belief, or one to the contrary, although by faith I am growing in understanding. The little I do know I will share with you in the hope that by doing so I can bestow the esteem due this precious currency of faith. I trust in it for no greater reason other than the fact that God has declared it to be of great value (1 Peter 1:7, Proverbs 8:19).

Faith without works remains dead.—JAMES 2:17

Pursuing, cherishing and growing the precious commodity of faith by stepping out in your calling as an artist will release wealth for every creative

endeavor you were created for. Turning away will just as surely impoverish you, often in ways that you will not fully comprehend when you make your choice.

If you will indulge me, I hope to fill you with the excitement of possibilities that you never even dreamed about. Consider for a moment what would happen if you could partner with an expert in art. He knows all there is to know about color, design, texture, technique, use of materials, creative expression, and of course, marketing. He gives you simple directives to follow and guides you to a completely fulfilling life as an artist. He assures you that you will never experience a lack of materials, ideas, imagination, venues to display your work, collectors, or meaningful expression. Would you then be so foolish as to turn Him away? Would you tell Him, "Thanks, but no, I already know that artists are doomed to live hopeless, unfulfilled lives. I think I'll just dabble in art on my own. If I sell, perhaps I'll create some more, and if not, then I'll get myself a 'real' job . . ."

What I've described may seem ludicrous when expressed so bluntly, but this attitude is far too true of many Christians who know in their hearts that they were meant to be artists.

Some who do become artists forget that they are also Christians. They seek sponsors, strive to learn from those who have coveted reputations, submit themselves to a jury of peers for affirmation of their talent, and overlook inquiring of the King of Kings for His opinion on the matter. They create work that is excellent yet far removed from their spirituality and closely aligned with current trends. They enjoy a measure of success that may be fulfilling, but will it merit a "Well done!" from the One they call Lord?

Could the making of art become instead a rich and fulfilling adventure, faithful to its source, independent of the affirmation of others, dependent only on the affirmation of One? I testify that it can. The making of art in partnership with God can be wonderful and full of unimaginable rewards.

One cool spring evening, I take Johann for a walk. He is only two. His little hand is in mine, and he toddles along by my side. There is much to point out and see. We live in an apartment on the edge of open fields. Later the expansive fields will disappear in a maze of concrete and glass as the city swallows them whole. Each spring the meadows explode with wildflowers:

bluebonnets, lavender verbena, and nodding wine cups, and later top-heavy sunflowers with enormous golden heads, Indian paintbrush, and delicate buttercups.

For Johann, the cars that speed by are far more exciting to watch. He spots one that takes his fancy, jerks his hand out of mine, and darts away. It is just an instant before I grab him firmly, pulling him back to safety. I think nothing more of it. When we return home he seems rather subdued. Watching him play quietly with his toys, I notice that his arm hangs limply by his side. It takes a trip to the doctor to understand what happened.

Johann is a victim of a common childhood accident known as nursemaid's elbow—a diagnosis that needs no further explanation! His desire to be free of me resulted in his elbow being pulled out of joint, apparently a frequent occurrence in children his age.

I realize that I've suffered from an adult version of nursemaid's elbow, no different from many Christian artists today. Our useful arm, which should create joyfully and freely, sometimes hangs limply, incapacitated by fear, societal norms, financial concerns, or simply because we want to go our own way. How much better to hold firmly to the hand of the One who wants to show us treasures yet unknown! There are worlds we have yet to explore and adventures in art that we have no clue about.

The remedy for Johann is simple. The doctor gently massages his arm back into place. His smiles and playfulness resume, although his urge to wander too far is temporarily curbed.

If only it were quite so uncomplicated for us!

The Poem

NO POEM IS A RANDOM COLLECTION OF WORDS without meaning or forethought. Instead, beauty is found in the complexity of a poem's meaning, its cadence and rhythm, the symbolism of its words, or its inherent structure or form. Poems resonate with a level of richness that a casual assembling of words can never match. And they express the thoughts and intent of the poet.

Just as there is no purposeless poem, neither is there randomness in nature. God's creation resounds with ingenuity and purpose. The creepy bugs are fodder for the birds, which are instrumental in carrying seed about, transferring gardens from one locale to another. No flower blooms without being an active star in a cast that is varied and diverse. To think for a moment that your creative urge is without purpose is to go against the very grain of God's personality as expressed in nature.

Ephesians 2:10 best describes His purpose for each of us. This is the soaring bird's-eye view of that purpose:

> *For we are God's workmanship* [the Greek word used is poiema,
> or poem—a masterful, unique creation or transformation],
> *created in Christ Jesus unto good works* [the Greek word used
> here is ergon—work, works of labor, including anything
> accomplished by hand, art, industry, or mind], *which God hath
> before ordained that we should walk in them.*

We are created in Christ Jesus as a unique poem for purposeful, preordained labor. This labor includes, but is not limited to, the creation of art. Every minute of the day, every circumstance, miserable or glorious—all of it is diligently woven together in a complex, ever changing, yet surprisingly

consistent tapestry of purpose for our lives. The tapestry changes only because of choices we make or circumstances, limitations, and restraints that others impose on us.

At an exhibit of Chinese crafters, I watch in awe as a woman deftly embroiders a painstakingly drawn image on a stretched piece of muslin. Her careful selection of colored threads results in the image on the front of the embroidery being magically different from what appears on the back. Much foresight in the design is crucial for the creation of such a masterpiece. It was fully realized in her mind before being transferred to the drawing on the fabric. What we, the gawking admirers, observe at the demonstration is the deft execution of what was earlier conceived.

Our lives are much like that. Our circumstances, some within our control and some beyond, form the viewable image of our life's tapestry. God, if permitted, works His genius behind the scenes. Like the magic embroiderers create on the reverse side of muslin, He integrates surprising beauty, only visible at first with eyes of faith, then coming forth in awe-inspiring loveliness for all to behold. If you don't see much beauty now, don't despair. Remember that He has only intentions of good toward you.

When it is turned over to Him, God can turn a splotch of inky hopelessness or a tangle of silken thread into a recognizable landscape of exquisite beauty. He has the power, creative ability, and desire to turn your life, the messes as well as the perceived triumphs, into a richly ornamented tapestry of worth. Are you willing to trust Him to do so?

My first act of trusting Him is impulsive. I blithely inform Him that I will permit Him to use me as an artist. It does not strike me as the least bit presumptuous that I, the created one, am telling Him, the Creator, that He has my permission to use abilities that He blessed me with in any way He chooses! Only later does the arrogance of my "surrender" gradually dawn on me.

I then expect that with God's help, my art will blossom into a breathtaking level of genius. Why not? God is with me! Time is compressed, and I expect success at once. But my act of trusting Him is all about me. Latent in my expectations in this tentative early act of trusting is that His will for me had better meet with my approval!

Yet Jesus does not turn me away. I do so love Him for accepting the selfish "gift" of myself with all the seriousness of a father opening with gravity His little girl's sloppily made valentine. The card is flawed, but it is all she is capable of. I am flawed; my turning over my life and art to Him, with all its egocentric motivations, is all I know at the time.

And my "gift" is accepted.

Listening to Hear

"Come ye near unto me, hear ye this; I have not spoken in secret from the beginning; from the time that it was, there am I."

<div align="right">—ISAIAH 48:16</div>

HEARING FROM GOD IS OFTEN THOUGHT TO BE RESERVED for the spiritually sensitive or the freak. The first women's meeting that I attend at church is an unforgettable event. I feel as if I am among people who are seriously delusional. They chatter comfortably over lemonade and brownies about "hearing from the Lord" on an astounding variety of subjects. It takes everything in me not to shy away from them, questioning my sanity for being in their midst.

Yet, it is an undeniable fact that these women are sensible wives and mothers. Comfortable in the warmth of their friendships, they have an enviable ease about them. Their lives are not uncomplicated, yet their solutions are. They simply take every troubling situation to God and expect Him to help them resolve it. I eavesdrop on their passionate conversations with Him, which they call prayer, faintly disturbed by their familiarity with One so awesome.

Does He really hear and care? Will He respond? Can I learn to hear Him?

Week after week, I observe and then timidly begin imitating them, hoping that I will not be discovered as an impostor with nowhere near the level of confidence in God they have. They draw me to them by their no-nonsense approach to life and to God. I cannot escape the depth of their character compared to the superficiality that I experience everywhere else. If they can speak to God as if He is right there in the room with them, then perhaps I

can too! They talk to God as if He cares about the details of their lives, from their gravest concerns to the silliest little question that baffles them. I return, addicted. An insatiable appetite for their results and their strange wisdom draws me with a force that surprises me. Incredulous, I hear them recount various answers to prayers that I was a witness to. God cares and answers far too often for it to be mere coincidence! The answers are so tangible and specific that I dare not deny them. My hesitant prayers grow bolder and more confident. Without my realizing it, I also develop a growing passion for studying the Bible. Jesus, whom they comfortably chat with, becomes my friend, confidant, and then so much more. He becomes my very life.

Today, I share lessons from this precious Book, the Bible, which I know to be the inerrant Word of God. Hidden in its pages are truths more powerful than the strongest force on earth. I have learned that Jesus and His Word are inseparable. You cannot claim to love Him and not be just as passionate about His Word.

The Bible is bottomless. Its depths can never be plumbed and its wisdom never fully comprehended. However, it is not unknowable or impossibly difficult to understand. As complex as any landscape, its truths can never be fully explored in one lifetime—there will certainly be some vistas left unseen, some windswept meadows unexplored, some verdant fields left uncultivated, and much territory left uncharted. Yet I promise you that all that you do explore and act upon will transform your life!

Somehow within its pages dwells a mysterious power, easily available to anyone with a smidgeon of faith yet completely elusive for a skeptic. The Bible is the Living Word. Alive and pulsing with power, the same words pack a different punch for each humble reader.

The Holy Spirit's magical role is to draw back diaphanous curtains of ignorance, revealing powerful truths which can be tested. I am determined to test it all in the laboratory of my life. His role is what makes reading the Bible such an adventure. What He brings to your attention will be subtly different from what I hear, though we read the same words. He tailor-makes each lesson to be pertinent to the unique needs of your own life experience. Reading the Scripture is like entering a garden filled with marvelous flora

and creatures that you have never seen before. You don't enter it alone, but holding on to the hand of the Creator of this Eden. He walks with you and points out the idiosyncrasies of each creation. If you linger long enough, you'll gather enough information to make your head spin. Your life will be enriched and transformed, never to return to its former dull futility.

If you merely step in for a quick glance around, all you'll see is a bizarre, alien land. Should you choose to wander alone, arrogant in your self-sufficiency, the same words will seem like archaic babble and the landscape unremarkable.

This too comes gradually to me. I realize the truths that I am swiftly learning appear nonsensical to those with whom I share them. Smiling kindly, they hope that I am going through a phase, that I will somehow outgrow it. They politely avoid "religious talk" with me until they are certain that whatever I've "caught" will pass like a bad case of measles.

A quarter of a century later, I am more convinced than ever that Jesus holds the answer to every question ever asked by humanity—certainly every question asked by an aspiring artist. As with any question, it must not only first be framed correctly, it must also be asked of the right authority. The answer must then be drawn out, comprehended, and acted upon. Only when the answer is tested, and verified as authentic, can it satisfy our human need for accuracy.

My questions lie deep within me, buried where I have no way of retrieving them. They sporadically float up out of the foggy depths of my being; questions that I've been unconsciously asking suddenly surface to wink at me with crystal clarity. These are not answered in a flash, or even many flashes, of brilliance. Instead they are gradually revealed to me over the years of my growing relationship with Jesus.

What is my life's purpose? Why am I here?

Do I really think that my limited ability to do a few creative things makes me an artist?

Why should being an artist matter?

How will I differentiate myself from the countless other artists in the world, most possessing breathtaking talent, certainly far more than I see in myself?

What sort of difference can I make? Must I even make a difference?

Why God, did You give me this ability? Is it just for my enjoyment, or did You have other plans for it?

Can I make a living out of it? Must I make a living out of it? How will I? These pesky, nagging questions do indeed have satisfactory answers. They are, however, mysteriously intertwined in a relationship with Jesus. Only He can teach us with lessons specifically targeted to tackle our predispositions as well as our weaknesses. We must be willing to stay the course. Being a good student requires persistence and an expectation that we will grow and understand if we refuse to quit. Learning is not an event but a process. God knows that we retain nothing unless we experience it for ourselves. Otherwise truths remain theories. All of us know that bees sting, but those who have been stung understand it better!

So agree with me that this is a journey worth embarking on. Trust that as you take timid steps forward, Jesus will take you by the hand and begin to educate you in all the various aspects of living an abundant life as an artist.

Toddling comes before walking confidently; expect to fall often, yet resolve to pick yourself up to learn to walk again. Somewhere in the future, there is a marathon waiting to be run. It will take rigorous training to complete it with excellence.

Communicating

OUR LISTENING TO GOD CANNOT BEGIN without drawing near to Him. As I take tentative steps toward Him, He speaks. I discover that He cares to speak to me, far more often than I care to listen. It isn't that I do not want to hear from God. It's just that I don't expect to hear. God seems remote to me, magnificent and completely inaccessible. Surely it is absurd and far-fetched to imagine that He has anything specific to say to me!

I discover otherwise. As He talks to me, I enter a spiritual world, which although at first it seems unfamiliar, grows more real over time than the tangible one around me. "Come near to me and listen," He commands—something I've never thought much about doing before.

As humans, we cast our conversations about, over our shoulders, in passing; while driving, scrambling eggs, pulling a sweater over our heads . . . yet if He says, "Come near to me and listen to this," it forces me to at least pause and give Him the attention due such a specific request. I've often held my children's faces in my hands and said, "Look at me!" before stating what was on my mind. Yet although their cheeks were stilled between my palms, I could do little about their eyes, which darted away to other more intriguing things! So it is with us. If we complain that we never hear God, perhaps it is simply because we haven't yet taken the time to restrain our roving attention and draw nigh. If we do, we will indeed hear from Him.

God does communicate with us in innumerable languages through various media: music, art, science, and literature, through inspiration, dreams, and ideas. His voice is in the very air about us! It tells us about His ingenuity, humor, creativity, care, subtlety . . . However, none of those ways of speaking gives us specific direction, insight that is unique to our lives, or warnings that must be heeded. None of them tell us about our future or deal with our past. They allude to His presence but leave us hungry for

more. And that is why we possess a foolproof, although often ignored, language of communication in the Bible.

While setting up my website, with no prior experience in computers, I wallowed miserably in my limited understanding of the confounding coding language, a process that systematically stole my joy. However, rather than mentally devising methods of cruel punishment for the geniuses who created such a ridiculously complex language, I wised up to the fact that if I was to communicate at all, I had better grit my teeth and set myself to the task of learning some of their lingo. The hours of repeatedly typing, checking, correcting, writing, and rewriting simple lines of code more than paid off when my first page finally looked as I had envisioned it. Then came the next, and the next, and before long I was comfortably, albeit in a very elementary fashion, communicating with the world.

Somehow, we rarely view the language that God provides for us in quite that light. Christians often complain that the Bible is not always easy to understand and quit attempting to master it, unaware that their future depends on it.

My life changes when I grasp that the Bible holds the secrets of all that I ever want to know about God—not just in an academic sense, but experientially if I choose to act on what I read. It does not merely contain the words of God, but claims to be the Word of God. If that were all, it would be remarkable and worthy of study. But it also promises that each of its words is relevant for me personally, in my present circumstance. I need no more persuasive reason to plunge right in and put those fantastic promises to work in my own life.

As rookies in our faith, BJ and I are just beginning to see everything in the Bible as an experiment worth conducting. We see no reason to entertain preconceived notions about any aspect of our faith. Everything we experience has never happened before, either to us or to anyone we know.

Young, naïve, and ambitious, we covet the American dream. BJ dreams of owning a business someday. Armed with a business plan, plenty of enthusiasm, and not much else, he approaches bank after bank for the funding to realize his dream. He is turned down repeatedly. Fresh out of college,

he has absolutely no experience to reassure any loan officer that he is a bet worth taking. It is the perfect catch 22. How is he to get the experience if he is never given an opportunity? Undeterred, he tackles the rejections with his usual dogged perseverance, although eventually they grate his dreams down to a ragged sense of despair. Somewhere during this season, we start turning to God in prayer with eager, childlike expectation. It seems blatantly obvious to us: we've invited Jesus into our hearts and lives; surely together with Him, we are invincible! But how then are we to reconcile our repeated failure at convincing others of the same, especially since those others seem vital to the success of our dreams? How do we get the money to begin without the help of a bank? We worry first and then pray.

Our days begin with the Bible and steaming mugs of coffee. We read, often grasping only some of what we read. We read because we yearn to understand more. We read when we feel least like doing it, conscious that our perseverance will eventually pay off with understanding. We read when our days threaten to overwhelm us and when they stretch before us empty of plans yet full of promise. We take our Bibles everywhere, even on vacations. Much of what we read floats over us, but some finds its way to our hearts, sinking deep roots and sprouting the tender shoots of a new and stubborn faith.

We are developing, by total immersion, a proficiency in this new language which becomes a powerful form of communication with God. Snippets of verses pop unexpectedly into our minds like dreamy wisps of conversations, leading us, prompting us to the right course of action, and sometimes challenging us to think differently.

One steamy Texas day, walking out of the library, I open the car door, climb in, and maneuver a pile of books into our old compact car. I complain that people on the street make better progress walking than we do in our car! Oh well, we are young and know that there will be better cars in the years to come. This one is a relic, more suited to a junkyard than the streets, and completely hopeless on the freeway. Anything can be endured when there is a time limit to it, even if it is only in our minds!

I am eager to return home to read the mountain of stimulating books I can barely carry out of the library. Keen on establishing the historicity of

Jesus, I hunt down biblical archaeology books and extrabiblical references to Jesus wherever I find them. Each new discovery leads me on like a moth to the inescapable light.

Who is this man who walked the earth over two thousand years ago? How does He still influence so many today? Are all His audacious claims true? What do they mean to me? I still stubbornly want to satisfy my curiosity about my newfound faith; it drives my quest for knowledge. The library, which I then considered a logical place to search, now no longer dominates my thinking as a resource to quench my thirst for knowledge of God. Today, I marvel at His many ingenious methods of revealing His character, plans, and purposes. Far more often than using mere words from library books, God cleverly employs the Bible, the Holy Spirit's quiet voice that speaks to my spirit, people, and circumstances to impart the specific experiential knowledge I must have to mature. But I didn't know it would be this way back then.

BJ is preoccupied, backing the car out of the narrow parking lot. On top of the pile on my lap is a red, hardbound book. It is dusty from languishing unread in some remote corner of the library. I flip it open and look at the flyleaf.

"Look at this," I exclaim, "someone wrote this for you!"

He casts an uninterested glance over his shoulder. "What is it?" he asks. I can hardly contain myself.

"Someone has written in pencil, *BJ, Rest in Him, and He will guide your every step. Phil 1:6.*"

Neither of us has a clue what the Scripture is about. I am too awed by the first two letters—"BJ"!—a nickname that only close family members know my husband by.

"Show it to me," he says, unimpressed. I dutifully shove the book over to him.

"It's just a coincidence," he declares.

"How can you say that? Look, it's addressed to just you. BJ, God is telling you to quit worrying and to trust Him."

We drive on in stony silence. I am trying to grasp the odds of this happening. How many BJs could there possibly be in Arlington?

The dappled sunlight casts bizarre shadows. It shoots flashes of blinding light followed by deep shade as we pass under some live oak trees, rather like the pinpricks of doubt and wild hope that flicker over us and then vanish.

The red book is the first one on my lap in my pile of at least fifteen books, selected from a library of countless volumes. What is the likelihood of my opening it to the flyleaf? I wonder. Who on earth reads the flyleaves of books? Certainly not I! I am usually too impatient to get to the meat of the material, frequently restraining myself from reading the last chapter first!

I press on, chattering about the impossibility of the circumstance, ignoring his skepticism. Because of all the recent disappointments, our roles are now reversed. Usually cautious in my newfound faith, I am convinced that God is speaking to us, despite how farfetched it seems. BJ, on the other hand, having experienced a fair share of disappointments, all still painfully fresh to him, is more reluctant to hope. His once vibrant faith is down to weakly flickering embers, filling him with uncertainty about God's involvement in the details of his life.

Under our circumstances, it certainly seems a stretch to assume that God cares enough about BJ's dream to bother reassuring him of His guidance. Yet the dull cream of the open page with its boldly penciled note seems to indicate that He has just done so, even addressing my husband by name!

I reach over the open book and turn on the radio. Any intrusion upon our uncomfortable silence is welcome. Within a few seconds, a fresh, cheery voice announces the next song to be played: it is based on the same Philippians 1:6, but we do not know that at the time!

"He who began a good work in you," sings a mellow tenor voice, "will be faithful to complete it."[2]

The song wraps around us like a soft blanket, comforting us with its amazing promise. We drive silently and listen. I look out with unseeing eyes at the gray buildings passing by, awed by the moment, drinking in the words and sensing the presence of God. Can it be, as the singer seems to suggest, that God is aware that the struggles we are facing are indeed slowly replacing

2 "He Who Began a Good Work," lyrics by Jon Mohr, 1988.

the excitement of our newfound faith? Dare we trust that despite the circumstances, God still cares about us and will work things out somehow?

The authoritative words resonate, accurately assessing our helplessness and offering hope. It is hard to shake off a happily eerie feeling that God is talking to both of us through the lyrics of that haunting song. Even BJ has to concede that this is certainly too pat to be mere coincidence. As if to further cement the power of the verse, which we rush home to carefully read—discovering to our amazement that it is the basis of the song—we have two more equally impossible "coincidences" later that very day.

At church that night, the featured song sung by the alto soloist is the same—"He Who Began a Good Work." It refreshes our now hopeful spirits. Before returning home, we linger in the church bookstore, browsing for more inspiring literature. I clumsily back into a stack of LPs (this is long before CDs and other digital media) arranged neatly on a table behind me. By grabbing the whole pile as it begins its downward slide, I barely manage to keep it from scattering all over the floor. The record on top of the stack that I rescue—you guessed it—features the same song on its glossy cover! I mouth the words silently in awe.

We repeatedly heard this pithy message several times that day. Our dreams are significant. They are a beckoning, an invitation to partner with God. He is pleased when we expect their fulfillment. They are like a wrapped gift that He eagerly waits for us to open. Once we do, His joy is made complete when we fully employ and enjoy it.

If this account were the only coincidence of our lives, you would be justified in being skeptical. However, this marked the beginning of a lifetime of such occurrences, which we quickly learned to recognize as bearing the fingerprint of God. Long after the library book was returned, the memory of those graphite words remains. The wonder of it still awes us; the improbability of my unearthing that book from a library of countless volumes and addressed so specifically to BJ still strikes me as strange. I could not make up something as absurd and improbable as that. Those words written in a quiet, confident hand, assuring us of our tomorrows, are indelibly etched upon our minds.

But what about the words themselves? Had they been an empty promise to calm our fears, then I suppose you could dismiss the whole incident as without worth. But what happened next convinced us even more of God's awesome partnership in the affairs of our lives.

Just a few days later, the jarring ringing of the phone interrupts our sleep. The callers offer us the needed funding as a loan. We didn't request it; they offer it because they heard from others about our futile efforts with the banks. They are dear members of our family, a couple whose kindness and generosity gives us the impetus to launch BJ's dream. The impossible has become possible; and so it is with every dream that is handed over to Jesus!

I have not spoken in secret from the beginning; from the time that it was, there am I.—ISAIAH 48:16

God speaks in a whisper, yet not in secret. He speaks from the Bible, quietly yet crisply. You will hear Him if you fervently yearn to do so. God always initiates the conversation when you are young in the faith. Yet only by cultivating a listening spirit do you hear. In His inimitable way He spoke in those early days, calming our fears, comforting us and inviting us to trust Him. Deep in the core of our beings, as we absorbed His Word to us, we settled down to trusting Him to resolve our dilemmas. It did not happen right away, but He proved to be faithful to His Word. "At the time that it was, there am I." His presence is unmistakable every time His Word is fulfilled!

His words to you, like tantalizing clues, will often reveal some aspect of His nature along with a cryptic instruction which must be carefully heeded. However, He has little to work with if we do not become fluent in His Word. As I grow, I learn that my ignorance or neglect of His Word will limit His communication with me—rather like a parent cooing to a baby instead of engaging in intelligent discourse as with an adult.

When God speaks, He commands a response—immediate and willing obedience. By reminding us that He who began the good work in us could be trusted to complete it, He was demanding faith from us to trust Him.

To doubt then would have been disobedient despite how impossible our situation appeared.

What if the voice you hear is not God? How can you know? That too, I discover, is something that we unnecessarily complicate. If that gentle yet insistent inner prompting is accompanied by a verse from the Bible, it is His voice. If it is an instruction intended for your eventual good, He has spoken. Never the author of confusion, He speaks with simplicity and clarity. I also learn that if what I hear is contrary to my own selfish inclinations, I've heard from God! He continually encourages me to rise above pettiness and then generously empowers me to do so. There are worthy rewards for hearing and obeying His unique voice, rewards that may not always be easily apparent initially.

Jesus promises that we will hear and know His voice, and the voice of a stranger we will not follow (John 10:4–5). That is a comforting promise to trust. So lighten up! If you intend to hear and obey, you will. Familiarity with His voice flows naturally from a growing, intimate knowledge of who He is.

I quickly realize that nothing can replace the dividends I earn from a determined study of the Bible. His voice, an accurate reflection of His character, becomes indelibly imprinted in my mind and heart. As I read the Bible, it is easy to get bogged down in historic details or events so removed from our contemporary culture that I sometimes have to remind myself of why I read it. I want to know Him so that I can say without hesitation, "Yes, that is so much like Him" or "No, He would never do that." Can't you recognize every nuance, pitch, and timbre of a loved one's voice on the phone from the very first "hello"? How then will you not instantly recognize the voice of God if you become familiar with His character and grow comfortable with yielding to Him?

There is another mystery to hearing His voice, which I submit as a warning: if, when you hear its gentle prompting, you ignore His command, His voice somehow becomes less clear. He will graciously grant you other opportunities to hear and heed. However, making a practice of ignoring Him and neglecting to swiftly obey His command will quickly cloud

communication. Through the fog of disobedience, hearing with clarity will become something you can only wistfully desire. You may hear other Christians talk about hearing from God without ever experiencing the thrill of it yourself.

I notice that the Christians I admire ardently seek to hear from Him. They are excited about truths they've uncovered from the Bible. They also live radical, uncommon lives of obedience. I yearn to do the same. They obey under the most grueling circumstances, relying less on their own perceptions and far more on His Word to them. They walk by faith and not by sight. They refused to be moved by the passage of time when trusting God's promises to them. Their lives are dynamic, fruitful, and gloriously marked by the supernatural.

On the other hand, I observe other Christians who live sadly defeated, bitter, fear-filled and frustrated lives, going through the motions of Christian living yet devoid of the vitality or power of a vibrant relationship with Jesus.

The sort of life I admire is born only out of an unquestioning trust in God and His Word, lived out in prompt, cheery obedience. I aspire to the same.

Obey

Rest,
When I would rather work.
Work,
When I would rather play.
Run,
When I would rather walk.
Strive,
When I would rather quit.
Give,
When I would rather grasp.
Listen,
When I would rather talk.
Your voice
It speaks from day to day.
Help me, Lord
To just obey.

The Adventure

CHALLENGES ARE TO BE EXPECTED, I SUPPOSE, in this exciting new adventure in Christ, and all of it will surely be effortlessly engaging. I envision a satisfying finish to match this thrilling beginning, with the loose ends neatly tied up in a fantastic conclusion. Naïve, I know. Grateful that the Bible already describes the glorious ending to my story, I still must somehow navigate all the unclear twists and turns of my plot. That is the reality I now face.

Much of life happens without my consent. There seems to be little I can do to steer it toward my goal of becoming an artist. In the early days, persistently consuming maternal tasks siphon time and energy away in a slow, deliberate trickle. I decide to educate my mind between chores and errands. Along with Tupperware containers of Cheerios and sippy cups of juice, I carry art books everywhere I go.

To my dismay, I read that the world's most lauded artists found that familial attachments hindered their productivity. They indulged their passions yet scorned marital commitments, considering their calling as artists to be far superior to any hold a wife, mistress, or unexpected offspring could have on them. Some of that reasoning makes sense to me. After all, if the majority of my waking moments are not spent painting or sculpting, how will I become proficient at art? I am left with an unpalatable conclusion. History seems to consider it acceptable that artists spend a negligible amount of time eating and cohabiting (never mind the consequences) yet somehow unthinkable for them to give family first place and art second in their lives! Not surprisingly, God was only occasionally involved in the equation. I've barely begun, and it seems as if my adventure is already miserably doomed! Besides God, my family occupies the center stage in my life, and I have precious little time off stage. So how then do I create great art if my time is not my own? Perhaps, I reason, this is a twist in the plot.

As I strive to coax time out of a hectic schedule, what follows is a season of unnecessary frustration. I learn gradually that God is the giver and keeper of time. He ordains seasons for everything.

> *Doth the plowman plow all day to sow? Doth he open and*
> *break the clods of his ground? When he hath made plain*
> *the face thereof, doth he not cast abroad the fitches, and scatter*
> *the cumin, and cast in the principal wheat and the appointed*
> *barley and the rye in their place? For his God doth instruct him*
> *to discretion, and doth teach him.*—ISAIAH 28:24–26

I read this, and rather reluctantly, all my scheming for time to paint grinds to an inglorious halt. I don't doubt that God has a plan for me as an artist—but suddenly it seems somewhere out in the hazy future. This is not the season. The well-being of my young family and my sanity depend on temporarily releasing my artistic aspirations from the death grip of my ambitious hands.

I dare not pretend that this is effortless. In the fleeting season gifted to me for enjoying my children in their younger, more dependent years, I am briefly distracted by the lack of time to create. If not for wise friends, this would be a needlessly trying time. Yet with their counsel, I throw myself into my nurturing role of being a mother with renewed zeal. The Lord will let me know when it is my time for art. It is not yet.

If you are in a trying season with demands that tug, pulling in many different directions, crowding out what you know to be your calling as a creative person, don't fret. Be confident that when you trust God with your time, something magical will happen. He will free up time for you.

Assess the season that you are presently in. Perhaps you are caring for an aging parent, or tight finances force you into taking a job that limits your time for art. Every season is clocked by God, its minutes firmly contained in parentheses. It will never stretch on unendingly. Trust Him with this season's length as well as with the provision of resources for handling every aspect of it.

Eventually, I become comfortable with biding my time. I do confess to occasional pangs of envy when I meet other artists who have every opportunity to hone their skills while I am temporarily delegated to diaper changes and car pools. Squelching those pangs, I expect a tomorrow when it will be my time for art.

Interestingly enough, this release and my inability to do nothing more than dabble has the opposite result from what I expect. Opportunities present themselves unexpectedly. Someone remembers that I paint watercolors and asks if I would consider working on a portrait for them. "Do you have any watercolors of India for sale?" asks another. A friend tells me about a group that paints together every Tuesday. She graciously offers to take me if I want to join them. I load all my paraphernalia into her car, and she drives me faithfully, week after week. When I least expect to have the time to paint, this opportunity of painting just once a week is a boon. It does not seem self-indulgent. I look forward to Tuesdays with the enthusiasm of a child counting down to her birthday. I paint with wonderful, seasoned artists who later become nationally famous. Little do I realize that I am getting an invaluable, albeit unconventional, art education simply by being around these mature artists. We paint, critique each other's work, go out to lunch, and talk art until late afternoon. When we part ways, I feel fulfilled. God is satisfying a deep need that I am wholly inadequate to fulfill.

Can God do the same for you? I know He will. You do, however, have to trust Him with it. If you are manipulative, all you will end up with is frustration, wasted time, and a mean streak that will take years to erase. Let Him be your time manager, and you will step back in awe at what He can work.

Besides, isn't that what an adventure is all about—the element of mystery and surprise?

Purpose

AS A SPECTATOR ON THE BEACH, I'm a few inches removed from the view in perpetual motion before me. As inevitable as a wave that crashes onto the shore, our lives have a decisive path, a destiny and a God-ordained purpose.

Beginning with just a flutter of the wind hidden from our searching eyes, then gathering force, the wave moves on toward the shore inexorably and powerfully. It carries in its swelling bosom unlikely treasures: gelatinous seaweed, shells, shiny pebbles from a distant shore, or tumbling crabs, smoothing out to glistening foam and seeping dampness onto the thirsty beach. That it will reach the sand, either in a thunderous roar or with a whimper, is never in question. Where the winds may carry it, and what mysterious riches will swirl in its wake, is left unknown.

I think about all this as I watch a wave lift its feeble head somewhere in the middle distance of my panoramic view of the ocean. Here, at Surfside Beach, I'm with BJ and my sons at a rented cottage for a brief Thanksgiving weekend. The certainty of God's purpose for each of our lives is as sure as that distant, timid wave on its determined path to the shore. It is also as unique as each one of us, as pictured in the glaring difference in my response to the sea and that of the boys.

Reuben left midmorning, wearing a T-shirt, shorts, and flip-flops. I joined him later at the water's edge, timidly picking my way through the kelp, skirting any but the mildest waves. The path leading up to where he stands is littered with his abandoned clothes, like the remains of a cocoon after the butterfly has long since vacated its warmth.

With a cheery grin, Reuben stands in slightly chilly, waist-deep water. He is covered with gray sand as if some giant saltshaker has emptied its contents over him. In late November, the waters of the Gulf are still warm, although there is the unmistakable bite of winter in the air. I am deliberate and hesitant,

while he throws caution to the wind and wholeheartedly engages in the sensations of the day—the sun, sand, salt, wind, and surf. Johann stands nearby, less timid than I am but not nearly as abandoned as his younger brother. He has divested himself of his loafers—inappropriate footwear for the beach but nevertheless an accurate expression of his personality.

God's purpose for each of us is marvelously integrated with our bents, quirks, and personalities, distinct as they are, allowing us to fully engage in abundant lives if we choose to partner with Him.

"What is God's purpose for any life?" is a broad question that can be answered as a generality. We know that He intends for each of us to enjoy a vibrant, growing relationship with Him through His Son, Jesus. Books have been written on that subject, and I cannot claim to know more than scholars who have devoted time to studying its every aspect. However, when the more specific question "What is God's plan for my life?" is asked, then a satisfying response is a little more elusive. It is different for each life.

I discover that the answer is never a pat, static one, but one that is organic, like an amoeba whose shape at any time in the future remains a mystery.

God's purposes are unchanging. It's the choices we make which cause the landscape of those purposes in our distinctly different lives to shift and change.

I have a frugal bent in my personality that is as persistent as the curl of my hair, and I imagine it is virtually impossible to eliminate, though it has modest potential for beauty if worked with. God determines early that it needs to be worked with! What I deem as frugality, He considers unvarnished selfishness and stinginess. Looking back, I see that a part of His purpose for my life involved taming my bent to become more like Him—large-hearted and lavishly generous.

Art materials are expensive, and at first I use mine carefully, sparingly, and yes, frugally. A part of me feels that expensive paints, heavy watercolor papers, and brushes in all sizes and shapes are a luxury. There is a sense of guilt attached to them. After all, I am never assured a valuable end product. All my splashing of paint and water could end up in the trash or in a forgotten portfolio somewhere. How can I buy another brush if I already have one that can be pressed into any sort of use if necessary? There are always other

needs to be met. Spending money on art supplies is relegated to special occasions, like birthdays or Christmas.

Gift certificates cause me untold agony. The choices are too many. Should I pick some pricey, acid-free watercolor paper that looks like it could hold tons of luminous color, or am I better off with a sturdy three-inch brush? I think about how much I hate fiddling around with the smaller round brushes I currently work with. Just then I catch sight of a juicy Prussian blue tube of watercolor and remember that I am low on blues. The debate rages on relentlessly in my head. When my gift certificate is eventually reduced to a receipt, I leave feeling relieved. All that remains is the nagging concern that the best buys were probably left behind in the store!

Imagine my response when one day, an alien thought pops into my head. *Spend the money you've saved and buy an artist friend some supplies.* Her name drops instantly into my mind. Not for an instant do I doubt that this is from God. I am under no illusions that I possess even a shred of the generosity to initiate such an idea. Quick to discount it, I would ignore the irksome thought if it did not persist with a tenacity not my own. The recipient of my generosity is not one who lacks the means, so I argue with God that she should be getting *me* the supplies, not the other way around!

The more I rebel against the thought's alien tenor, the more uncomfortable I become. I know instinctively that not doing as God commands me will not only displease Him, but will also hinder my hopeful, hazy, creative future. I have the intuitive sense that pleasing Him is somehow tied to this simple act of obedience.

I head off to the art store and buy, rather reluctantly, supplies that I feel I deserve. "She is just a student!" I mutter under my breath as I toss paints, paper, and brushes into the basket. However, with each new item, I grow more convinced that this is the right thing to do. Eventually, feeling rather magnanimous, I pay for it all. I then send my grudging gift to my friend, feeling an overwhelming wave of relief that I've obeyed God. I never hear back from her, but it doesn't bother me. I have the thrill of knowing that I've heard and followed the voice of God. I sense His pleasure—and I have never lacked in supplies since.

The prompts for giving that began then only grow more frequent and grand in value over time. I struggle with my own selfishness and overcome with His generosity. In the ensuing years, the battle within me becomes briefer and the move to action swifter.

There is a divine purpose at play in first shaping our character before fulfilling our other artistic aspirations. I am almost tempted to explain it as a sort of cloning, except that that only partially explains it.

> *For whom he did foreknow, he also did predestinate to*
> *be conformed to the image of his Son, that he might be the*
> *firstborn among many brethren.*—ROMANS 8:29

Part of our destiny is intertwined in voluntarily becoming conformed to the image of Jesus. We will resemble Him yet be unlike clones, since our uniquely distinct personalities will still be retained. How can I be sure of this? I see it everywhere in His creation. There is such artistic relish displayed in the sheer variety of creatures, even within the uniformity of a species. Scientists, at last count, suggest estimates from three million to as many as one hundred million species of land animals alone! Did you know that scientists have discovered that the diversity of species of land animals only increases as the size of the animals decreases? In other words, the smaller they are, the more varieties of them exist! There are more varieties of monkeys than there are elephants, more insects than rodents. Imagine this—there are over nine hundred thousand kinds of insects. Ugh, that is not a happy thought!

We struggle with believing that God, who created such extravagant variety and provided for their continued existence, could also care about our unique concerns. We simply cannot grasp the enormity of God, just as surely as we cannot wrap our minds around His interest in the minutiae of creation.

Johann and Reuben, my sons, could not be more alike and yet more different. God's personality would surely balk at cloning any of us. It would be inconsistent with who He is. Yet children within families, although different, do resemble their parents. As adopted children into God's family,

we are molded by Him to bear the unmistakable stamp of Jesus—a resemblance that is the evidence of adoption, regardless of whether we are from Anchorage or Zimbabwe or anywhere in between. We bear His character in growing measure in response to His life in our very nature. Of course, that transformation is entirely dependent on how yielded we are to Him.

Life offers up a blank canvas for the marking of His Spirit. I sometimes tone an entire canvas with a warm gold acrylic. It forms the underpainting for whatever comes in the subsequent layers. Every stroke of color over that layer is affected by the underpainting. Occasionally a landscape that I initially envision as sunny and luminous inadvertently takes on a shadow deeper than I had planned. My high-value painting becomes somber and increasingly unsatisfying. It is a relief, then, to be able to wipe off the oppressive hues to reveal the warm gold below. I like to imagine that this is what God does with our messes.

And we know that all things work together for good
to them that love God, to them who are the called according
to his purpose.—ROMANS 8:28

Sometimes we are acutely conscious of the process. I have mature Christian friends who, when faced with an enormous challenge, face it with "Here we grow again!" They are aware that circumstances have the potential to change them for the better if they face them with Jesus.

At other times, the process happens unnoticed by us. Growth is, without exception, either sped up or hindered by our cooperation or lack thereof. I wise up to that rather quickly and am determined to be a good student. What I discover, to my dismay, is that the very lessons I desire to master prove to be so completely contrary to my personality that it may well take me a lifetime to gain that coveted "Well done!" from Jesus. Selfishness is in the very fiber of my being. Yet I remind myself that I've now inherited new DNA. My new birth makes "all things new" (2 Corinthians 5:17). To live out that newness, I need both the empowering of the Holy Spirit and a renewal of my mind. Without either of the two, I am doomed to repeat

myself—like Sasha, our hamster on the wheel, racing purposefully yet clueless that she is heading nowhere fast!

Some would like you to believe that finding God's purpose for you is about as futile as searching for the elusive four-leaved clover in a grassy patch. The Bible disagrees with that premise. Its pages offer countless ways to help you make that discovery. Besides, unlike that of any other book ever written, its Author, if invited, will spend a lifetime with you, assisting you in comprehending all its content in the context of your unique life. "Ask," He says. "Seek and knock" (Matthew 7:7). The answer will be given to you and much, much more will be revealed than you could ever imagine!

Too many waste their lives seeming to achieve much, yet their potential is sadly squandered. They never glimpse what could have been had they included God in the fabric of their aspirations. Do you consider that an outrageous opinion? Yet the gravity of Jesus's words of warning in Matthew 16:26 is glaring. Why gain the whole world only to lose your very soul in the pursuit of that gaining?

Somewhere deep within us we have a built-in sensor warning us of the danger of missing the mark. It is easy to wander; it seems to come naturally to us. The disquiet that results is also universal. Success appears hollow. Dreams that should be thrilling end up monochromatic. Bitterness and sadness replace excitement and vitality. Happiness may be possible, but abiding joy is usually short-lived or utterly unattainable.

But we can lead a better life than that. If His purpose were not easily accessible, it would be cruel of Him to have any expectations of us. Instead, His will is always present in simple choices that either lead us toward its fulfillment or away from it. He also promises every possible provision to attain His purpose.

I become aware that God's purpose for me as an artist involves *all* of me. Conforming me to the image of Jesus is an integral part of that purpose, as important to Him as developing skills in drawing, painting, and sculpting is to me. I expect to find myself in circumstances that will hone and develop those traits that will, over more than a lifetime, eventually make me indistinguishable from Jesus, yet somehow I'll still be distinctly me.

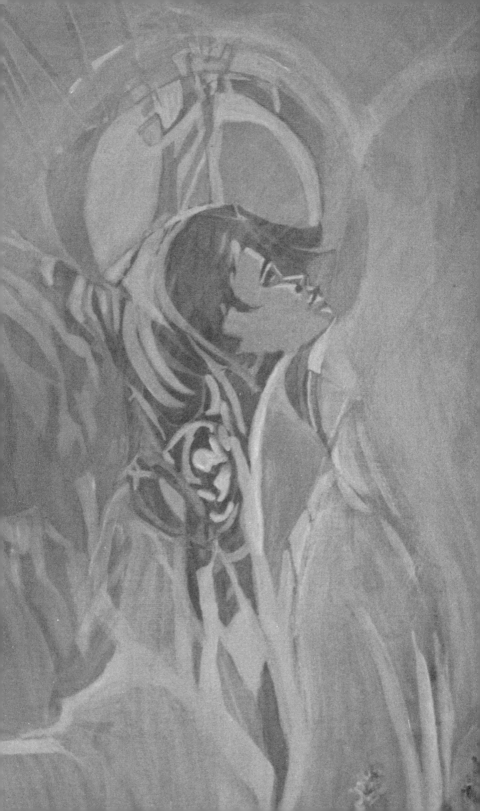

Being Me, Yet Becoming Him

AS A CREATIVE CHRISTIAN, I FIND THAT MY GREATEST CONCERN is either with the process of art or with the product. Jesus is concerned with both. He is also concerned with more. He begins a process of change in me that leaves nothing unchanged.

I decide that my skills need developing, and I labor at the task. Painting whenever I can, I read about art at other times. I am really not very good at painting, conscious of possessing just a mite of talent. Yet I plod on, stubbornly and diligently. What I lack in ability, I trust I'll make up for in zeal and sweat equity. I can paint a fairly charming watercolor in transparent, elegant paint. It is, however, the product of a tortuous process; there is little that is truly inspired or effortless about it.

Full and exciting as life is, l lack opportunity to worry about developing the essential skills of an artist. Much of my time is consumed with my family. Days are long and lazy in summer. School is out; there are few routines. Greeting the morning with coffee and my Bible outside on the patio is a cherished part of the day. I light the citronella torch to keep hungry mosquitoes away and sit facing a still-dark, mysterious, and moving landscape before me. The air is always pleasantly cool, giving no indication of the sultry heat to follow. My favorite breakfast is peanut butter spread thickly on toasted homemade bread and slathered over with blueberry preserves, which I enjoy almost as much as my time with the Lord. Most often the latter feels like richer fare.

When I read the Bible, I give it my full attention. Reading through the promises is easy enough; I sense God's presence encouraging, guiding, or sometimes calming me. Struggling through Leviticus or some of the dreary, seemingly endless "begat" passages is more challenging! But each listed name, I remind myself, represents a life, God's faithfulness, and

the timelessness of the account. I ask the Lord for something to take away from my time with Him, and He always rewards me. Each day begun this way changes me in ways I don't often immediately perceive. Sometimes He grants me a glimpse of His character; at others he gives me a warning or a reprimand. Most often He makes me promises that require every ounce of faith in me to believe. I feebly place my trust in a few and watch in wonder as they unfold in my life despite my meager faith.

Over the years, journals capture snippets of my conversations with Him, occasionally as insight, sometimes as prayers, and often as a record of promises. They also bring to light my particularly weak memory of answered prayer.

If you don't keep a journal, I encourage you to do so. My memory is surprisingly powerful and accurate on miraculous answers to prayer. What I am usually vague about are the specific answers to prayer that are less spectacular but no less important. Jotting them down remedies my forgetfulness. Not surprisingly, I find that I am not alone in this forgetfulness. The Israelites seemed to suffer from similar memory lapses:

And [they] forgat his works, and his wonders that
he had shewed them.—PSALM 78:11

Imagine experiencing the spectacular miracles of the Bible and then forgetting them! Something in our nature must be predisposed to a sorry amnesia. Yet God desires that we not only remember His goodness, but also recount His acts to our children. He expects that we will treasure the events of our lives when we have experienced Him.

Rereading my journal also spotlights imperceptible changes that have occurred in me that seemed unremarkable when they were hurriedly jotted down. The passing of time exposes the shallow and trivial nature of much of my complaining, as well as the fragile yet distinctive growth of interests outside myself. The act of cherishing this fluid account of answered prayer, changed circumstances, and modest growth forms the building blocks of a tremendous monument of faith. The edifice goes up, defying the elements,

standing tall and stately, its improbable presence something that no one can take away from me.

I realize, as I read, that I've stumbled on an infinite resource to draw on for creative expression. In Acts 1:8 Jesus says, "And ye shall *be* witnesses unto me." Simply existing and enjoying life in Him makes us witnesses. Surely, then, celebrating God's faithfulness with the fruit of our hands and the creativity of our minds, in multiple media like art, music, poetry, writing, and dance, should offer the creative Christian an inexhaustible resource of expression!

> *"Thy mercy, O LORD, is in the heavens; and thy faithfulness reacheth unto the clouds."*—PSALM 36:5

Thy Faithfulness

If to the clouds Your faithfulness extends
Where do I begin and where do I end?
Like playing with Lego, I'll make a stack
You forgave my sin and took me back

This block is for food, in famine and plenty
A block for patience, when foolish and twenty
This block for heeding faithless prayer
When hastily whispered with nary a care

Lofty the blocks I stack for Your kindness
Spurning me not for my witless blindness
Blocks a-plenty for revealing to me
Truths slowly learned when too blind to see

Snap goes a block for keeping me healthy
Many a block for making me wealthy
Blocks for friends and dear family
This tower it totters precariously

Higher and higher, beyond all I can see
Colorful blocks sparkle cheerily
Further in the heavens is Your mercy
Your faithfulness no longer a mystery

If all the world's Lego were mine to build
My memory true of promises fulfilled
This tower of faithfulness yet I abort
Of blocks and of thought, I'm woefully short

Antidote for Amnesia

LIKE EXPENSIVE GIFTS STORED AWAY AND FORGOTTEN despite every intention of being retrieved for special occasions, my conversations with God frequently end up forgotten. I find that astonishing promises, which are a stretch to believe, are simply tucked away in my fickle memory unless they find their way into my journal.

However, the Bible teaches us that promises, cherished and nurtured with eager expectation, are pleasing to God.

> *And we desire that every one of you do shew the same diligence*
> *to the full assurance of hope unto the end: that ye be*
> *not slothful, but followers of them who through faith and*
> *patience inherit the promises.*—HEBREWS 6:11-12

Recording His promises honors Him and is a tangible demonstration of faith. Unfortunately, instead of grand declarations of enviable faith, my journal entries are often simply rants of helplessness, like this one written on April 16, 2010, in free verse:

> *Help,*
> *Lord*
> *I weaken*
> *My resolve*
> *Dissolves*
> *Into hopelessness*
> *Help, Lord*
> *I yearn*
> *To speed up*
> *All that I must learn*

Help, Lord
I resent
This state of mediocrity
When I'm spent
And nothing displays
The excellence of my intent.

At other times, a desire to articulate what lies buried within me and to examine it, not so much with line, color, and design as with words, finds it way onto the page. This excerpt is an example:

August 3, 2010

Time passes by, and I long to able to pen words of power, words that can inspire, transform, and intrigue. Instead I am stuck in this impasse, aware that my time may soon be consumed by other, less pertinent tasks.

"Pertinent to what?" you may ask. Perhaps it is to the very pressing desire that I have to make a difference in another's life, to mark my life here upon this earth, to not live unnoticed.

No, it isn't a desire for notice, so much as a desire for all the immense riches available to enjoy in a lifetime—riches of experiences.

Yet I do not want simply to enjoy life, but to learn fully what I can enjoy, by stretches of faith, by trusting the Father and His Word, and then to succinctly explain those experiences to those who are stuck in the very same impasse that I am stuck in today.

Somewhere there is a key that will unlock the path that I must take. Things will clear up like a fog lifting, and I will see clearly. Now I wait, albeit impatiently, for what I know is already mine by faith.

Occasionally my journal records lessons that the Lord impressed on me like a father pressing a gift into my arms.

May 15, 2010

Today I was sitting outside the gym. Reuben was inside, being photographed for annual gymnastics team pictures. I had a whole hour, and since I couldn't pray out loud, I simply sat still in His presence and prayed in my mind—hard to do—found myself dozing off frequently. Still it was sweet to sit there. It was overcast, with occasional rumbles of thunder in the distance.

As I sat, a little bird came hopping about briskly, going this way and that, as if led. Her ways seemed random, except she would stop suddenly, her head would bob down, and most of her would disappear in the tall grass. Shortly after, she'd pop up with something in her mouth. Sometimes a bug, once a juicy worm.

She kept this up for a while and then briskly turned around and made her way back, this time systematically collecting dried grasses in a neat pile in her beak. She flew quickly to the billboard, where she was either lining or building her nest.

I was struck by how her abundant breakfast, followed by her acquisitions for home improvement, did not in any way diminish the landscape or the bug population! How marvelously God led her to be well fed and sent her on her way with trimmings for her home!

And I heard His voice, within me, saying, "How much more will I care for you, Sara, O you of little faith!"

Sometimes my journal was the hiding place for a fervent prayer, entered rapidly, amusing me later with its intensity. Yet when I wrote it, I meant every word. Revisiting my own promises to God, which I tend to dispassionately view later with a cool sense of disconnect, is certainly another useful reason to keep a journal.

May 3, 2010

On this my birthday, Lord, I sign on to be a fool for You.

Help me not to shirk, back off, compromise, or change tracks on doing what You've called me to do.

Help me to be bold and to speak Your truths as You show me—faithfully, with little regard for what others may think.

Thank You, Lord, for all that You have done for me. Forgive me for my ingratitude.

Unfortunately I promptly break these ardent promises despite my best intentions. Frequently concerning myself with the opinions of others, I am cautious about appearing too passionate for the things of God, am timid about speaking God's truth, catch myself whining about less than ideal circumstances, demonstrate churlish ingratitude . . .

Yet a quick read of my journal sets me squarely back on the path I've purposed to take. It reminds me of all that God has already done for me. It steadies me in my purpose to resume my journey, despite my failures, in becoming more like Him while still being me.

Yielding to the Light

I STAND IN A DUSTY ROOM WITH AN UNUSUAL GROUP of student sculptors. Some are retired from various professions; others are young, energetic college students. A few are unemployed, and some are merely there to satisfy their curiosity about working in clay. All they have in common, other than their presence on a weekday in this studio with its gritty floors and harsh gray light, is an interest in creating three-dimensional art.

To my right, adjusting his turntable, stands a plastic surgeon who has cleared his schedule for the morning to be here. A large black dog, absurdly named Zero, ambles in; his shaggy black coat is dusted with the same dull clay. The younger students from local colleges are adding a couple of studio hours to complement their more formal art curriculum.

I don't quite fit in any category. After hurriedly dropping Reuben off at his Preschool Creative Learning Center, I am at the Creative Art Center in Dallas, brimming with nervous excitement and every bit as eager as my toddler. The block of clay feels heavy, wrapped in plastic, looking gray yet promising. A makeshift, clumsy circular plywood stand is prominently placed in the center of the room around which other sculpture stands are arranged.

I stand awkwardly, unsure of what to do. Around me, in the bustle of the conversation, I hope for clues about what is expected of me. The talk, unfortunately, is about completely unrelated subjects: the weather; a movie that someone claims is worth watching, if you enjoy blood and gore; someone mentions the traffic on the way over; an inexpensive, popular Ethiopian restaurant . . . the conversation swirls around me, forceful yet useless.

There appears to be no officious-looking art instructor. Eventually a model saunters in, walks to the back of the studio, undresses, and reappears wrapped in a colorful robe. There is more chatter. I listen and watch, mimicking the others by setting out my new tools. The model removes her wrap

and steps onto the wooden platform, which wobbles precariously under her. All conversation ceases for a few seconds.

An older woman, exuding an undeniably wiry strength despite her slight frame, steps forward. She is the instructor, I conclude with relief. Nothing distinguishes her from the others—she wears drab jeans and a T-shirt with smears of clay on it, looking as if she has never ceased playing with mud since childhood. Asking the model to pose on the stand, she smiles indulgently as the room erupts in objections on the merits, or demerits, of the pose. I watch bemused at the passion with which the student sculptors argue and bicker good-naturedly until the model strikes a pose that is acceptable to the majority. Once a grumbling consensus is reached, everyone settles down to capturing his or her view of the model in clay.

Never having tackled three-dimensional work before, I begin sloppily squishing a lump of clay, attempting to capture what I can see of her. *It can't be too different from drawing,* I tell myself.

But it is! The stand is turned in fifteen minutes, and to my dismay, I feel as if I may as well be facing a totally different subject. Someone, catching my expression of confusion, yells at me to turn my stand to the degree that the model is turned.

Of course, now it makes perfect sense! I quickly get the hang of it. When the model is turned, I turn my work and resume describing this new view until the next fifteen minutes fly by. Eventually she is turned completely around once. I've worked on my lump of clay from all angles, and the session is abruptly over.

Sculpting, I discover, is like making many different drawings from every conceivable angle around the subject. The greater precision with which each view is described in clay, the more accurately the model is captured. This far I have been comfortable describing the three-dimensional world onto the two-dimensional surface of paper. I am now pleasantly jolted into the challenges of learning to grapple with the physicality of a subject. To master this, I return to the studio every week for the next six years of my life.

Learning comes unexpectedly. I assumed that I would be told what to do and how to do it. I quickly discover that I've come to the wrong place for such

specific instruction. My instructor is convinced that showing someone how to sculpt by demonstrating will adversely influence the student. One must, she reasons, find one's own artistic voice. Others in the studio are already used to her methods, which amount to nothing more than overseeing the session. She is a fount of technical knowledge and is more than willing to share, but only if asked. I have little choice but to jump right in and learn, a little from her and far more from those around me. I watch the others, wandering around during the breaks and pestering everyone I think might know more than I do (which is most of the class) with a battery of questions.

One day, in frustration, I hand her my tool and exclaim, "Please show me how to do it. I don't care if this is supposed to be my piece, just show me—please, please, please!" This is well before the Internet, with its abundance of YouTube videos demystifying the processes of artists in a variety of artistic media. Without such an option, my instructor is the source of secrets to skills that I long to have. When asked with such fervency, she has little choice but to comply. With a smile, she reluctantly picks up my tool. Deftly plunging it into the soft, moist clay, she shapes the curve of a leg, the voluptuous rise of the calf and the graceful slope of the ankle.

I feel as if my world has stopped and a light is turned on. I can't fully express all that I learn as she expertly wields that simple tool. It is a light of intuitive, instant understanding. If I could distill the most memorable learning moments of my life, they would come together in that one fluid act. The demonstration of the use of that crude wooden tool stands out in my mind with crystal clarity. Today, I hardly use any other tool, favoring a smaller version of the one shown in a dusty, gray studio by a reluctant teacher to a persistent student.

Whatever your level of skill or ability as an artist, you will require more. Each fragment of understanding, like a correctly fitted piece of a puzzle, dispels the darkness of ignorance, making you increasingly confident as an artist. I yearn constantly to be more, to be better skilled, to improve in ideas, approaches, techniques . . .

There are teachers everywhere—from those who teach the nuts and bolts of using materials effectively to those who do more by allowing you

into their minds. Teachers of the former sort inspire by proficiency and skill. Others do so by example. Some clearly elucidate their thought processes while creating the work of art. Rarer still are those who share all that they know, giving you access not only to their techniques and material resources, but also to their sources of inspiration. Like walking into their homes, we are warmly welcomed to explore every nook and cranny and to ask any question that pops into our eager, learning minds. No room or closet is barred to us; we are generously given free rein.

I read, with a twinge of regret for ages past, of the master and apprentice roles that were the practice of the Renaissance era. The apprentice learned simply by being around the master. His mundane tasks, of sweeping floors and tidying the workspace of the master, made him privy to a wealth of knowledge. There were few, if any, formal lessons. He stayed alert, observed every move of the master, and duplicated it later. From grinding and mixing colors in complex formulas to understanding precisely the best time to wrap a moist work of clay in damp rags, the apprentice was the unnoticed observer and student. While rarely being given the privilege of lessons uniquely tailored to his needs for growth, the apprentice learned by being wholly present, absorbing like a sponge lessons that he would someday put to practice in his own work. I learn later that we have a far superior privilege as apprentice to an unparalleled Master. In His presence we absorb far more than is immediately apparent, lessons infused with His wisdom and creativity.

Initially, I accept the premise that to be an artist, I will require a formal art education. Skilled academics from art schools and colleges, I reason, dispense knowledge about the mechanics of art. Today, however, I run into more proficient self-taught artists than those with degrees in art from accredited institutions. They dive in and teach themselves using every available resource. Knowledge once restricted to educational establishments is now freely acquired from the Internet, libraries, and bookstores.

Yet how do you sift through the sheer volume of information available for every aspiring artist? How will you filter the tantalizing but useless information from the essential?

I've often been asked if there is any curriculum tailor-made for a Christian artist. The answer may surprise you.

I have found a course of study available for you as a creative Christian, whatever your medium of expression. It is free, even though it comes paradoxically at a price. Taking you systematically through all you need to learn, it will train you for mastery in your medium. It is perfectly customized for you. Upon completion, your weaknesses will be unnoticeable and your strengths will be honed to excellence. This course of study is so unique that it is nontransferable in the truest sense.

There is only one prerequisite—faith in the Instructor, expressed by a willingness to work hard and the grit to rigorously follow instructions. Only in hindsight do the lessons become clear; the instructions often seem too few. It may feel a bit like trying to find your way in the dark with a dim candle. Visibility in the flickering light is limited to just a few feet ahead of you, just enough to take a small step forward. That step is secure, safe, and assured.

I move forward by faith. Anything beyond that is an adventure that is still waiting to unfold, not one fraught with anxiety, but one that is wonderful, heading to a destiny beyond my wildest imagining. I take that step, and others follow, occasionally in unexpected directions. Remarkably, all of it happens in the daily clutter and chaos of life.

I choose that curriculum and begin an unconventional education. I already have an undergraduate degree in Fine Art, so I am not a complete novice. But the lessons that I learn later, in Christ, are infinitely superior. My former education is no match for them. All that unfolds later merely enriches and builds on my basic art background.

The three-hour session each week spent sculpting at the Creative Art Center is a gift from God, guiding me to a medium I never anticipated working in when I first studied art. Invariably when I arrive to set up, someone has already turned the radio on. There is never any silence. Music blares, rudely intruding into conversation, thoughts, and sculpting. Groaning loudly, someone invariably marches up to the radio and changes the station. "This is driving me nuts!" they announce to anyone who dares challenge them. No one does—for a while. It is the unspoken rule that whoever

arrives first gets to pick the station—for a while. It never bothers me. I learn early to tune it out when working.

Words flow freely as well. There is rarely a lull in the conversation. Gushing like a faucet left inadvertently open, the talk drenches everyone in its path. This I find harder to avoid, because occasionally a question may be directed my way. Every manner of liberal viewpoint is aired. Like dodging bullets, I attempt staying silent to avoid being dragged into the fray. My opinions and perspective could not be any further from theirs. Yet I develop friendships, share the joy of art, and cautiously avoid controversial topics.

I learn of workshops that others are taking, exhibitions and gallery openings. Opportunities seem plentiful for artists, but to find the best path, or even a reasonably successful path, seems to be hit or miss. I listen to complaints about teachers who are lousy and events that are a waste of time. We cheer those who are accepted into famous galleries and are appalled to hear the occasional stories of commissions being withheld or work returned damaged.

Plunged into this creative environment, I am eager for opportunities to study more. There is so much to explore and learn. It feels as if the artists who surround me know more than I could ever digest in a lifetime.

In this season of frustration and eagerness, I stumble on verses in the Bible that assure me that if I trust God, He will lead me and even educate me.

What man is he that feareth the LORD? Him shall he teach in the way that he shall choose.—PSALM 25:12

I will instruct thee and teach thee in the way which thou shalt go: I will guide thee with mine eye.—PSALM 32:8

Quite playfully, aware that the possibility of further education in an art school is slim with the responsibilities of raising my young family, I assign Jesus as dean of my art education. I make a note of the date in my journal. Feeling an irrepressible sense of adventure well up in me, I ponder this promise to me. How will He do it, I wonder?

Would it surprise you if I told you that shortly thereafter, we spend spring break, when the boys are out of school, in Europe? I do not plan the trip with the objective of improving my art education. Art is furthest from my mind at the time. In the midst of a hectic school year, I search online for a vacation that will fit neatly into the limited time we have—a time to make memories with the boys and to see a world so different from our own. The charm of Rome, Venice, Burano, and Florence seems intriguing. Little do I expect to be overwhelmed by art and creativity everywhere I turn. This is a customized field trip, a tactile experience, an explosion in color, shape, design, and texture like I've never experienced before! Art that I've only read about in dry, colorless textbooks comes alive before my eyes.

Acutely aware that my flippant prayer is being answered in such an unexpected manner thrills me more that I can describe. I planned the trip with the boys in mind, but God instead blesses me with an intense art education by immersing me in a culture that combines the best of historic and contemporary art exploration. Millions of tourists visit the Academia in Florence, but undoubtedly none experience what I do—a sense of wonder about a God who cares so much for me that He orchestrated just what I needed, when I needed it most, despite the playfulness of my request!

I stand in awe before Michelangelo's *David* and am moved to tears before his *Pieta*. My eyes hungrily devour works of sculpture, paintings, tapestries, and other exquisite masterpieces by the world's best artists. I wander reverently on the hallowed grounds of the Coliseum in Rome and shudder at the high cost of faith. The ground where we stand once thirstily absorbed the blood of many. Death was faced not only bravely but jubilantly as Christians sang praise to a God they knew intimately and found sufficient. I look up at the towering statue of Augustus Caesar, stilled by the expression of absolute power exuding from his impassive stone face. Yet his power was temporary and no match for my Lord and His purposes!

We drive through the countryside dotted with rustic farmhouses; vineyards and orchards burdened with fruit fly past in tidy, swift rows. I grasp precisely the fresh hue of Tuscan green that I have only read about. In monumental splendor, off in the hazy distance, stand the cool, blue hills that

yield milky, pristine marble, the medium of choice of Renaissance sculptors. "Burnt Sienna" takes on new meaning as we stop for lunch in Sienna. I will never again squeeze out that creamy, chocolate color onto my palette without recalling the copper-colored town square with its fluttering dove population against a backdrop of cloudless, sunny skies. Beyond that stretch the immense flats of terra cotta, gray and moist, waiting for inspired hands to shape, fire, and harden for posterity in warm, voluptuous, earthy sculptures.

I also stroll in a happy daze through galleries featuring the works of the newest generation of Italian artists: painters, sculptors, glassblowers, and lace makers all breathing the air of the past while creating art of the present—bold, sleek, and elegant. It is a visual feast that leaves me sated and overwhelmed. Who can ask for more?

As for BJ and the boys, they enjoy the food and the cars!

That summer, an unlikely group of sculptors from the East Dallas studio, where I am still studying figurative sculpture, decide to make a trip to Loveland, Colorado. An opportunity to take a workshop with a famous contemporary figurative sculptor is discussed during one of our arbitrary conversations at the studio. I know nothing about the sculptor. I am unaware that Loveland is one of the country's prominent regions for teaching and promoting contemporary figurative sculpture. The opportunity simply presents itself. As a relatively new student, I am uninvolved in the planning, cheerily tagging along with the rest. Never having taken such a trip before, I am excited yet skeptical about its potential benefits. Somehow all the various logistical challenges seem to work themselves out. Along with four other sculptors from the Creative Arts Center, I set out on another weeklong adventure. Everything that can go wrong before any eagerly awaited trip does. Reuben runs a fever the day before I leave. Other trying issues rear their insistent, compelling heads, demanding my attention. I pray fervently and then ignore them all, handing them over to more able hands—those of my Lord Jesus and, of course, BJ!

We stay at a charming bed-and-breakfast brimming over with original art. It is only a few miles from where we will immerse ourselves in learning about figurative sculpture. For a week, like a thirsty brush I absorb practical

help in various aspects of technique, design skills, and freedom of thought. We breathe and live art during every waking moment. Lunches are spent in animated conversation about what we learn. In our spare moments, we wander enthralled through exquisite sculpture gardens and galleries, featuring even more figurative sculpture.

Once more, the trip is precisely what I need, specific in every detail. It addresses gaps in my knowledge that no one but God could know about. I am not conscious at the time of what is happening. The process of sculpture is gradually becoming demystified in my cluttered mind. Mysteries of building armatures are laid bare, as well as other options to working in messy terra cotta. My week in Colorado so thoroughly equips me that for the next decade I don't take another workshop! I feel no compulsion to do so. My newly acquired knowledge must first be put to work. There will be time to learn more later—just not yet.

As I write this today, I am a co-owner of a thriving art gallery and school, where talented teachers of international repute teach all kinds of workshops. Our gallery continues to grow in reputation as a venue for excellent instruction in art. Although there are no classes offered in sculpture, a variety of exciting workshops are offered in two-dimensional media. I work in multiple media, yet none of the workshops tempt me, which is strange considering how hungry I once was for instruction. It is not that I am so skilled, or that I learned all I ever needed to learn with that one workshop. I've simply never felt led by the Holy Spirit to tackle any more classes. Often I hear of unfamiliar techniques and new materials that are being demonstrated and discussed. It would be reasonable to assume that such knowledge would benefit me. Yet I know intuitively that I have been given all I need for whatever God desires of me for this season. He instilled in me, with precision, tools that would fuel me for the next decade. His training was accomplished efficiently in a trip overseas and one week's instruction with a renowned sculptor!

Lest you be tempted to attribute all my progress to that sculptor's teaching ability, I'd like to disagree. True, he is a master at his art, and his teaching was generous and useful, but something else happened. I absorbed

knowledge like never before. Revealing the identity of that instructor is rather pointless. He was merely the tool God used to overcome my deficiencies with knowledge and understanding unique to my need. God most certainly has others who can do the same for you. God fulfilled His promise to me with precisely the best instruction possible. Without Him, finding what I needed would have been like searching for a single manual of instruction in the Library of Congress without a catalog and only my ignorance to go by. Incredibly, I learned that God's resources are available simply for the asking and the taking, if, of course, you will believe.

Becoming intensely aware of His working in this manner regarding my calling has enriched my life. Watch for patterns that emerge, and you will recognize His hand in the most mundane of life's moments, especially if you make Him, like I did, the dean of your art education!

Obedience

"Be ye not as the horse, or as the mule, which have no understanding: whose mouth must be held in with bit and bridle."

—PSALM 32:9

A VITAL SPIRITUAL DISCIPLINE FOR EVERY CHRISTIAN ARTIST—one which trumps prayer, fasting, studying God's Word, or even memorizing Scripture, all of which are necessary for growth—is active, cheerful, and immediate obedience.

What will you do with what you already know?

Should you choose unconditional obedience to God's Word and the voice of the Holy Spirit, you will experience God's best and your richest destiny. Your choices alone undermine or energize His plan. He may urge or inspire you, prompt or encourage you, and send others to steer you in the right path, but He will not violate the agency of your free will.

Do you know how many bits and bridles there are in this world? A Google search coughed up 2,890,000 results for my query—more than I ever anticipated. There are all kinds of them: some ornamented, some minimal, some complex, some gentle, and some cruel. Created for the sole purpose of urging the independent spirit of the horse to respond instantly to the commands of the rider, they are all effective. They work by applying pressure on a sensitive part of the horse's mouth. The mastery of the rider and obedience of the horse are both on display in the choice of a particular type of bit or bridle!

As I walk with God, I purpose to develop a consciousness of being led so that God need not be compelled to apply pressure to elicit an obedient

response from me. Despite my resolve, I quickly realize that while obeying can be rewarding, it more frequently requires of me a dogged persistence to follow through on my promises when I least feel like it, or when I perceive no favorable outcome for my good behavior.

Obedience takes the form of heeding His promptings within me, the gentle little nudges to action or inaction which can easily be disregarded. Yet they are fortunately insistent, possessing a power like the unexpected strength of a silken strand of a spider web. I know that ignoring them is not wise.

I learn not to take God's voice for granted. He is ingenious, has creative insight, knows the end from the beginning, and is, in every matter, far smarter than I will ever be. He is never dull, and His strategy is never the same from one day to the next. So it is to my advantage to pay close attention to His leading.

If you have never received the Holy Spirit to fill and empower you as the Bible promises, I urge you to ask, believe, and receive. Like salvation, the filling of the Spirit is yours for the taking. Ignore churchy traditions and prejudices, which complicate what is a sweetly simple act of receiving by faith. If you ask and believe, you will receive (read John 14:26 and 20:22). Toss out preconceived notions or inhibitions that hinder your receiving. You will then be sensitized to His voice. Be quick to obey.

Initially, it is in hindsight that I recognize the leading of the Holy Spirit. Now that He is a familiar friend, I sense His prompting much sooner. Although it is possible not to hear clearly because of distractions or your own agenda, trust that if you are eager to hear and obey, He will faithfully lead and guide you.

As I am learning to recognize His voice, someone requests a donation of my art for a church event as a door prize. Rather uncharacteristically, I find myself offering a watercolor portrait. *What was I thinking?* I later wonder in dismay, unaware that I was responding to the little nudge inside me. That internal prod gently affirms that I've done the right thing. Yet, with a sense of panic, I hope desperately that no one will claim the prize! As that is unlikely to happen, I hope that it will be someone with a beautiful

face simply begging to be painted. I wonder anxiously about the name to be drawn. It will be someone remarkable, I feel certain, praying that God will be involved in the selection and that I'll be able to do the subject justice. Who has merited God's attention for this project? It does not occur to me that on this occasion, both of us are in His sights, the artist and the model—for entirely different reasons.

A name is drawn, and it is unlike any of my preconceived expectations. The winner is a shy, reserved, single woman with a timid, unremarkable face. The critic in me swiftly evaluates her—her eyes are too deeply set, her nose too long, her hair too short. It is going to be a challenge to make this subject into an attractive painting. That is my brash assessment.

When I meet her to take some reference photographs, I attempt to draw her out in stilted, awkward conversation. She is utterly overwhelmed by the idea of having a portrait painted. Feeling an uncharacteristic pang of compassion, I photograph her, still hopelessly uninspired by my subject.

Suddenly, unbidden, a thought pops into my mind. Does God want me to demonstrate in paint how precious she is to Him? I toy with this peculiar and uncomfortable possibility. It is so foreign to me that I have little doubt as to its origin. I work stodgily on.

It surprises me when a strange beauty, hidden beneath her awkwardness, flicks at the fringes of my consciousness.

How had I failed to notice that there is a quiet strength about her eyes? How had I missed the gentleness in her hesitant smile, hinting at wisdom that must be mined as rare treasure?

Little by little, her beauty, which is not lovely in any conventional sense, is laid bare before me. From then on, I almost have little to do with the portrait making its way onto the paper—the watercolor paints itself. Colors fluidly marry on the thick, soft paper, glowing with a luminosity that is far more than a product of my ability. God has His say through my brush!

Words are inadequate to describe the emotion with which she receives the painting. For the first time, she sees herself as beautiful. She experiences Jesus as she looks at herself in that portrait. I am fortunate to be able to share in the intimacy of that love, expressed by Him through my fluid,

watery brushstrokes. I feel like one who has inadvertently stumbled on a private moment between lovers.

Perhaps, I muse, that is some of what art is meant to be? Why not? It already is a language of love between God and me. Now it appears to be even more than that, spilling outward and touching another life and heart.

My art is not for all, but for specific others. They almost seem to be predestined to be drawn to specific work. I grow secure in the knowledge that each work, whether a painting, sculpture, or drawing, has a home somewhere, even if it is sometimes the trash can! The more I create at His impulse, the stronger I grow in that conviction.

Slowly, I stop being bothered by work that languishes in the back of my closets. Often it is years after a work is completed before it goes home with someone who is ecstatic at having acquired it. Time seasons the work and me. I may see it with fresh eyes and relegate it to the said trash can. However, I no longer fret about it like I once used to. I create in response to God; I am already richer for the experience. Our time of peaceful communion in the studio, as I paint or sculpt, is priceless. No longer do I struggle at creating art. Instead, I reverentially savor each moment shared with Him in the creative process. The urge to have another enjoy it as much as I do is not as pressing as it once used to be.

It is His business what is done with the work upon its completion. How liberating it is to not worry about it anymore!

Another casualty in this slow stripping away of all that once consumed and stifled me is the desire for the praise or the approval of others. The sense of God's approval grows more tangible over time. I do not claim to be completely impervious to other opinions of my work; it is merely that they now matter far less. Instead, I participate in many more moments of His love, sacred and holy. I am asked to paint posthumous portraits of beloved parents who have long ago entered eternity; disadvantaged children from the inner city who crave the assurance that they are loved, that God cares for their futures; infants who live but a few precious hours . . .

Art takes on a seriousness and beauty I never quite envisioned.

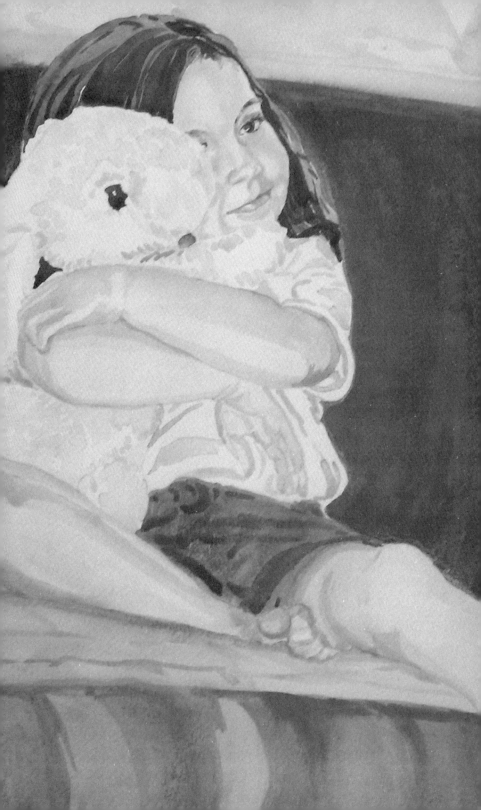

Absence of Fear

Princess Sara wakes up eager for the day. Yawning, she thinks dreamily about what lies ahead. Her sleep has been deep and sweet; the day now stretches before her filled with possibility. Her father, the King, is a wise and generous monarch. Nothing reasonable is ever denied her, and should she make an unwise request, He is quick to explain its denial.

When she was younger, in her ignorance, she would stamp her feet and scream in protest when denied. Now, when He declines to explain why, she knows Him well enough to trust Him. She is loved and the apple of His eye (Deuteronomy 32:10). Why be consumed with getting her way always? Much is hers for the taking if she ever expresses a need for it. Her needs are always met, usually well before she is even aware of them. She is royalty, yet only now growing somewhat accustomed to her privileges.

From the very first moments of life, she heard her Father's voice. Once she knew it not, but when He rescued her from her old, hopeless life, His voice became a lifeline, gradually transforming her. It calms her when she is restless, saddens her when it is tinged with disappointment, and lifts her spirits when she is dejected.

Now she listens with interest as He teaches her, using stories she can easily understand. She grows to enjoy the timbre and pitch of His voice; she can recognize it anywhere, even if He calls her in the faintest whisper. He teaches her how to behave as royalty. She is coached patiently and taught that a princess never needs to beg, scream, manipulate, scrounge, or steal to enjoy her privileges. She has but to ask, and she will receive.

She too, like her Father, is expected to be wise, generous, brave, honorable, and kind. She learns about what it means to belong to Him, to bear His name and to carry it well.

Her Father's kingdom spreads far and wide, filled with other young heirs. They are her brothers and sisters. Some are far wiser; others, like her, are still learning.

Her life is not her own. She is happily part of a satisfying mission of great import to her Father. With other young royals, her role in the kingdom is to search for and rescue as many brothers and sisters as possible from the clutches of an enemy. This enemy rules by wielding the effective weapon of fear. Forgetting their regal lineage and heritage, the young royals have succumbed to being his pathetic victims. Fear dominates and governs their lives. Instead of living as joyful children of the King, they've become beggars, cowering helplessly in awful, crippling circumstances.

Their enemy is artful, no doubt, yet no match for the young heirs if they but knew it. The King has gone to great lengths to ensure that this enemy is a defeated foe. He sent His firstborn son, Jesus, to win that decisive victory to free all His children. In His name they have only to enforce that victory—not battle or even labor to win it.

The foe has a vast and despicable army, wandering freely for a season. Panicked that time is quickly running out, they've unleashed a brief season of wickedness on the earth. Their captain has been granted only a limited, and temporary, lease of power on the world. Yet he deludes the young heirs into believing that his power is absolute and permanent.

The Father promises his children that this is an easily restrained enemy if the young royals will only resist him. The enemy's success hinges on convincing the children of the King that they are common, with none of the power and privileges of royalty. He encourages them to forget that they are spiritual beings, tempting them to live only by their physical senses.

Their Father teaches them otherwise. The enemy uses every opportunity to steal from them, striking them with poverty, lack, diseases, strife, depression . . . keeping them shackled in a world they only view through the prism of their physical and material limitations. The Father gives them royal weapons of spiritual power for effective combat if they would but heed and exercise their authority. He teaches them how to speak His words in faith to manifest in the physical world what is already theirs in the spiritual.

Every resource needed for dynamic, princely living has been provided in abundance for them, if they would but believe Him. They are destined to be victors, yet they live blind to that fact.

Their Father urges them to enforce that victory. Yet those who are duped give up territory, struggling desperately unless others from the royal family rescue them. Many live their lives bound despite the victory that is theirs for the taking.

Sara knows how desperate life used to be and how privileged she now is. Such marvelous resources are granted every time she exercises her authority that she now lives in awe of the honor of belonging and the power of her Father's name. Ever conscious of how easy it is to be fearful or to be deceived into releasing territory intended for her, she draws close to her Father to follow His lead. Attentive to His wishes, she strives to eagerly follow His instructions for victory. Regardless of the challenges she faces each day as a choice target for attacks by the enemy, she knows that she never need succumb to fear. If she resists, no matter how terrifying life becomes, she is promised that the enemy will flee. He is no match for her, since she is of royal blood and can command with the Father's authority as He teaches her to. She is to be cautious because dangers abound, yet to her belongs the right to live fearlessly in her Father's kingdom, confident of the victory already won.

Does this sound absurd? Have you ever considered yourself as royalty? Perhaps it sounds ridiculous and naïve. Yet nothing I've written thus far is untrue, far-fetched, or a figment of my imagination. The Bible describes each of us, in Christ, as royalty—the sons and daughters of the Most High God. Yet, have we really grasped the implications of such an outrageous declaration? If we have, how can we ever allow fear to be a part of our lives?

And if ye be Christ's, then are ye Abraham's seed, and heirs according to the promise.—GALATIANS 3:29

We are children, true, but we are also heirs of the highest authority known to man. There exists no greater power than that of our Father.

*"But ye are a chosen generation, a royal priesthood,
a holy nation, a peculiar people; that ye should shew forth
the praises of him who hath called you
out of darkness into his marvelous light"*

—1 PETER 2:9

Sara

*Ah! The regal breath divine
New in me, heady like wine
A silly girl, a trifling being
Filled with breath and told to sing
In wet paint and pliant clay
With words of hope taught to pray*

*Petty and inconsequential
Conniving and trivial
I breathe the Ah! of this assign
In awe that such a name be mine
S ah! R ah! Now I hear His beat
Ah! The breath of God complete
Sweet in me, robust yet meek
S ah! R ah! Now Jehovah speaks.*

It took me a while to grasp my royal position and power, initially relegating the words that I read in Scripture to some distant hereafter. The truth, however, is far from that: "Fear not!" is, not surprisingly, one of the most often repeated commands in the Bible:

> *For God hath not given us the spirit of fear; but of power,*
> *and of love, and of a sound mind.*—2 TIMOTHY 1:7

Perhaps we think of the verse above as words so shrouded in mystery that we will never unlock the power that the simple act of believing them can unleash.

What does life lived fearlessly look like? How does it feel to be free from fear forever?

I taste it and never want to be bound again.

> *"Our soul is escaped as a bird out of the snare of the fowlers:*
> *the snare is broken, and we are escaped. Our help is in the*
> *name of the LORD, who made heaven and earth."*—PSALM 124:7-8

Unshackled

I beat on bars of rigid steel
Bruised and wearied, too drained to feel
Feathers fly, I'm dulled by pain
Pounding a rhythmic, hopeless refrain

I know not how this fowler's snare
Snatched and bound me unaware
To free myself beyond my ken
My earnest hope to soar again

Feel my joy as nail-scarred hands
Break the vise and loose the bands
Rend the bars that held me fast
To bid me flee, to soar at last

The swift escape, a joy to share
This freedom from the fowler's snare
When bound, with liberty still unknown
I craved this joy that I now own.

No gift of praise will ever repay
This debt of soaring unrestrained
Trusting my Savior to watch my way
Should I unwary, be fettered or chained

He is the Maker of heaven and earth
Our help from the time of our new birth
His Name is powerful, ours to bear
With regal strength as His own heirs

Since beginning the Christian Artist Resource website, I've become aware of the crippling effects of fear on artists. E-mails from artists around the world tell me about their struggles. They love God and are conscious of their gifts of artistic and creative ability, yet they face their calling with trepidation and uncertainty. At the core of their struggles, cold and ugly fear emits its pungent odor, sabotaging their effective witness and robbing them of the joy of the mission.

Fear comes in many forms. We all fall prey to it at some time or another. I experience a miraculous unfolding freedom from fear as I grow in understanding. Even so, it requires constant vigilance to keep myself free from its miserable bondage.

If my words can walk you too out of fear, then I am fulfilling my role as Princess Sara, silly as it may sound. There will be no greater joy for me than if, when you are freed, you lead another out, and they in turn rescue someone else.

Fear is familiar. From my childhood it stalks me, pressing its oppressive tendrils into most actions and choices of life. Crossing a busy street causes me to be gripped with fear; as a child, I worry about losing my parents, my brother, my dog, my life . . . Nothing adventurous is ever attempted, because "I might get hurt!" The stray cold, cough, or runaway bus might well be the end of me. Risks of any sort, even building new friendships, are fraught with aspects of fear. I fear being vulnerable. "What will people say?" is a constant refrain in my head, clouding decisions about various life's choices.

When I marry and begin a family of my own, even greater fears make their presence known. I could be mugged, raped, murdered; my husband could leave me; I could be widowed or lose our children; our home could be burglarized. The list grows and mushrooms endlessly. Every experience someone else has, whether I hear about it from a friend, on TV, or in print, is kindling for new fears. Real and oppressive, they hold me captive. I do not know how to be unafraid.

Then I am born again, of new, incorruptible seed, with new DNA and a new lineage. I am now of royal blood. I am the daughter of the Author of Life Himself and gloriously freed from the shackles of fear. Nights when BJ is out

of town were once spent wearily drifting in and out of sleep, sitting propped upright in bed with the lights on and a small sofa pushed against the door of our apartment to keep out the lurking burglar. No more! Now I sleep like a baby. The change is so noticeable that those who knew me before marvel at the difference. Fear of impending doom and calamity has simply packed its unwanted bags and vanished. My Father cares for me; my life and times are in His capable hands. Nothing that comes my way catches Him unawares. No malevolent force of evil is a match for the power of His love for me.

Although living in this fallen world, in the constant presence of an enemy, makes each of us a desirable target for attack, every attack can be victoriously overcome by listening to Father's voice, following His guidance, availing of His help, and enjoying the companionship of His promised abiding presence. If I should be bruised or wounded, He offers comfort, healing, and the ability to rise up again and return to the battle. I am loved. Of that I am assured.

There is no fear in love; but perfect love casteth out fear:
because fear hath torment.—1 JOHN 4:18

If I could be set free from stomach-turning fear, so can you. Fear need no longer torment you. Perhaps you are not gripped by the kind of fear that held me captive. Your fears may be far subtler, even seemingly harmless. But do not delude yourself: there is no harmless fear. Fear and faith cannot coexist. Fear contaminates faith and renders it ineffective. The vast majority of fears that kept me chained miraculously vanished the night I was born again, yet some fear still occasionally presents itself to me. Always disguised in a form that seems perfectly reasonable, these fears take the wisdom of the Holy Spirit to reveal and uproot. Fears creep in unnoticed—insidious fears with little power at first, yet more than capable of maliciously derailing God's plans for me if I submit to them. As each ugly fear is exposed, with His help, I walk boldly free. I discover that it is possible to stand in the midst of overwhelmingly terrifying circumstances and to resist fear and deliberately choose faith.

To create as we were meant to do is impossible until we identify and eradicate fear. No one is more capable of illuminating each of our many fears than the Holy Spirit—if you invite Him to do so. There is no loss or setback that He cannot most gloriously redeem if you will allow Him by following His counsel. Courage will bubble up within you as you absorb the truth of your adoption into God's family.

"Be not afraid of sudden fear, neither of the desolation of the wicked, when it cometh. For the LORD shall be thy confidence, and shall keep thy foot from being taken."—PROVERBS 3:25–26

Fear Not

"Have no fear," you say to me
"Disaster is not your lot to be"
Softly lit the predawn hour
I struggle, hope, fail, then cower
Pages rustle, I seek to know
Fear's cold robe smothers me so
"Be not afraid," I doubtfully read
"Trust in me and from fear be freed"

Quickly see how grave my trouble
Swore you not my blessing to double?
Firm the voice that bids me "Yea,
Blessed are you if you hear and obey"
Back I turn to wrinkled page
To Word of hope deep and sage
If others obeyed, dare I do less
And grieve Him who will surely bless?

Still I lie in morning's hush
Rejecting fear's dry, heavy crush
Coarse the garment I cast aside
I'll have no fear, nor run and hide
Clothed by Him, though weak inside
Calmed to learn in whom I abide
Dressed for the day in armor bold
My day to have and His to hold

One Overwhelming Fear

ONE PREDOMINANT STRAND OF FEAR RUNS as a stubborn fiber in my conversations with artists. Ugly and persistent, it consistently ruins the tapestry of fruitful lives reflecting God's marvelous grace. It stems from an overwhelming preoccupation with the currency by which success is measured in our world—that of money. An artist's response to his or her divine call is so fearfully and messily intertwined with this that unraveling all its various nuances is complex.

I grapple constantly with this fear, since it frequently clouds my motivation and muddies the clarity of my call. It takes watchfulness and time to pry this sticky strand from the fabric of my life as and when I discover it. Being vigilant about identifying it is far easier than attempting to pry it out after it is tightly woven in. Perhaps, as I tell of my journey, the Holy Spirit will lead you to your own insights into your own life.

"Will I be able to make a living as an artist—never mind a Christian artist?" I am asked this frequently, although not always this blatantly. Prevailing wisdom would suggest a resounding "Of course not!" as the correct answer. The reasons are convincing and many: the economy is bad; Christian art, as it is defined today, has a narrow and limited market; galleries are usually uninterested. For me to attempt to convince you otherwise is an exercise in futility. If, however, with the help of the Holy Spirit, I can help you see your calling differently, then the question above will never need to be asked at all.

Initially, the parameters by which I measure my success, or the lack of it, are in terms of money, accolades, and popularity, usually determined by the frequency of sales. Gradually the Lord shifts my horizon and changes my perspective, and I now see differently. You would too if you were suddenly removed from a worm's-eye perspective of a scene to a bird's-eye view of the same panorama.

Ask yourself the following questions: Where, in the Bible, is there a reference to "making a living"? What exactly is "making a living"? Is it having enough money to pay your bills, taking care of your needs for a home, clothing, food, vacations, and some luxuries? When are we ever asked to be the "makers" of anything, or even more outrageously, of our "living"? If it appears that others are successfully doing so, consider who granted them breath to exist, the ideas they need, the skill to implement them, and the favor to make their living. Don't you see how ridiculous it is to presume that we, who have not even the power to "add one cubit unto our stature" (Luke 12:25), could actually "make" our "living"?

I know I sound radical and impractical here. However, are you really willing to squander your calling by taking on another profession because you perceive that it will better serve you financially? It is reasonable to make the assumption that you should do so, if you are unable to see any other way and pursuing art seems futile. Yet there is a way.

If ever there is a repetitive theme taught in our churches, it is to "Seek ye first the kingdom of God, and all these things [material stuff which God knows we require while dwelling on this planet] will be added unto you" (Matthew 6:33)! We sing it as children in Sunday school, discuss it in our Bible studies, and have our eyes glaze over when it's preached from the pulpit for the umpteenth time, yet when it comes to the practical application of its truth, few of us put it to work.

Will you consider testing it out, as I did? Then you too will discover that the promise is more than just true: it is, without a doubt, the most liberating and exhilarating way there is to live.

All I need, Jesus promises, will be lavishly supplied when I need it. I have only to believe it and take it by faith while continually seeking *first* His kingdom.

What does that really mean, I want to know? What does seeking His kingdom in my art and life look like? Can it be that as I pursue Him in this calling which He has uniquely created me for that He will empower and provide for me?

And God is able to make all grace abound toward you;
that ye, always having all sufficiency in all things, may abound
to every good work.—2 CORINTHIANS 9:8

I discover from the Bible that God promises to establish His kingdom in this sliver of time that I dwell in, in this specific field that He assigns to me, if I will partner with Him by believing His promises to me. Faith and a stubborn determination to persist in my calling are what it takes when I may not immediately perceive success as I desire it. I am also promised that the kind of success I crave will come, in due time.

> *"The way of the LORD is strength to the upright."*
> —PROVERBS 10:29

The Way

Man boasts of ways for every act
Pertaining to life and living
A way to work and a way of tact
A way for smarter, greener living
There are ways that tell you how
To meet to woo your heart's desire
A way to give you thrills right now
To spark love's dwindling fire

But came a Man one glorious day
Who boldly claimed, "I am the Way"
His Way a life of righteousness
Hope and light with grace to bless
Paid by His blood and dearly bought
A Way that's new to all man's thought
As God He taught this marvelous Way
Black and white, no shades of gray

Hopelessly futile, all man's wisdom
His Way a path to a different kingdom
Spurning our ways of selfish living
Better than getting, He says, is giving
Toil not for wealth and riches for living
To hoard and store all that is gained
His way is rest from selfish pursuing
Nor urgent striving without restraint

"You bless when others curse," He urged
"Pray for them when they rudely hurt
With My great love their hatred purge
Stay with your wife and do not flirt"

Yet none can walk this Way alone
Only in Jesus, as bone of His bone
Blessed of God on a fruitful journey
On this high way come join with me.

I sense a deep yearning in me as the years go by, a yearning for fruitfulness. I write about it in fervent prayers in my journal. I grow in understanding but see little fruit as I envision it. My role, I remind myself, is to persevere in art; His is to feed, clothe, and care for me. He also has the responsibility of increasing the seeds of my faithfulness by providing me with ideas, resources, and inspiration to continue in this task. I desire talent, ability, and immense resources immediately. He requires patience, diligence, and steadfastness. These take time to develop.

Restlessness is followed by seasons of quiet, knowing that my time is not yet. I sense being reined in, so I reluctantly comply. I learn that He has seasons for everything: sowing, pruning, reaping, gathering a harvest, leaving ground fallow for further fruitfulness. I chafe against seasons, preferring by far one long season of excellence! I waver between faith and peevish whining. Inexcusable, I know; nevertheless it forms a significant part of my journey. It is heartening to know that I am not alone.

My aspirations are grand, embarrassingly so. (If you are willing to admit it, yours are too.) I learn that God has placed them here—they are not just a product of my own ambitions, nor are yours. Of course, they must be purified, but God Himself has planted the raw material of my dreams in me. I wish I'd had someone to tell me so earlier—but there was no one to guide or mentor me. I knew no Christian artists on a similar pursuit. God, however, patiently leads me into stretches of hope and faith greater than I have ever contemplated. Over time, He confirms that I have not misunderstood Him.

As I grapple with my hunger for excellence, I search for answers. "Dare I believe," I write in my journal, "that the hunger is from God, requiring only Him to answer and satisfy?"

Then I am led to the words of John G. Lake, an American missionary, from a sermon on December 11, 1924. They inspire me as I read what he discovered. "The hunger of man's soul must be satisfied," he wrote.

> God's purposes come to pass when your heart and mine gets the
> real God cry, and the real God prayer comes into our spirit, and

the real God yearning gets into our nature. Something is going to happen then. No matter what it may be that your soul is coveting or desiring, if it becomes your life, the supreme cry—not the secondary matter, or the third, or the fourth, or fifth or tenth, but the first thing, the supreme desire of your soul, the paramount issue—all the powers and energies of your spirit, of your soul, of your body are reaching out and crying to God for the answer; it is going to come.[3]

Reaching for and living out God's plan for my life as I envision it takes more time than I ever anticipated. I read that even Isaiah, a giant in the faith, wavered. He too struggled to stay hopeful, discouraged by his apparent fruitlessness. "Then I said, I have laboured in vain, I have spent my strength for nought, and in vain," he wrote in Isaiah 49. Somehow God reassured him that his labor was safe with God. There is far more at play than what is immediately apparent in the quiet labor that seems to go temporarily unrewarded.

3 John G. Lake, *The Complete Collection of His Life Teachings,* compiled by Roberts Liardon Ministries (Tulsa, OK: Alsbury Publishing, 1999), 454.

*"In the shadow of his hand hath he hid me, and made me
a polished shaft; in his quiver hath he hid me; and said unto
me, Thou art my servant, O Israel, in whom I will be glorified.
Then I said, I have laboured in vain, I have spent my strength
for nought, and in vain: yet surely my judgment is with
the LORD, and my work with my God."*—ISAIAH 49:2-4

The Yearning

Surging forth from deep within
Yearning swells, a foaming wave
Gaining force with roar unbidden
To crash on shore alone and brave
Where will its substance flow to bless?
How will its hope find some rest?

If yearning were a winter fur
I'd cast if far to choose the chill
Fevered of heart, vision a blur
I long for respite, grace to be still
Will hopes of a life, indelible and dear,
In obscurity end, its prize disappear?

Bolstered in faith with hope undimmed
Honed to soar one day in the wind
Polished, returned again to the quiver
Where dim light flickers in only a sliver
Someday soon in a flashing gleam
In swift flight will I live my dream?

I'll be that arrow, sleek and true
Loosed with speed into the blue
Razor sharp, He'll make the mark
Whistling in air free of the dark
In perfect time His hand seeks me
From quiver to a target I can't yet see.

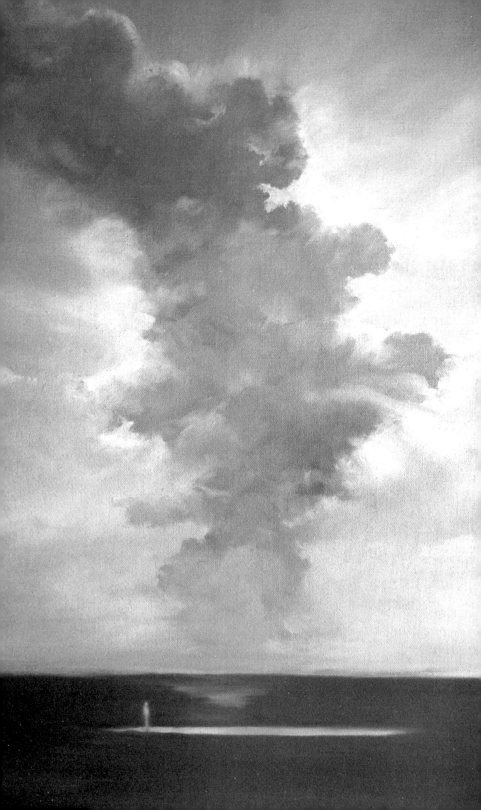

A Clear Mission

JOHN G. LAKE'S POWERFUL WORDS CAPTIVATE ME, and I discover that they are biblically consistent:

> Jesus Christ comes to us with divine assurance and invites us when we are hungry to pray, to believe and to *take* from the Lord that which our soul covets and our heart asks for . . .
>
> By every law of the Spirit that men know, the answer is due to come. It will come in more ways than you dreamed of. God is not confined to manifesting himself in tongues and interpretation alone. His life in man is rounded.[4]

Intuitively I sense that the role of the Holy Spirit is multifaceted, indefinable, and marvelously creative. His work in the life of a willing Christian cannot be pinned down, boxed, packaged, or labeled like some have attempted to do.

Emboldened, I pray, "I am hungry, Lord, for Your Spirit to be poured out in my life—so that I may create art that will, without words, draw the trained and untrained eye upward to You. I pray for the Spirit to be so manifest in my work, to move men in the depths of their souls where speech, logic, and persuasion cannot touch or even reach."

I write those words, unaware that I am penning what becomes the mission statement for the rest of my life—lofty, grand, and completely out of reach. All mission statements, I read somewhere, ought to be unattainable. Mine certainly is that.

4 John G Lake, *The Complete Collection of His Life Teachings,* compiled by Roberts Liardon Ministries (Tulsa, OK: Alsbury Publishing, 1999), 455, 460.

To say that it is *my* mission statement is, without a doubt, vain. As the words tumble out of my pen, startling me with their boldness, I am acutely aware of entering into a partnership with God at His initiative. A mission is given to me as I attempt to seek first His kingdom and His right way of living, doing, and being. Without Him, all my efforts are destined for the dung heap of futility, or as the author of Ecclesiastes so aptly puts it, are simply vanities. With Him, I have to stretch beyond my puny understanding to reach the place of faith where "all things are possible" (Mark 9:23). "My circumstances are common," I write that morning, "but my God is not; my faith and hope rest in that."

Slowly the currency of money, which has choked me with worry, is replaced by the exciting currency of faith. Faith will appropriate all that I need to fulfill my destiny as a Christian artist. Strangely enough, faith is not an unfamiliar currency. All of us possessed it once, sadly trading it for much that is counterfeit and cheap as we grew older and more cynical.

Reuben, at two, is a delightful, curious little boy, no different, I'm sure, from countless other children. He never for a moment worries that he may not be fed when he is hungry or given a drink when he is thirsty. He never entertains a thought about what he is to wear or even where he is going to be taken. The morning of a transatlantic trip to visit his grandparents dawns no differently for him than the other mornings of his limited lifetime. He plays happily as I bustle about making sure that his passport and visa are current. I am responsible for his ticket, clothes for the trip, snacks, money . . . I push him in his stroller through security, customs, and immigration; he is entertained while in transit at many airports: Honolulu, Taipei, Kuala Lumpur, Singapore.

None of it makes any difference to him. When he is hungry he is fed, when he grows weary I am expected to cuddle him and give him a place to sleep, and when he wakes up and wants to play, I am to be his playmate. All his demands are made with a cheery expectancy. He simply entertains no other options. Neither do I, as his mother, question his dependency. How much more is this true of our relationship with our heavenly Father? How frequently does He declare that He delights to care for us, provide for our needs, and exceed all our expectations?

For your Father knoweth what things ye have need of,
before ye ask him.—MATTHEW 6:8

Now unto him that is able to do exceeding abundantly above all
that we ask or think, according to the power that worketh in us . . .
—EPHESIANS 3:20

Once I find Reuben's plastic bank left open on the floor of his room. His money is carefully piled into neat stacks by size. In an attempt to teach him that money has value, we have told him that he can have the coins that he finds around the house. Intended more to encourage his older brother to empty his pockets before tossing clothes into the washing machine and discourage his father from leaving loose change around, it turns into an exciting game for Reuben. He becomes an expert at "finding" money, sometimes tearing into a room to stake his claim when he hears the clink of coins clattering on the tile floor! The act of sorting his acquisitions is pleasing to him, size and color being his only criteria. He is oblivious to the value assigned to the coins by the adults in his world.

His dearest treasures are also secured in his bank. With childlike awe, he shows me a shiny gold sequin and a smoky grey feather. He finds fascinating the brilliant colors hidden in the depths of the sequin's sparkle as it catches the light. He sighs contentedly as he strokes the soft feather against his cheek and then mine. The plastic Richie Rich bank guards no more worthy treasures than these two!

Our journey into art and creativity, much like Reuben's, begins with an innocent sensitivity to beauty felt in our very depths. Unable to articulate it, we breathe it in with every fiber of our being. A visceral rejoicing, placed within us by the Father, becomes a nonverbal language of the appreciation of beauty. We are born with the capability of absorbing, enjoying, and then interpreting our appreciation in some expressive medium—a language of joy and praise in response to beauty.

We feel the urge to include this beauty into our lives somehow. Occasionally a form of that splendor is brought into our homes; we wear it,

carry it around with us, or find other means of expressing a response to our delight. Our busy, creative minds find myriad ways of prolonging our enjoyment of the beauty that captivates us.

Art is then born, responsively and naturally. We do not concern ourselves with its value, with making a social statement, with developing a skill or technique, or with marketing its worth to another, making a living, or even being original. Instead, we collect, sort, arrange, rearrange, create, and enjoy simply because we can hardly help doing so. Unfortunately, someone invariably tells us how creative we are. The focus then subtly shifts from the joy of creating to the product made by our hands and inevitably to ourselves, as splendid artists!

Think of the work that our children bring us. We proudly clear a place for it amidst the clutter of travel and pizza magnets on our refrigerators, making the work central. Could we have emphasized the joy of creating over the work itself, or even over the little artist? Perhaps, yet few of us do so. The art and the artist are lauded, but the process of creating art—a superb divine reward in itself—is rarely acknowledged.

As we grow up, we receive all sorts of subtle responses from our peers, teachers, or family members. Our response to art is gradually polluted. Our creative endeavors are either deemed worthy or lacking in merit. If others consider us talented, we pursue the making of art. If we are criticized, we shy away from every opportunity for creativity, forsaking the joy intended to infuse our lives with vitality and energy.

Those who are commended for possessing this now-elusive artistic ability as adults still steer clear away from careers in art. The concern that reigns supreme is invariably monetary in nature. Art is now only enjoyed occasionally. Relegated to a pleasurable pastime, the making of art plays second fiddle to jobs that are identified as being essential to fund the necessities of life. Sadly, we know intuitively that deep fulfillment is only experienced when we are creatively engaged. It is often with relief that some return to art as time permits.

Maybe you sense that the moments that sing truest in your life are those spent expressing yourself in art. Do you dare entertain the possibility

that the fulfillment of your divine destiny may be inextricably intertwined with the pursuit of your artistic calling? If you were to step up boldly to live it out, do you worry that you would starve? Then ask yourself this: would a great and benevolent God call you to something only to bring you to utter poverty? Of course not!

Instead, you will discover that if you do step out in faith, God will abundantly provide for your every need, despite how improbable it may seem.

Every Sunday after church, BJ and I weave our way through the crowds in the foyer to a classroom where our pastor's father has taught an adult Bible class for years. This silver-haired retired pastor inspires and challenges us, transparently living out that first principle of Scripture of seeking first the kingdom of God. He never tires of telling us how he witnessed this principle at work in the lives of the two little women who first drew him to Jesus.

When he was a young man, he sought room and board in the home of two unmarried sisters. They had made an unusual arrangement with God. At His leading, they opened their modest home to take in young, rowdy tenants as a means of "making a living." Their mission was that either these raucous lads would receive Jesus as their Savior in six months or God would move them out to make room for others to have the same opportunity. The temporarily "unsaved" lived in the lower floors, while the "saved" were moved upstairs.

They applied themselves to this mission with passion and diligence. The young men frequently heard the two sisters in fervent prayer for them as they stumbled each night to their rooms, drunk. Our pastor's father was one of those men, young, impulsive, and with a reputation for a quick and terrible temper. He loves adding that, at the time, he was certain that the two sisters were crazy!

Undeterred by the amusement of the young men, the sisters treated their mission with gravity. God blessed their endeavor as the young men in their home were either saved or invariably moved out within six months to find lodging elsewhere! The latter was a small group indeed, while the rest became ministers, pastors, and missionaries, leading innumerable others also to Christ.

Commendable as their results are, it is the clarity with which these women viewed their mission that impressed me. They never lost sight of their objective despite trying circumstances, and God honored the tenacity of their faith.

Once, our pastor told us, a fight broke out among the raucous youngsters at the dining table. In the chaos that ensued, the dining room furniture was destroyed. Someone made a move to call the police but was prevented from doing so by one of the ladies, who begged him not to do so. "God will always provide new furniture, but if this young man is hauled off to prison, then we won't be able to visit him there, and he may never be saved!" she exclaimed.

So urgent was her sense of mission, her disregard for the damage to her furniture, her faith in God, and her love for the young man that she never wavered.

"Then," the pastor told us in his booming voice, "I never will forget what happened next." Within a week, he was excitedly beckoned outdoors by one of the sisters. He watched dumbfounded as a truck pulled up from a furniture store, bringing brand-new furniture for the dining room to replace what had been destroyed! How that came about is lost in the twinkle of his eye and the passionate retelling of the rest of the story: a jubilant description of the sisters' prayers, their faith, and their persistence, resulting in his coming to the Lord as well and turning his whole life upside down!

We gather that God prompted a furniture store owner to give the sisters new dining room furniture. Whether the owner somehow heard the story or merely obeyed God's prompting is unclear. What is certain is that the sisters neither told anyone of their need nor asked a soul for replacement furniture. No one knew of what had happened besides the rascals who destroyed it and God, who loved them. New furniture, better than what they once owned, graced their humble home for years thereafter as a testament to God's faithful provision.

Those two sisters sought first the kingdom of God, and all they lacked was indeed added unto them! How precious the fruit of their seeking God's kingdom! Because of them, our pastor's father found his way to the Lord,

and he has since led countless others to Jesus as well. All his children, grandchildren, and now great grandchildren also reaped the benefits of his transformed life from a belligerent, irreverent young man to a godly, wise, and gentle leader.

Almost sixty years later, BJ and I, immigrants from another continent, were also moved by this account of two nondescript little Texan women with Herculean faith, wielding such uncommon power. Their faith is still changing lives, long after their mission on earth was completed. What a legacy!

If you have been called to be an artist, pray to be clear about your mission and set yourself to the task of being one. It is a tangible act of your faith, an affirmation of your commitment, even if aspects of it still seem blurry to you.

Who better to praise God for what He has done for us than Christian artists! Who better to respond to the beauty around us in awe, if not we who call the One who created it "Father!"

Ask God for abundant ideas and inspiration. Ask in faith, expecting to hear. When you do hear, act, decisively and with excellence. Begin somewhere, anywhere—just begin. Your weakest, most fledgling efforts, if done in faith, will be added to. Begin with whatever you have on hand. Some absolutely fabulous art is created using recycled materials—cardboard, plastic, yarn, old CDs. We toss so much away that can serve well as media for creative expression. God will supply you with exciting inspiration and necessary materials. He will refresh you when you are weary and reward you for your faithfulness. Be single-minded, purposing not to be swayed from your mission regardless of what trial Satan may concoct to derail you.

To pursue your calling as an artist is not a single act of your will so much as a lifestyle choice. Be certain that as you are added unto, more will be expected of you. By then, like catching the wind in your sails, you will already be skimming along to distant shores you once only dreamed about. So what are you waiting for?

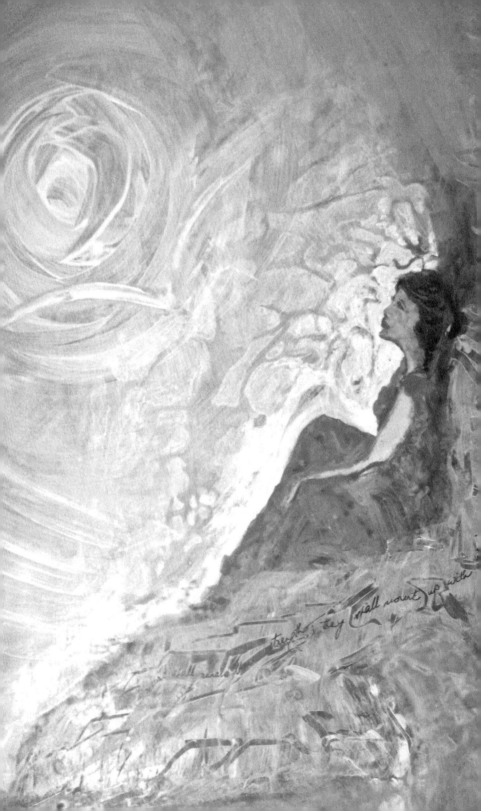

Salt for Success

MANY CHRISTIANS WHO ASPIRE TO SUCCESS are either ignorant of or ignore tithing. It is, however, the very salt which ensures palatable success in all aspects of life. Tithing, or the giving of the first ten percent of income as an offering of worship to God, is a radical command in the Bible.

When I first hear of it, I am intrigued. To give away such a large sum seems overwhelming. My memory is shamefully clear—I've never given away anything of value.

I was born into a family belonging to an ancient church denomination, tracing its roots back to Thomas the apostle. With such a rich heritage, my testimony ought to be better. For over two thousand years, as the first converts of Thomas, my grandfathers worshiped God in spirit and truth, turning to Christ from Hinduism and idolatry. When Thomas's ship dropped its anchor on our tropical shores, he brought the Good News to what was sadly his final destination. His faith cost him his life in the city where I grew up, far from where he first doubted Jesus.

Although trivialized as Doubting Thomas for questioning the resurrection, the rest of his life testified to the strength of his conviction. The same *zoe* life of Jesus that is transforming me over two thousand years later transformed him. How else can you explain his uncommon courage after his infamous skepticism?

Obeying the command to "Go into all the world and preach the good news" (Mark 16:15), he made this perilous journey of thousands of miles, eventually reaching the sandy beaches of India to begin the church of my fathers. It was certainly not a task for the fainthearted. Yet his arduous travels must have paled in comparison with the challenges of reaching the hearts of those who spoke a different tongue and were darkened in their spirituality. With the certainty of truth as his firm conviction and God's

powerful partnership and affirmation, Thomas won my fathers over. They then continued the mission. I am the fruit of their faith and labors in prayer and deed, over two thousand years later.

A faded journal entry by my great-grandfather, the Reverend Jacob Chandy Sr., reads, "Lord, help us to remain faithful and steadfast in Thy service and enable us to glorify Thy name amongst our friends and neighbors who know Thee not."

Generations later, it is a vastly different church from the one my great-grandfather knew, a body of members choked by a slavish reverence for social hierarchy and power and either ignorant of, or disobedient to, the truth of God's Word. Who knows? Whatever it is, I reverently attended church as a child on numerous occasions, always respectful of God but blissfully ignorant of any salient knowledge of Him.

The offering receptacle is still a scarlet velvet bag with a wooden handle, as it was then. Passed from hand to hand, it cleverly hides in its forgiving depths whatever is dropped into it. What others give remains a mystery; as children, we were each handed a meager rupee or two to bury in its soft folds as it passed by. The priests who counted the offering must have clicked their tongues in disgust. Surely no more than a handful of rupees and paltry loose change clattered out whenever its contents were emptied! Our rupees were most likely the largest denomination of offering. Yet, this is an understandable response from a congregation that could not possibly have known about the blessing or power of tithing. I do not recall any teaching on tithing, increase, or prosperity in that church.

Today the church resorts to clever ways of funding projects, salaries, the parsonage, and the buildings. Besides the usual home-cooked food and bake sales, house calls take care of the matter. Huge sums of money are extracted from members of the congregation in awkward face-to-face meetings in well-appointed living rooms. Donors are lauded and their names published in a directory according to their "generosity." The largest donors naturally attempt to out-give each other, vying for the top spots in the listing. The whole system is a not-too-subtle form of blackmail and extortion, effectively playing on people's inherent sense of pride—or shame, if they are unable to give much.

Thomas would have been dismayed.

Perhaps it is tolerated not because everyone agrees with the system, but rather because it is too disruptive to attempt reform of any sort. Why rock a boat that has been sailing comfortably for at least some of two thousand years! No great reaches of faith are required, and God is comfortably absent from the process.

In America, far from the land of my childhood, as I begin this new affair of the heart, I learn about the command to tithe. In obeying, I gain a concrete understanding of a divine covenant and come face-to-face with the power of a covenant-keeping God.

"God is a Spirit: and they that worship him must worship him in spirit and in truth."—JOHN 4:24

An Affair of the Heart

In stained glass splendor, You were once a stranger
Elusive as smoke from an incense burner
Obscure words chanted from a page
Remote in a church with a curtained stage

Sang ageless hymns joined hip to hip
With those who later loved gossip
I knew of You, yet knew You not
Until You kindly changed my lot

Far from home, You came to me
Because my husband spoke with Thee
He spoke with You from a heart set free
Said You still speak, and startled me

Charismatic church full of Your presence
Rabid Pentecostals, had they no sense?
Expecting healing, miracles, prophecy
Loudly singing, raucous and crazy

Far from proud and pompous priests
I found You there among the least
You graced with power this humble throng
Voices lifted in earnest, grateful song

So why are those in ordered pews
Content to follow the priestly few?
They heap contempt on the simple soul
Who, loving Your Spirit, is made whole

Priests in robes, hearts chilled by pride
Worthless traditions behind which they hide
Leading their indifferent flocks astray
Disdainfully rejecting Your Spirit's way

Mocking those who live with zest
Convinced that they surely know best
Scornful of those who call You "Lord"
Spurning talk of a covenant God.

By faith in Your Spirit-inspired Word
I believed and received that which I heard
To join with those who boldly stake
Their claim on a life I need not fake

Spirit-led and now Spirit-filled
Prosperous, healed, deeply sated
Combating evil with a certain end
Though Satan's foe, God calls me "Friend"

The words of a promise, an integral part of the command to tithe, tickle my curiosity and tantalize my vivid imagination. BJ and I are in tough financial straits at the time. God seems to dare us to take on this challenge. I find it irresistible.

Bring ye all the tithes into the storehouse, that there may
be meat in mine house, and prove me now herewith, saith the
Lord of hosts, if I will not open you the windows of heaven . . .

What would it be like to have the windows of heaven opened by God?

. . . and pour you out a blessing, that there shall not be
room enough to receive it.—MALACHI 3:10

Imagine not having room enough to receive blessing!

And I will rebuke the devourer for your sakes, and he shall not
destroy the fruits of your ground; neither shall your vine
cast her fruit before the time in the field, saith the Lord of hosts.
—MALACHI 3:11

If tithing is an uncomfortably new idea to you, let me assure you that it was certainly so for me. More Christians talk about it than truly practice it. However, like all spiritual truths, none of its power is unleashed without putting it to the test. My self-serving streak only serves to make tithing easier. What safer bet is there? Tithing ensures God's protection and continued provision. Fortunately, BJ is committed to it as well. We tithe when we have little. It is easy. God proves to be true to His Word, and we soon find ourselves with more. Despite knowing His promise to bless us, there is something indescribably exciting to witness it actually happening in measurable concrete ways! God blesses and multiplies our resources, and we find ourselves with more. Ten percent of the multiplied portion is a far larger amount than we ever imagined.

It is a struggle as we begin to walk in this blessing to not balk at the greater amounts of the tithe until we discover a simple way to overcome our hesitation. A separate, untouchable account, which we consider holy, is opened, into which we promptly write our first check of any increase that comes our way. God teaches us that it is not only vital to write our tithe check *first,* but also with the right attitude. It becomes a worshipful experience of hearts full of gratitude and faith for the morrow. We guard against taking tithing for granted or developing an obligatory mentality about it. Consistency is also crucial. If you only tithe once, or even a few times, and never do so again, don't expect God to carry out a promise that you have not truly entered. Tithing is not an event, but a lifestyle. Failing to tithe, God declares in the Bible, is akin to robbing Him, which is a serious indictment. I've found that all aspects of faith require patience, consistency, and a dogged perseverance to receive what has been promised.

And we desire that every one of you do shew the same diligence
to the full assurance of hope unto the end: that ye be not
slothful, but followers of them who through faith and patience
inherit the promises.—HEBREWS 6:11–12

How grateful I am for God's promise and His unfailing integrity to honor His part as we do ours! As the money grows in our sacred account, we seek Him constantly about what aspect of ministry to sow into. Both of us hear independently, and yet in perfect unity, exactly where and how much to give! This happens too often to be mere coincidence. Sometimes the account is emptied out; at other times it accrues to meet some specific need in the body of Christ. Like a master choreographer, the Holy Spirit directs our giving effectively and with precision.

We tithe not because we are coerced into it, nor even because we are moved by the urgency or gravity of a need. The world is a desperately needy place. Feeling its oppressive burden or attempting to solve all of its problems is not what we are called to. We learn to not only tithe but to also give more whenever we hear from God and only then.This, we discover, is a far simpler role, for which we clearly hear His call.

We tithe because we revel in His care and protection. Our eyes are opened to unexpected favor and timely protection even as we share the joy of blessing others. We watch in awe as disasters are averted. Circumstances beyond our control somehow suddenly become petty obstacles which are no match for our heavenly Father. He clears a path for us to live an existence like never before, one that is purposeful, exciting, and immensely rewarding. When we face challenges that threaten to overwhelm, we find peace in the knowledge that we are tithers with a divine covenant with God Almighty. We watch amazed as He repeatedly honors that covenant, despite our wavering faith and the odds stacked against us. Even so, we know that our final grand recompense is not yet, but pending until the time when our earthly lives conclude and heaven's promise awaits.

As we tithe, we sense God's pleasure and His partnership. We give because we take seriously the accrual of a heavenly account for our own earthly needs, one which we draw on frequently and generously. This is an account which, although severely tested through enormous demands made on it, magically never runs out!

One day it dawns on me that we now tithe because we simply cannot afford to do otherwise! As an artist, I enjoy the security of the covenant I share, a divine partnership, knowing that God is honor bound to keep me well supplied in every area of life. My need becomes insignificant in contrast to His ability to abundantly provide for it. What more can I tell you to persuade you to walk this same path?

No bank balance, trading stock or fund, gold, or silver, no matter how substantial, can match the thrill of managing, maintaining, and withdrawing from this account with God as our banker.

Seed for the Sower

DESPITE SOME ASSURANCE OF YOUR CREATIVE CALL, you may find your-self in a hopeless situation. Perhaps you are destitute, utterly impoverished in money, family circumstances, education, or health. One artist told me the heartbreaking story of her life being turned upside down without any notice because of divorce and unexpected legal issues. It is possible that you are in a situation that is so awful that even if you nurture the dream of being an artist, you perceive no available means to do so—no peace of mind, financial resources, or supplies. Maybe you only possess a smidgeon of talent. How can someone so disadvantaged, you wonder, ever serve God as an artist and still be assured of the essentials of life?

I have good news so marvelous that if you receive it and put it to prac-tice, you will be astounded at possibilities you have never even dreamed of!

You are *not* totally destitute. You possess two great resources provided by God: your calling and your time. Despite how pressed you feel you are for time, everyone has been granted twenty-four hours in a day. Ask God for wisdom on how to squeeze just a little out of your day, week, or even month. You may discover that you are not as impoverished as you first thought. Respond to your holy calling by putting your gift to work with whatever you have on hand. If that is nothing, then pray for something to begin with. Regardless of how little clarity you have about how to continue, you can be willing. You share in the larger mission of getting to know Him and making Him known. Remember, no matter how insignificant you feel, you are still called to be a witness. No born-again child of God is exempt.

Sow time in your work, as much or as little as you can, in faith, as diligently as if you are sowing the most precious seed available. Sow it will-ingly, trusting Him, even if it appears fruitless at the moment. Willingness is of infinite worth in God's eyes. How many deficiencies do we overlook as

parents if our children demonstrate willingness and responsiveness to our love! It is no different with God.

Isaiah 1:19 reads, "If ye be willing and obedient, ye shall eat the good of the land." It is a promise I hold dear, giving me sufficient incentive to be willing when I least feel like it. I seek to obey when every instinct in me would rather ignore God's commands. If I press on, the promise will become my reality.

God's kingdom operates on the simple principle of sowing and reaping. Before you decide to gloss over this because you've heard it preached untold times before, would you give me a chance to tell you what I learned rather inadvertently? Sowing is a secretive thing. The seed is buried in dark, moist earth, away from prying, assessing, evaluating eyes. Sowing is a private act. It is little, of almost no apparent worth, yet it holds immense power. The full potential of a plant or tree abides quietly in the seed. Does the wrinkled cherry pit that we spit out give any clue to the breathtaking beauty of the tree in spring, smothered in delicate blooms, or the sweetness of its fruit shortly after?

It is completely consistent then, that in Matthew 6, Jesus begins teaching with a call to secrecy in the act of giving:

Take heed that ye do not your alms before men,
to be seen of them: otherwise ye have no reward of your Father
which is in heaven.—MATTHEW 6:1

Productive sowing is a secret transaction between you and God, since He is the one who gives the increase. The need for similar privacy in our conversations, or prayers, with the Father is absolutely vital. Our petitions are to be made in secret, as are our worship of His holiness, requests for bread to sustain us, choosing to forgive others in obedience to His command, seeking forgiveness for grieving Him, fasting, and other interactions with Him. They are all secret, private matters between God and us. Quietly, all those actions executed in holy secrecy bring us a sure reward.

Jesus abruptly changes the subject further on in Mathew 6, from secret acts of service known only to the Father to the matter of money

and our relationship to it. Although these things are seemingly unrelated, He instructs us on our appropriate response to money. Why would such instruction be given to us unless Jesus knew that the Father would indeed reward us with material wealth, among other things, as we sow? If there were no possibility of acquiring wealth that required wise handling, why address the subject at all?

And thy Father, which seeth in secret, shall reward thee openly.
—MATTHEW 6:4

Lay not up for yourselves treasures upon earth, where moth and rust doth corrupt, and where thieves break through and steal.
——MATTHEW 6:19

The blessing of gradually growing wealth, our promised increase, is inevitable when we sow in secret, regardless of how meager our beginnings may be. There is a fine, shadowy line between receiving and enjoying this wealth, while recognizing its source, and becoming obsessively consumed with it. Once we taste this promised and certain increase, we come face-to-face with the temptation of pursuing wealth by any means possible instead of recognizing that it is best only when it comes from God. If we succumb, our perception becomes foggy. We lose the clarity of our mission, art becomes polluted, and the true harvest is compromised. Thankfully, Jesus in His infinite mercy always steers me back, when my pursuit veers off track, to the abundant place He has for me as opposed to one of my own making.

All education has as its objective the systematic accrual of knowledge to accumulate wealth. We no longer challenge the assumption that being armed with knowledge in a lucrative field will be rewarded by society and is therefore the surest way to acquire wealth. Children are sent to school and on to college in the hopes of giving them a superb education so that they can eventually get a "good job" and one day support their own families. Professions that society rewards with money are universally considered wise choices for a career. As you know, being an artist, in this sliver of history, isn't one of them.

This worldly criterion of making a living as a means for determining our life's work is in direct opposition to the process of seeking God's calling first, whatever it may be, and then trusting Him to add the wealth to us as we pursue Him and His plan without strife or sorrow, and of course, in His timing.

> *The blessing of the LORD, it maketh rich, and he addeth no sorrow with it.*—PROVERBS 10:22

All that our creative call entails—technical knowledge, skill, adequate material resources, and the power to be effective in its purest, most trouble-free form—lies with God. We seem to have lost our faith to trust Him with this. As we become smarter in worldly knowledge, we ironically grow colder to the biblical way of fulfilling our God-given call—why wouldn't we? Our dependence on Him is no longer vital. Is it any wonder, then, that the call to be an artist is being answered by few today? Worldly wisdom does not support its pursuit.

The big question of "How do I do succeed as an artist and have my material needs met?" still lies unanswered. There are a few superstar artists who earn a lot from their creative work who are probably uninterested in knowing more. Yet how about artists who are novices, unremarkable today in their art and altogether in the dark about their potential? How about those who earn little or nothing from their art at the moment?

Only in the pages of the Bible do we catch a glimpse of how we are meant to acquire wealth and increase while pursuing the call of God on our lives. First, we must believe that we are intended to be more than adequately supplied in every area of life. Therefore, by the most straightforward definition of wealth, we are meant to be rich. That may sound naïve, but I assure you that it is a biblical truth. A diligent search will uncover numerous verses that promise just that. We are urged to help a hurting world, which is a ridiculous notion if we are impoverished in resources as we become aware of needs or have barely enough for ourselves. Besides, what sort of a King would allow his royal heirs to be continually bankrupt?

If you hold to the mindset that being a prosperous Christian is a lie propagated by self-serving charlatan TV evangelists, I recommend a careful, unbiased study of the Bible. You will unfortunately receive precisely what you believe, so be cautious in what you toss out as improbable. Don't allow a lack of faith in the generosity of God to become a constraint, boxing you into a narrow tight space with little room to grow and become all you were meant to be. It is God's idea that we constantly increase in all areas of life. The blessing for heeding God's commands in Deuteronomy 28 outlines blessing and prosperity in every conceivable area of life; nothing is exempt.

Regardless of how poor you are today, God intends that you prosper. Do not question God's will of abundance for you based on your present experience or what you see around you in the lives of other struggling Christians. We were never intended to live lives of poverty, lack, or fruitlessness. The Bible indicates that our destiny is an enviable state of blessedness. If we are not expecting or experiencing that, then the fault lies in our inaccurate understanding of the Bible, which cripples our faith. It is impossible to receive what has already been promised to us, by a God who does not lie, if we stubbornly refuse to believe His promises.

God promises me that all that I need to accomplish what He has called me to do has been amply provided for, well before I even recognize a need for it. To receive that promise, I also read that it is imperative that I am a prompt and cheerful giver. Then God assures me that all I will ever need will be granted in order to thrive in every good work. The Greek word used in this verse is *ergon,* which means business and occupation as well as "any product whatever, any thing accomplished by hand, art, industry, or mind" (Thayer). Can you now doubt that God considers creative pursuits "good works"?

> *And God is able to make all grace abound toward you;*
> *that ye, always **having all sufficiency in all things,** may*
> *abound to every good work.*—2 CORINTHIANS 9:8, EMPHASIS ADDED

What He has done for me repeatedly, He can and will do for you. He has a supply that is uniquely tailored for your specific needs. If you fight that

possibility, then you shortchange yourself of a future that is unimaginably satisfying and rich. It never ceases to amaze me that so many Christians do indeed argue their way out of considering such a wealthy, well-supplied future as God's will for them! Yet if you read Psalm 1, Psalm 23, Psalm 112, Psalm 103, and many other passages, how can you believe otherwise?

If you open your heart to the possibility of a life that is a pulsing, growing, cell-by-cell increase, like a magnificent tree planted by living waters, then you are on your way to learning how to garner the rich supply intended to anticipate and supply all your needs as they arise. Act on that belief by trusting God to provide when tackling whatever He leads you to do. Soon you will recognize that you are dwelling in your wealthy place as you find yourself not lacking in any resource pertaining to your life and calling. The Holy Spirit will guide you, if invited, and teach and empower you to tap into that boundless supply as needed. The truly wealthy never stop to consider what cannot be accomplished, pausing only to consider how to best employ the resources always readily available to them. You can too. Gratefully living the well-supplied life, the Bible teaches, establishes His covenant on the earth.

> *But thou shalt remember the Lord thy God: for it is he that giveth thee power to get wealth, that he may establish his covenant which he sware unto thy fathers, as it is this day.*
> —DEUTERONOMY 8:18

As you begin sowing time by studying the Bible, spending time with the Lord, and obeying His commands in art and life, more time will be magically freed in your day. I discover to my surprise that tasks which once took me ages to complete somehow resolve themselves quickly. Other bothersome chores that once drained me somehow trouble me less. Now when I sit down to art, I find that time, a precious gift, has been wrested from a busy schedule just for me in order to accomplish the task I've been called to.

Besides time, I learn that giving at His bidding can trigger and then set in continuous motion the increase I crave to escape lack and limitations in my pursuit of art.

Give, and it shall be given unto you; good measure,
pressed down, and shaken together, and running over, shall men
give into your bosom. For with the same measure that ye mete
withal it shall be measured to you again.—LUKE 6:38

My initial motives for giving of any sort are, of course, far from altruistic. As members of our church, we are expected to participate in all sorts of philanthropic activities. I give of my time because it is a socially acceptable thing to do; everyone does it, so I do too. Besides, it is fun. On one day it is the task of sorting clothes for the homeless; on another, it is organizing craft supplies for Vacation Bible School. With no lack of activities organized by our church, I choose whatever is convenient. Each occasion is an excuse to make friends and to feel the satisfaction of serving.

These events follow some grand vision that the church is fulfilling. At first I give little thought to whether this is what God wants me to do and merely join in for the camaraderie. Then I catch a glimpse of the precise expectations that God has of us, even with the specifics of our acts of service. Remember Ephesians 2:10?

For we are his workmanship, created in Christ Jesus unto good works,
which God hath before ordained that we should walk in them.

This verse hints at treating with gravity the works that I do walk in. Is this what God has called *me* to, or are there others He has better equipped to fulfill this task? I listen for that inward witness if I am to serve or a restraining check if I am to steer clear.

Instead of mindlessly picking whatever feels right as an act of service, I discover that God had precise tasks for me, specific needs He wants me to meet, because He has uniquely gifted me for the task. It is far more important to be led and prompted by His Spirit than to sloppily, or even casually, govern my own philanthropic agenda. God also exposes unseemly attitudes and motives that corrupt my service and urges me to regard His prompting as the sole incentive and reward for all generosity.

Lest you be tempted to brush off what I have written thus far about tithing or giving because you assume I began with plenty, let me assure you that it was otherwise. My husband and I do come from affluent families, however, when we first began tithing, our business was in its second year, in the predictable financial trouble that visits every start-up company. We gave our first tithe sitting in a church with only two dollars in cash in our wallets! BJ had to make payroll for other employees at the company; other families depended on us. Money was due us from somewhere, but we were otherwise empty, as was our bank account. I'm foggy about the details. All I remember vividly is the panic of our circumstances and our desperate search for hope. Also painfully clear is the memory of the pastor's message urging those who were down to "their last few dollars" to tithe and allow God to turn things around!

Our plans for quick financial success in America, the land of opportunity, had met with some major hiccups along the way. So we laughed nervously, parted with our last two dollars, and have never looked back since!

God has more than provided for our every need since that day. Somehow money mysteriously appears whenever we need it—bills are always paid, and there is always more than enough for us, as promised. We are also blessed with excess to sow generously into lives around us and ministries all over the world. It is far more than either of us could ever have imagined when we first began. We've been able to help others when they lacked with resources and a generosity not our own. We are fortunate to participate with the Father as a tangible expression of His kindness and grace. You can too. This is not the lifestyle of the poor, but rather one of the immeasurably wealthy, simply because our wealth comes from a limitless, unfailing source.

There is a breathless sense of adventure of living at the Lord's command, eagerly anticipating His sure reward and confident of never coming short. To help another is a priceless experience and a tremendous privilege. To purposefully do so in response to accurately hearing the quiet voice of God, when a need was only voiced to Him in secret prayer, is an even greater thrill. The enormous satisfaction that it brings cannot be adequately expressed; you just have to experience it for yourself!

If, after reading my account, you purpose to tithe and give, I must warn you of something entirely predictable. Like the bully in a schoolyard, who always shows up whenever the teacher's attention is turned away, Satan will promptly challenge your decision. I do wish someone had warned me! No one ever did. "What a stupid decision you just made!" he'll insinuate. "You just gave away money that you could use! You have so little; don't you know that you need every penny? How could you give to that preacher? The church is so rich, why should you give more? How can you know if your hard-earned money will be well spent? Preachers are crooks! Others have more, they can easily give . . . you shouldn't have to."

Occasionally something more trying happened, like an unexpected expense, shaking our faith in God and challenging our sanity at giving in such circumstances. Yet we persisted and watched in amazement as God performed His part of the covenant in caring for our needs in creatively unconventional ways.

Now we see such trials as an opportunity to stand firm on our commitment, unwavering and steadfast, because God has more than lived up to His promises. Today there is no longer a temptation to waver in our commitment to live this way; it has become an integral part of our lives. Once it became apparent that we were not going to budge on this decision, we were left alone. We are also no longer plagued in our own minds about optional uses for our tithe money or our decisions to give beyond that.

The tithe belongs to God. We do not dare steal from Him, deny ourselves the reward of seeing it joyfully given into His care, or jeopardize the future prosperity that He has promised us. We have already enjoyed enough to know that our tithe is safest with Him. Our giving in addition to the tithe builds our future, one of continuous wealth best expressed in the provision of every need met. With a sense of adventure, we feel the abandon of knowing that if God does not fulfill His part of the promise, we will be finished financially. Yet here we are still thriving decades later, prospering in more ways than just financially!

What amazes me is the ambivalence with which tithing is treated by many Christians, especially when they are no longer ignorant of what

the Bible has to say about it. They seek the blessing without obeying the command. There is nothing neutral about a decision to ignore the tithe. You leave yourself wide open to every manner of attack from Satan. Like the parent of a stubborn child who refuses help, God is unable to help us with our needs. He will not violate our free will. We have to choose Him and life, or else struggle needlessly by subjecting ourselves to unpredictable or endless cycles of lack. I was once ignorant to this tremendous opportunity for blessing and increase and am so grateful to know what I now know.

Tithing

Bless me, bless me, Lord, I pray
Labored hands have no other way
Eager for my hard-earned pay
Your grace to abound as I pray

Earnest prayer in church so grand
Hearty choir that drowns the band
But not the call to give and tithe
That irks my heart, so full of pride

Why give what I toiled to earn?
Mine alone, surely mine to burn
Bless me, bless me, Lord, I pray
Bless the labor of my hands today

In a death grip, I spare not a bill
Though church is over, I linger still
A prisoner now no longer free
Poorer somehow and oddly empty

Alone, I turn to pages worn
His voice compels my heart of stone
"To give is gain." I am so torn
"Test Me in this, don't walk alone"

In tithing I cleave now to His side
Freely giving and joyful besides
Plenteous provision, this I've found
His care is sure, His math astounds

A tenth for thirty, sixty or more
This sure bargain is no dubious lore
Never more lacking, nor ever poor
With each tithe blessed forever more

One Sunday, our pastor issues a bold challenge to those who are nervous about tithing. "Partner with God and give your tithes, and it will be refunded completely if the giver feels, after a couple of months, that it was a waste." If, however, the tithe becomes a catalyst for an exciting cycle of blessing, the giver is invited to tell the story on Testimony Sunday. Not surprisingly, we hear many excited accounts of events that defy logical explanation—unexpected checks in the mail, debts being canceled or paid off, promotions, found money . . . No one I know asked for a refund. Besides, our church does not exempt herself from tithing. Ten percent of every dollar that comes in is sent out to other churches and ministries before the rest is spent on pending church needs.

Skepticism, however, is the superglue that will shut with finality the door on possibilities far greater than the pitiful monetary amount that you first allow to leave your tight fists. Tithing is like that breathless moment on the very top of a roller coaster when time stands still. The thrill of the drop is imminent, yet without moving further, it remains a static moment with an incredible view. Begin hurtling downward, and indescribable sensations overwhelm—your stomach threatens to fly out of your mouth, the wind tosses your hair all over your face, and that magnificent view blurs; it is a heart-pounding adventure that if you enjoy once, you are eager to repeat!

Are you in a financially hopeless situation? Then begin tithing. Your way will become mysteriously clearer, more fruitful and more prosperous. I find that God's creativity in bringing resources my way is always beyond my wildest reckoning.

Because tithing is not a singular event (even though it will feel monumental in import the first time you do it in your desperate need), there are some important things to remember. Be persistent and fastidious about it—accurate in your math, and most importantly, in your attitude. Remember that the tithe is to be given with a heart of gratitude, acknowledging that God is now your source. Tithe reverently and tithe first, before your money goes toward anything else. It is a holy act of worship not to be undertaken casually.

You will have more to tithe each time. Know that you will balk at the larger amount with each incremental increase. Remind yourself, and the

voice that might tempt you to forgo tithing, that your larger tithe amount was impossible to fathom just a few brief months ago!

If, like us, you only have a two-dollar tithe (it was not quite a tithe but rather all we had at the time), it will grow to twenty, then two hundred, two thousand, then who knows, perhaps twenty thousand, two hundred thousand, two million . . . impossible, you think? Where will it end? Only God has the answer to that. Those will seem like overwhelming amounts to give at each stage! Tithe anyway.

Tithing will seem risky, and it is a risk easiest taken when all you own is two dollars! Of course, if you have more to tithe, remind yourself that there is no financial venture that offers a safer return. This one guarantees it. Do you want to stagnate or subject yourself to the vagaries of the world's economy? How about transcending them instead with a guaranteed heavenly system that offers unstoppable increase? Seems like a fairly obvious choice, doesn't it?

We forget, deliberately or inadvertently, that tithing is both a command and an opportunity. Yet somehow human nature is supremely clever in justifying lapses in both memory and duty! Tithing is the open door to enter a world so unlike our own—a safe world where we are loved and supernaturally protected. Now instead of striving, we seek, listen, learn, and obey. In return we are coddled, encouraged, inspired, and nursed ever onward to excellence and achievement, all of which, without tithing, are unthinkable in our initial impoverished state and impossible to retain through the trials that will visit us in our lifetime. God's partnership defies trite definition because it is extravagant, affecting aspects of our lives far greater and deeper than mere dollars and cents.

Having tithed now for about a quarter of a century, I can testify honestly that we have never gone without, nor have we gone back to having only a couple of dollars to put into the offering at church. We have weathered some storms but have never succumbed to the temptation to quit tithing; therefore, we always come out ahead.

No system in the world can deliver on a guarantee this true and powerful!

Even so, tithing is only the first step. Equally dynamic is the principle of sowing, adding a further level of excitement to the walk of faith.

Behold the fowls of the air: for they sow not, neither do they reap, nor gather into barns; yet your heavenly Father feedeth them. Are ye not much better than they? —MATTHEW 6:26

Jesus points out the obvious edge we have over the freely soaring birds. They never miss a meal, and although well fed, they don't have the advantage of sowing, reaping, gathering, and increasing. We do. The life Jesus empowers us to live is immensely practical, taking into full consideration all that we may encounter while living it.

While hard work is commended and expected of us, stress and struggle are unnecessary. Like dancers who are energetic, dynamic, and exquisite to behold, moving in breathtaking unison and choreographed perfection, we are to live with verve. When they breathlessly pause, we sense that their graceful and controlled movements have drawn from them every ounce of energy. Yet their exertions are joyful and satisfying, not grievous or burdensome.

Our lives can also fully deplete our energy and yet satiate our longing for fruitfulness. Eating, drinking, and living become rich acts of faith even as we consider that some of the heavenly provision sent to us is seed to sow for our futures. Continual secret sowing will bring continual increase, until the initial seed becomes a foggy memory. There is no turning back.

This is the solution to tackle the greatest fear of a Christian artist. Your living as an artist will be made not by the labor of your hands, your marketing and promoting of your work, your inherent creativity or the lack thereof. Your living will be supplied by your tithing and giving at His bidding. Hidden in the secret handling of your seed in union with God lies the secret to your future.

Sowing humbles me into recognizing the smallness of my role in the process. The seed is not of my making; it comes from God. The carefully prepared soil may reflect my hard work, but when it receives the seed, I am powerless to make it grow. The new shoot, tender and vulnerable, may benefit

from my care and watering, but its very sap contains life that I have no part in creating. Every part of the process thrives only in a dynamic partnership with God.

Keeping the pests at bay and weeding competing nutrient thieves may help the continued growth of my sapling, but I am still powerless to make leaves burst forth. God alone controls the power and life—the sap, leaves, flowers, and eventual fruit.

Yet my role is not insignificant. In fact, without my sowing that seed, there would be no plant at all! The most important lesson I learn is that the harvest is for *me*. God is not going to eat it; He provided it for me. However, it is not only for me, but by its sheer abundance, it is to be shared and spread abroad. Some of it is meant for me to wisely save as seed to sow again for another season in the future.

Artists concerned about making a living have before them a choice. Do they strive, labor, and pursue material prosperity by every means that their minds can concoct, or do they put to practice the biblical principle of tithing, sowing, and obeying God's voice to receive more than enough for all life's needs?

Sowing and reaping is such a relaxed way of living. After softening up the soil, amending it with God's Word, and removing rocks, debris, and weeds that might hinder the growth of the sapling, there is not a whole lot left to do. Germination varies from seed to seed, but it happens in the dark. I dare not lift the seed and examine it to see if that first strong taproot has worked its way into the loamy soil. All I do is enjoy the sunny days and wait, expectantly and watchfully.

Weeding, if done promptly when the first offending shoot breaks the surface of the soil, is a fairly painless task. Some perennial weeds that push through, like resentment, bearing grudges, or nursing bitterness, need to be watchfully uprooted. That done, I wait some more, peacefully, without stress, basking in the certainty that the seed will produce in time. Heaven-sent showers water the ground, the sunshine warms it, and miraculously the seed is producing, unseen to human eyes. Upon maturity, I am thrilled that it does not return to me just one seed for my vigilant yet easy efforts, but

hundreds! Hundreds of seeds to plant, watch, and harvest once more—an exciting cycle of exponential increase!

The Bible promises such abundance if we will just obey and live by its principles. We wallow instead in the mundane. How astute of Jesus to address those specific concerns of humanity which remain unchanged even today! We still fuss about stuff—our clothes, our bodies, our food! Jesus, pointing to the snowy fields of fragrant lilies blanketing the Galilean hillside, declared, "Even Solomon in all his glory was not arrayed like one of these" (Luke 12:27). The flowers neither toil nor create their own clothing; they exist in exquisite beauty because of the Father's creativity and generosity. As long as I persist in trusting the Father for increase, there is no reason for an interruption in the flow of God's resources for every need of mine.

If you believe that you have no seed, then pray for some, since His promise covers that excuse as well:

Now he that ministereth seed to the sower both minister bread for your food, and multiply your seed sown, and increase the fruits of your righteousness; being enriched in every thing to all bountifulness.—2 CORINTHIANS 9:10–11

There is simply no reason not to be abundantly supplied with all that you would ever want for a rich life as an artist. God virtually guarantees it if you take Him at His Word.

Seed is given for sowing and bread for food. If both the seed and the bread are quickly consumed, you face a famine of your own making. But you wouldn't do that, would you? Instead, offer God your best in thanksgiving for the harvest, then set your seed aside for sowing, and finally, joyfully, sit down to feast on your warm, abundant bread.

Redemption's Response Sara Joseph

Small Things

"For who hath despised the day of small things?"

—ZECHARIAH 4:10

REFRAINING FROM UNGODLY LANGUAGE WHEN STEPPING BAREFOOT on Legos has got to be the litmus test for self-control! Wincing in pain, I hobble over to Reuben's desk, littered with my art supplies. I have to hurriedly clear it up before he's back from school. It is disgruntling to work in brief snatches of time. Much energy is wasted setting up and clearing up.

Out on our patio, last year's hanging basket, now taken over by a mourning dove and her mate, is a cozy love nest. She busies herself in it, unhurriedly fluffing this corner and that, anticipation lacing her every move. Someday soon she will hatch her smooth eggs. Standing on a wrought-iron chair gives me a better view into the basket. The lovers have creatively used found material to line the nest: twigs, feathers, leaves, and even some scraps of shiny gift wrap. I wonder if they argue over whether the colors and glitter match the décor of their nest! They are unafraid, flying back and forth in graceful, smooth arcs, comfortable with my scrutiny.

Sighing, I return to clearing up. I work on occasional portrait commissions in Reuben's room. It's a nuisance being extra careful, wiping off spills as soon as they happen. I long for a place of my own—a studio—a nest. Somehow, I think that having such a place would make my existence as an artist legitimate. I begin to pray for one.

Yea, the sparrow hath found an house, and the swallow a nest
for herself, where she may lay her young, even thine altars,
O LORD of hosts, my King, and my God.—PSALM 84:3

There is an apathy that settles in when circumstances are not ideal. I tend to justify laziness because it takes so much additional effort to even get to painting. Jesus patiently encourages me to continue by providing me with deadlines to meet—requests from collectors for new work! I keep creating at a plodding pace—not always, I'm ashamed to admit, because of any inherent sense of mission or direction, but simply because I must. Occasionally I am jolted out of my complacency by a verse I read that urges me to dream, to expect more, and to believe that there are indeed greater things to come.

Sometimes a testimony I hear gets me back on track. This one still inspires me, and I take some artistic liberties (only in descriptive details—the story is true) in its retelling:

Lizzy is incapacitated due to a back injury, confined to her bed and powerless to do much. Eager to do something to obey her Savior's call to spread the gospel to a hurting world, she decides that she is going to find a way to contribute to missions. Making a quilt to sell seems like a good idea, so she spends hours in precise labor, cutting and piecing one together. Finally, her patient labor of love is complete. It is a humble hand stitched work of art, but sadly no one wants to buy it.

Undaunted, she puts it away and reasons that perhaps people are more likely to buy smaller items, like bookmarks. Her busy hands go to work making small fabric bookmarks to sell. She earns herself quite a reputation for her prodigious output and her faithful contributions to various projects in her church with the money that she earns.

Time goes on. Lizzy perseveres, creating bookmarks one at a time and selling them one at a time. A little here and a little there. Every Sunday she always has something for the offering.

One day a preacher from another church, upon hearing about her diligence, decides to visit her. He is eager to meet this remarkable woman who

refuses to allow her circumstances to curb her desire to do her part. During their visit, she mentions the quilt, which he asks to see. Lizzy explains to him that it was her first project, her small beginning. "No one ever wanted to buy it," she tells him, "so you are welcome to have it if you like." The preacher thanks her for her generosity and takes the quilt to show it to his congregation.

On a nondescript Sunday, facing an apathetic church, the preacher tells Lizzy's story to the congregation. In a moving account, he captures her helplessness to serve and her eagerness to make a difference in the kingdom of God.

They listen enrapt. He solemnly paints her disappointment at being unable to sell her quilt. Then he tells them of her accomplishment of creating and selling, at last count, about twenty-seven thousand bookmarks! Sitting in silence, they are convicted by their lack of passion for the same mission, for their squandering resources far greater than Lizzy has ever known. They are moved to action they can scarce comprehend in the moment. With a flourish, the preacher spreads the quilt over the altar for them to see.

It is pieced with simplicity, using ordinary fabric and plain stitches. Coarse textured squares join cheerfully with the soft remnants of clothes which have seen better days. The quilt itself looks like it has taken hours of patient sewing, but it is otherwise unremarkable. No one stirs, each lost in personal regret and guilty thoughts.

Finally, a woman stands up and walks slowly to the altar. Standing silently before the quilt, she pulls out a tightly wadded fistful of money from her purse and places it reverently in its soft folds. Then, like the slow spilling of customers from a restaurant at closing, people begin shuffling out of their pews and emptying their wallets and writing checks. The quilt receives in its warm embrace money, repentance, and the silent resolve of the congregation to aspire to do more with their own lives.

At the conclusion of the service, Lizzy's labor of love has nestled in its folds $100,000, a mind-boggling offering for missions!

Unknown to her and to human eyes, hearts of stone have been mysteriously stirred to action. The timid among the congregation reconsider their

potential. Those who frequently offer glib excuses for their unfruitfulness are compelled to a humble acknowledgment of their complacency and lack of faith.

No one is inherently inconsequential to God, but anyone can be fruitless and thereby inconsequential in effect. God seeks and expects fruit.

A certain man had a fig tree planted in his vineyard; and he came and sought fruit thereon, and found none. Then said he unto the dresser of his vineyard, Behold, these three years I come seeking fruit on this fig tree, and find none: cut it down; why cumbereth it the ground?

And he answering said unto him, Lord, let it alone this year also, till I shall dig about it, and dung it: and if it bear fruit, well: and if not, then after that thou shalt cut it down.—LUKE 13:6–9

If we are blessed with life, we inhabit the ground and are therefore expected to be fruitful. Lizzy expressed profound faith each time she picked up her needle and thread. She trusted that God would answer the cry of her heart to serve. When it appeared as if no one cared about her work, she still trusted that her labor was not in vain.

There is One who cares. He keeps careful account of seeds sown. Her faith did not go unnoticed by Him. Faith never goes unnoticed. It laughs at impossible circumstances, transforming them into triumphs and bearing the recognizable signature of God's goodness. Faith always seems to accomplish this victory far away from human eyes, in silence and with little fanfare. Faith captivates God's attention.

For the eyes of the LORD run to and fro throughout the whole earth, to shew himself strong in the behalf of them whose heart is perfect [complete, safe, peaceful] toward him.
—2 CHRONICLES 16:9

The eyes of the LORD are upon the righteous, and his ears are open unto their cry. (Psalm 34:15)

In a world where we strongly favor and trust our senses, faith does not come easily. Training ourselves to depend less on our senses and more on the promises of God is the only way to walk in continually growing faith.

Knowing these things, I begin to exercise my own fledgling faith. When I trip over a toy car to reach my palette, I thank God for the studio, a nest for my creativity, which He has prepared for me when I am ready. I remind myself that what I see with my physical eyes is not all there is. My faith declares the manifestation of that which I am as yet unable to see.

I begin by not despising the small beginning. You can do the same.

Do you have just a single sheet of notebook paper and a pencil? It is not too little. Begin there, offer it up to God. Value it, because even if it means nothing to another soul, it gains worth through what you do with it. That is your act of faith.

Is the work you do feeble, poor in ability, and amateurish? Do not despair; I've experienced the same frustration. You will improve, if you faint not and persevere.

He will teach, guide, and lead you. If your heart cry is for increase in every aspect of creativity, God promises to hear and grant your request. He seeks fruit; He will empower its production if you get to work by, and in, faith. Faith is meaningless without God and His infinite, unfailing faithfulness. We are bolstered and encouraged by the peace that pervades us when we determine to be unmoved by circumstances that are contrary to the victory we aspire to.

Eventually, we will recognize the unmistakable hand of God bringing forth fruit that we were powerless to create, but for which we eagerly reach in faith. So what is it that you are waiting, trusting, for?

For me, it is the studio—a distant dream that is now suddenly becoming true.

The Seeker, Polymer Clay

A Bruised Reed He Will Not Break, Polymer Clay

Gifts for the King, Polymer Clay

Unshackled, Polymer Clay

Refiner's Fire, Polymer Clay

Affairs of the Heart, Polymer Clay

They that Wait, Acrylic on Yupo

Through the Valley, Watercolor

Cast your Bread Upon the Waters, Mixed Media

His Own, Pen, Ink and Watercolor

First Glimmer, Oil on Linen

Drawing from the Well, Polymer Clay

Hope, Polymer Clay

My Cup Runneth Over, Polymer Clay

Zoe, Polymer Clay

The Studio

I RUN BREATHLESSLY UP THE STAIRS TO ENTER the dimly lit lobby of the Victory Arts Center. I finally have a studio—a space I can call my very own. In this room, with its window overlooking the tops of trees to endless skies beyond, I aim to create art that is worthy of my Father.

Much of my praying, yearning, and even nagging, I'll admit, has brought me this far. This is to be my time, pried out of a cluttered life.

There is no one in sight. Hauling my hastily packed lunch, I walk briskly to the elevator. It comes as no surprise that it is not working. I hear the rhythmic thump of hammers somewhere in the building. I am one of the first occupants; the building is still under construction. The elevator works whenever it pleases.

The Victory Arts Center has an unusual history. She is a beautiful old building that long ago gleamed under the loving care of nuns before she fell into almost inescapable disrepair. Once, the giggling of hundreds of little girls filled her spacious halls. She served as a finishing school for the daughters of cattle barons who owned ranches miles away.

In the years that followed, the wind whistled, bitter and cold, blasting through shattered panes into empty rooms which now only hosted the occasional tramp. Reverent praises to an Eternal God in this once sacred building were replaced by the slurred curses of drunken hobos.

The Lady of Victory Convent building appeared to have a certain appointment with the wrecking ball, except for the creative enterprise of a group of developers eager to restore select old buildings that give the city of Fort Worth its timeless sass. She was spared. Her Gothic charms took almost a decade to restore. Floors were waxed, mosaics patched, windows freshly paned, and rooms meticulously returned to their former warmth and dignity. She arose once more, stately in grace, still hiding within her

walls the secrets of those once full of divine hope and those sadly hopeless. She was now ready for the newly hopeful.

The Victory Arts Center is reborn as a haven for creative people. The developers imagine her charm to be a magnet to draw those with an eye for classic beauty. They envision a community of creative people: artists, writers, poets, musicians, dancers, and actors once again filling her stately spaces with the dynamic energy that she once knew. To sweeten the offer of acquiring one of her airy studios, rent is subsidized and is far less than the norm for a commercial building. That is the bait I eagerly bite. With a deep sense of gratitude to God for leading me here and to BJ for indulging me, I sign the lease that weds me to a studio in this magnificent building for the next two years.

Running up three flights of stairs becomes a predictably familiar routine. The mechanics of the elevator are an unending work in progress. There is a sink in my room for rinsing paint-soaked brushes. It is three flights down if I want to use the restroom, but I am too delighted to complain.

My studio is a large spacious room which, with the help of BJ and the boys, I fill with art supplies retrieved from the attic—some still useful. Others, like dried-up tubes of paint, I leave around to remind me that I am now truly an artist! I schedule a regular time to "work" and attempt to stick to it, despite calls like "Ma, I forgot my science notebook, could you please bring it to school?" BJ and the boys are abruptly forced to take me and my time seriously. It is hard not to balk at the gravity of this decision. What I do with my time at the studio and away from it now becomes vitally important. I have to ensure that my family is not neglected while I spend time in here.

Am I indulging myself, or am I answering the call of God? Did I really hear from God? I wrestle with these questions but remind myself that God has graciously confirmed that I am indeed in the center of His will. Asking yet again seems weak and faithless. I've always felt that Gideon must have tested God's patience with his many requests for proof of God's plan. Yet here I am doing the same!

When the door clicks shut behind me like the last note on a score, I panic. What comes next? What am I doing here? Who do I think I am?

"And Jesus said, Make the men sit down.
Now there was much grass in the place. So the men sat down,
in number about five thousand."—JOHN 6:10

Green

Green pastures as far as the eye can see
Viridian blades in the lazy breeze
I must be seated to receive my fill
Yet I am restless, can't seem to sit still

Voices raised, men jostle to comply
But I must see how, I must know why
This hungry crowd must sit to be fed
No telling how—there's no sight of bread

Gulls soar above, unmoved by our plight
A gnawing hunger turns the meek impolite
Two fish and five loaves are handed to Him
While He waits stalwart on the verdant rim

Below Him slope grassy fields of green
Beyond a sea twinkling aquamarine
Though seated my eyes dart anxiously
From loaves to His face to my hands empty

Only when seated do I look around
At such plenitude in the sweet, green ground
Each blade of grass so unlike the next
Spoken into being by His potent text

Over five thousand are gathered here
Sated somehow with that meager fare
Feasting on plenty our hearts are thrilled
The multiplied bread my hunger stills

When now I see green, olive, or lime,
Emerald and teal or parsley or thyme
Reminded am I, to feast on such plenty
I must remain seated, trusting, and empty

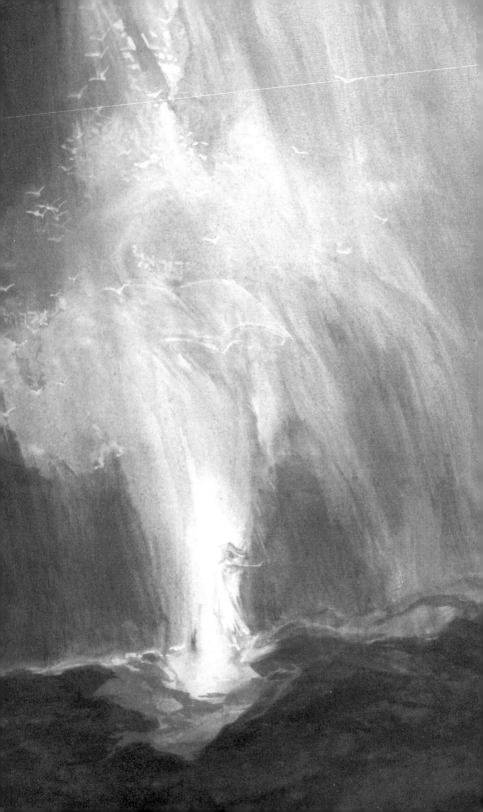

The Precision of Timing

THE WALLS OF THE STUDIO I ONCE YEARNED SO FERVENTLY for now hem me in. Somehow I must justify my presence here. Each passing minute is costing me dearly. Despite knowing that I have God's approval and that He initiated this endeavor, which now seems overwhelmingly bold, I still balk. It was far easier to complain about my less-than-ideal circumstance when this studio was only a prayer! The possibility of renting never crossed my mind then. The Victory Arts Center was brought unexpectedly to my attention. I now dwell in a future that I desired but never quite envisioned in precisely this way.

God places great emphasis on timing. He exists outside time itself, while we are confined by time. He authenticates His presence in human affairs by disclosing events before they unfold. The Bible is full of historically verifiable examples of God stating His timeline and the ensuing events following in obedient precision. Names of kings, wars, battle plans, political events, and the courses of nations are written about as if we are reading the newspapers of the day; yet the time of their writing and when they eventually occurred (or are in some cases are yet to occur) are usually separated by hundreds of years. That they transpired at all, and with such precision, is mind-boggling! His prophets proclaimed the future at His bidding. Their words came to pass in the fullness of time, authenticating God and His omnipotence.

And it came to pass at the end of the four hundred and
*thirty years, **even the selfsame day** it came to pass, that all the*
hosts of the LORD went out from the land of Egypt.
—EXODUS 12:41, EMPHASIS ADDED

Son of man, write thee the name of the day, even of
this same day: *the king of Babylon set himself against*
Jerusalem **this same day.**—EZEKIEL 24:2, EMPHASIS ADDED

Neither Moses nor Ezekiel could have guessed the eventual outcome of the prophecies they gave, far removed in time as they were from their fulfillment, which happened precisely as stated. These are just two Scriptures among scores of others that indicate the precision of God's reckoning of time. The arrival of Jesus as the Messiah was neither too soon nor too late. His return also follows an exact schedule, down to the smallest unit of time. The Bible is replete with examples of timeliness, using words such as "in the process of time," "at the appointed time," "this time," "in time to come," "the time drew nigh" . . .

God also choreographs a rhythm and flow of events in our own lives, regardless of whether they appear to be of major or little significance to us. Without keeping a journal, remarkable patterns are unlikely to emerge. A journal encourages dating each entry. It adds gravity to the day that has been lived. In the simple retelling of the events of the day, each set of twenty-four hours pulsates with life and meaning. Add to that the precious words of a prayer, along with a detailed record of a promise noted by chapter and verse, and my journal becomes an ongoing record of my unique journey with the Lord set squarely in time.

In the past, I never paid much attention to timing in my life. Apparently I am not alone. Jesus is familiar with our disregard for the gravity of the ebb and flow of time. He was acutely conscious of the timeliness of events and circumstances.

Then Jesus said unto them, My time is not yet come:
but your time is always ready.—JOHN 7:6

Whenever I have a decision to make, I pray and seek the Lord about it. Attempting to stay as neutral about the outcome as possible, I wait until I sense His direction and He gives me a promise from the Bible, assuring me of His hand in its outcome. It is a sense of knowing within me that is

not easily explained, yet once you experience it, it is unmistakable. I then date and record the promise. Sometimes answers come swiftly, while at other times, His promise takes years to be fulfilled. When it happens, I am acutely aware of living the answer to a prayer. I date with gratitude its fulfillment, in either my Bible or journal.

Should I rent the studio at the Victory Arts Center? Is this God's will for me at this time, or is the answer still a "not yet," as it has been thus far? On a trip with BJ to Orlando to get away from the familiar, I seek God on this matter. The timing for renting could not be worse. Other priorities ought to take precedence over spending time alone in a studio, creating art for an audience I have yet to define. It somehow seems so self-indulgent.

I pray and listen, hoping for the relief of hearing that it is still not my time rather than the prompt to rent. Instead of a feeling of peace, I grow restless, sensing a difference in the season, yet I have no confirming word.

A week goes by. On the day before returning to Fort Worth, I read journal entries from the past. One in particular, dated October 1989, catches my attention. On that day I decided to ask God for the empowering of the Holy Spirit specifically for art, conscious that without it I was limited by my own inadequacy. I asked confidently, knowing that His help formed part of God's expressed will for me. There is a date by that entry and the promise that "all things, whatsoever ye shall ask in prayer, believing, ye shall receive" (Matthew 21:22).

I expected to find myself swiftly growing in this new anointing, full of great expectations of God and of myself. Yet time passed with little noticeable growth, at least in my cursory assessment. The graphite faded in my Bible; the promise was forgotten and the journal entry set aside.

There is another entry precisely seven years later, when I began figurative sculpture in clay. I noticed with interest that seven is always the number of completion in the Bible. The doors of a thrilling world, undiscovered until then, were suddenly flung wide open with my exposure to this new medium of expression. I reveled in that discovery.

Now, years later, in my hotel room in Orlando with a warm mug of coffee, I reread those journal entries and then pick up my Bible. I yearn for specific direction. Is this timing of my own making, I ask, or is it His? My reading for

the day is the account of Joseph from Genesis. The words leap off the page. I read, "And Joseph was thirty years old when he stood before Pharaoh king of Egypt [or entered the King's service]. And Joseph went out from the presence of Pharaoh, and went throughout all the land of Egypt" (Genesis 41:46).

Why is this important? I am not thirty. I sense a gentle prompting within me to count. Thirteen years had passed from when seventeen-year-old Joseph had his first God-given dreams to when he entered the service of the pharaoh in a position of power and influence. The scope of his dreams was grander than Joseph could have grasped, resulting ultimately in rescuing his family and culminating in the birth of a nation. In stark contrast stood the thirteen intervening years that must have seemed to drag on endlessly, replete with trials, disappointments, and what must have seemed like the repeated demise of those very dreams. Young Joseph surely expected the fulfillment of his dreams, if not immediately, at least in the imminent future—certainly not thirteen long years later!

I mull it over . . . thirteen harrowing years of horrific circumstances when the dream seemed remote. His tenacious faith kept those dreams from fading with each passing year. Did he wonder if they had merely been a figment of his imagination?

Joseph somehow trusted God. He submitted to circumstances which appeared to have no bearing on his magnificent dreams. His hopes must have seemed so absurdly removed from the harsh reality of his daily experiences. Did the years run together, filled with sadness and an irretrievable sense of loss? He appeared to lose his family, his cherished social position, and his dreams.

Nothing negative is written in the biblical record about Joseph. His steadfast faith found favor with God, who rewarded him by recovering all that seemed lost and blessed him with more than he could ever have imagined. Those bleak years developed in Joseph the ability to correctly handle God's reward. God's generous purposes usually include more than just the person who chooses to trust Him. The faithfulness of one person, like tossing a pebble into a placid lake, can spread ever outward to shores unknown.

Hebrews 11:6 tells us, "But without faith it is impossible to please him:

for he that cometh to God must believe that he is, and that he is a rewarder of them that diligently seek him." Then surely with faith, it is reasonable to conclude that we can truly please God. Seeking Him is never in vain. Did Joseph lose track of time? I wonder. God certainly did not.

"Count your years," I hear unexpectedly, not audibly, but from the quiet voice within. I prayed for the anointing of creativity in October 1989. In hushed awe, I count: it has been thirteen years from that very month, from my first prayer concerning art. It is my time—my season for what seemed only a dream to finally come to pass! I am about to enter the service of the King of Kings. I'm stepping into a new season; I sense it in the precision of His timing and His prompting. It may even be to the very day—I'll never know, because I didn't bother to be precise with the first entry, penciling in only the month and the year.

What does it mean to enter into His service? I don't have a clue, other than the certainty that it will be a fantastic, rewarding adventure.

Upstairs in my new studio, I am confident of nothing more than the perfection of the timing. Yet I am not immune to worrying about what to do once I close the studio door to the outside world and find myself alone with God and my art! His promise reassures me: "Come ye near unto me, hear ye this; I have not spoken in secret from the beginning; from the time that it was, there am I" (Isaiah 48:16). He will be present, and His presence is all I need. He has thought of everything!

I clear the soil piled haphazardly over my art aspirations, remove the debris of past failures, till and amend the soil with hope and faith, and then carefully plant my fig tree. My earnest labor is concluded, at least for the moment. I watch and wait in faith. He will grow it cell by cell. Someday soon, since He is faithful to His Word, if I stay true I'll be feasting on ripe, sweet figs. I'll share them with you and others.

It will come as no surprise to me if that "someday," is a very specific day, a precise number of years from today, in the fullness of His time completed with mathematical precision to the very day.

It will be a "someday" of His choosing, and I can hardly wait for its fulfillment. What joy!

What Is Christian Art?

I COULD PRETEND THAT I PONDER THIS QUESTION DEEPLY at the studio and come up with an apt answer. But I would be lying.

The truth is that I am hurled into this new turn of events. There is little time to think. Days are rushed, lunches packed, laundry done, children driven to school, and all followed by a dash to the studio. There, time stands still and yet time flies, followed by more driving to after-school activities, dinner, helping with homework, preparing for the next day, and then dropping into a sweet, dreamless sleep which folds seamlessly over into another morning.

In the studio, I take a deep breath, slow my frantic pace, read a little from the Bible, turn on some music, and sit. Whenever I feel panic well up in me, I take a piece of clay and mindlessly squish it, or brush some paint onto paper and wait. Invariably, thoughts of the day come rushing in. Prayers that are simply "Lord, help!" work themselves into the clay or paper. Ideas form in my mind, half-baked and vague, like sentences without endings or phrases missing words. My most urgent concern is expressed in shape, color, or form. Like a prayer, it flows from within, a conversation with the Father. *If I were to say this in clay or paint, how would I do it?* I ask myself. *Is there a way to say this differently, or better?*

I don't attempt to illustrate the Bible. Plenty of art has done that effectively over the years. Works of art attempting to recreate scenes from the Bible, inspired by research as well as the imagination of the artist, abound. Some of it is fabulous, some mind-numbingly trite; other pieces are excessively simplified and used as clip art in Sunday school books and greeting cards. I have no desire to add to that.

Instead, as the swelling strains of Mozart's Mass in C transform my studio into holy ground, my fingers press into soft clay, soaring with the music, filled with praise, unable to contain it, shaping, correcting, and

forming until something suggests itself. I play with it until it arrives at some satisfactory stopping place.

These are my conversations with God. I feel the liberty to explore— no emotion or subject is off limits. I can take everything to the Father in prayer. These are my prayers. On some days, I enter the dialog angry or resentful about something and conclude with repentance; at other times I begin restless and end in peace. The studio is a happy place; God is always present, at my invitation.

My time in this holy place is never dull, but neither is it without some struggle. Working my way through conflicting emotions to where God leads me sometimes takes a while. Most of the time, I simply enjoy the thrill of His creation, responding to the exquisite beauty of the world around me. Light, shadows, color, shape, and design all take on an aura of sumptuousness and grow heavy with meaning as I view them through the prism of my relationship with Jesus.

There is little opportunity to take myself too seriously. I laugh often at my silly mistakes; grimace at polymer clay work that I burn to a bubbly, noxious crisp in the oven; groan at entire passages of oil paint that I accidentally wipe off a canvas because of my clumsiness . . .

Eventually, I conclude that Christian art is more than art that illustrates the Bible. It is also more than art that illustrates biblical principles. Much of my art does the latter. Surely then, Christian art must be authentic, honest, and uncompromised, flowing from my spirit, where Jesus dwells. I surmise that it is art created by a Christian who lives fully and translates that earthy, sometimes painful human experience with all its chaos and triumph into tactile, sensory media, but who does that by the empowering of the Holy Spirit who dwells within.

Contemporary artists thrive by creating art as social commentary. I read with horror of an artist at an Ivy League college presenting what she considers her relevant contemporary "performance art." She videotapes herself being artificially inseminated, inducing an abortion, cramping, and eventually losing her unborn children. Not once, but repeatedly. This is the "art" of the times, exposing our raw humanity in all its ugliness. This "art" is

commended enough to enjoy an elite audience who either agree with the artist or are sufficiently intrigued (or duped!) to support this abomination. Other artists grimly describe our fallen state, creating art that graphically describes emotions like despair, loneliness, and futility. If authentic art flowing from within is an expression of the artist's reality, and if the artist knows no other reality, then vividly expressing his or her hopeless condition is at least an honestly valid reason for engaging in the making of art. Perhaps, for just such a reason, it is worth exploring. After all, grief, sorrow, pain, and loneliness are universal emotions. However, such explorations offer little hope unless they draw the artist in the pursuit of that which is lacking.

The Christian artist, on the other hand, can express both sides of the human experience, simply because we have firsthand experience. We know our meager and limited reality before we knew God and the joy and delight of now belonging to Him. We understand crushing defeat and impossible victory, overwhelming sorrow and irrepressible joy, desperation and quiet satisfaction, brokenness and wholeness, loneliness and completion. Artists who are still without Him cannot grasp what we know deep in the core of our beings—the sufficiency of Jesus for every earthly lack and loss. None of us experiences it all. We only live out some of it. We have been rescued from specific trials, freed from different chains, and loosed from unique prisons; therefore, we comprehend more than those who have never experienced His resurrection power.

Each victory is an experience begging for expression in acrylic, clay, watercolors, oils, or other creative media. Each journey searching for that victory is also kindling for expression. Every trial and challenge, every lesson learned—all of it carries the kernels of abstract, symbolic, or literal expression. Even so, these experiences remain only a small fragment of all that Christian art can be.

Most of the artists I know predominantly concern themselves with the visual, studying to capture an accurate depiction of the world that is before them, neither seeking nor attributing any further meaning to their subjects. Uninterested in symbolism or expressing life's experiences, they delight in becoming masters of light, color, design, and shape simply as elements of an ongoing quest for beauty. This too is valid and a worthy pursuit.

However, could a Christian artist not employ this very passion for excellence in the depiction of beauty and pursue it further? Could it not also be a tool for expressing our tangible witness of God's magnificence and our joyful praise? Could it not also be a means of tasting and testing unexplored arenas of faith, documenting our journey and celebrating our triumphs? What about creating Christian art that is an awestruck response to the beauty and creativity of the One we call "Father"? The more I explore, the more expansive the possibilities appear, stretching ever outward.

I am eventually convinced that Christian art is not some minor subset of art, some fad, outcaste, or art movement like impressionism, fauvism, or cubism. Instead, it is the totality of all that art is meant to be, finding its complete expression only in Christ and only with His resources: spiritual and material.

There is no room then for imitating another. The creation of art for the Christian artist is a unique expression lived out in tactile media, authentic only if lived out honestly. The desperate search for a style is unnecessary. We already are "fearfully and wonderfully made" (Psalm 139:14), unique in every way. If we do not compromise by slavishly imitating others, chasing trends, mindlessly copying fads, or scrambling to use whatever means necessary to make a sale, our work will be fresh and authentic.

Then, regardless of whether or not our art has an earthly audience, heaven will surely applaud! That kind of art possesses at its very core the divine pulse of truth, bearing resemblance to the nature of the One who calls Himself the Way, the Truth, and the Life.

drawing from the well

Tara Varga

Persevering

NERVOUSLY STEPPING INTO THIS NEW SEASON in my studio, I pray, "Father, if I run out of resources or ideas, I will be glad to resume my previous role of mother and homemaker." That role has fit me thus far like a snug pair of old jeans, safe and familiar; to return to it would be a relief.

My prayer is not unique; others have prayed the same. A giant of the faith, Smith Wigglesworth, is reported to have prayed, "The first time my shoes are down at the heel, or my britches need a patch, I shall go back to my business!"[5] A simple, unschooled plumber, he heard and obeyed God's call on his life as an evangelist, and he lived an incredibly fruitful life. This man of God never returned to his plumbing business, finding Jesus more than sufficient for every need in his personal life and ministry. He stirred the faith of many worldwide in the early 1900s and still continues to inspire many through books that bear his testimony.

I trust God for my supplies. I've never run out, but it has been quite the walk of faith. Determining to trust Him is a whole lot easier than living it out, especially when things don't always go as anticipated. The process of waiting patiently is one that I have yet to master. There was a challenging season once when all that remained was blue and white clay. I had my "blue" period, much like Picasso—not by choice, but rather by circumstance! Yet, my supplies have never dwindled to nothing. Somehow just when I run low, I sell something or win an art competition. I can never quite anticipate how He will do it, but I can count on the fact that He will always supply.

Even in the realm of ideas, I am helplessly conscious of my limitations. In my conversations with the Lord, I make certain He knows that without new

5 Albert Hibbert, *Smith Wigglesworth, The Secret of His Power* (Tulsa, OK: Harrison House, 1982), 23

and exciting ideas, I'll repeat myself in art ad nauseam! I trust Him to make up for even that deficiency, considering it His responsibility to keep me fresh in my art. I find myself abundantly rewarded as I stay faithful to persist in my calling. Ideas flow, each one with shiny potential for the next, and the next . . .

Noah's story encourages me. Despite the contempt directed at those who are simple enough to believe the biblical account of the flood, there is serious ongoing scientific and archaeological inquiry into its veracity. I consider it a credible event for just one reason—Jesus verified it, saying,

> *And as it was in the days of Noe, so shall it be also in the days of the Son of man. They did eat, they drank, they married wives, they were given in marriage, until the day that Noe entered into the ark, and the flood came, and destroyed them all.*—LUKE 17:26

That settles the debate within me. Thus far He has given me no reason to doubt Him or His Word. If Jesus spoke of the flood as a historical event, then it is not a myth. So with that settled, what possible lessons can we learn from Noah's ark project that will benefit us as Christian artists?

Building the ark was a challenging architectural endeavor for the times, with some very strict guidelines and requirements. Noah was no stranger to the voice of God. He possessed the sensitivity to listen and receive complex instructions for this mammoth project. God also considered him worthy of a partnership because of his righteousness. That seems to be a requirement for any joint venture with Him! None of us would qualify except for the sacrifice of Jesus, which bequeaths us with "the righteousness of God in Christ" (Philippians 3:9).

Noah exhibited implicit trust that God would provide him with enormous amounts of material for building the ark. There is no account of his arguing with God about where all his supplies were going to come from. I gather that they were simply made available as and when he needed them. Had provision presented a challenge, I doubt that it would have been excluded from the account.

There is no clear statement on how long it took to build Noah's ark, yet it is possible to make an educated guess. Noah was five hundred years old when he is first mentioned and six hundred at the time of the flood. So at a maximum, the ark took a hundred years of dedicated labor to build.

Interestingly enough, Noah's name means "comfort." His calling was to demonstrate the extension of God's comfort of redemption to a world gone foul with sin. His one-hundred-year project was performance art at its best. With every blow of the hammer, he proclaimed one message: "Repent before the coming flood." His hard labor was undoubtedly met with ridicule, or there would have been more people in the ark with him—or perhaps no flood at all.

God was specific with Noah; I can expect Him to be specific with me. Like Noah, I refuse to be daunted by the scope of God's call. If God could bring the animals to the ark and provide every scrap of wood and bucket of pitch, then He can supply me with ideas and tangible material resources as the need arises for whatever purposes He has foreordained. I commit myself to get busy with the task like Noah did, conscious that it will involve strenuous effort. There is a powerful momentum that gathers strength with each action, no matter how seemingly insignificant, if I choose to stay true to the mission that God has called me to.

There is much inconsistency in the world of art. Artists chase trends and fads with the intention of staying current, popular, and relevant as they perceive it. But Noah didn't stop building his ark after fifty years and then decide that for the next fifty years a lookout tower was a more relevant project! His message never changed, and his work never lost fervor or urgency. He refused to be swayed from his objective. The world had not yet experienced any flood, let alone one of such magnitude! Noah could not have grasped the full implications of his own warning, much like us. Jesus will return, and not as a vulnerable infant this time. The flood came right on cue when the countdown ended! We too await a flood of judgment, not by water this time, but by fire and the presence of God.

Although each day with its sunrise and sunset seems the same, as it must have in Noah's day, time is racing toward a collision with eternity. And for

each of us personally, there will be a final completion to our artistic endeavors and our earthly journey. Then will come the testing of the fruit of our labor. God summoned Noah as He summons you and me. He provides the plan, yet we must seek it out. Scripture records that He also had the final word. It was God who closed the door of Noah's ark, completing the work!

On that final day, when I stand before Him, may the record show that I too was like Noah, of whom it is said that he "did according unto all that the Lord commanded him" (Genesis 7:5). To that end I strive with all that I am and all that He has blessed me with. Won't you do the same?

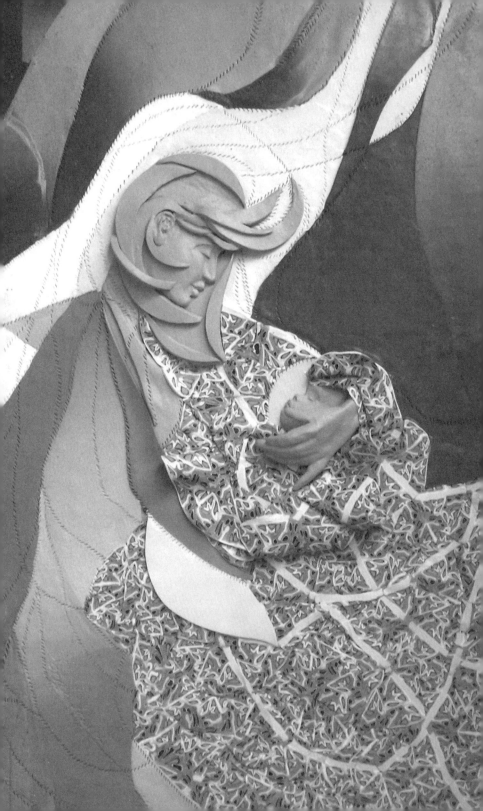

EPT: Early Pregnancy Test

I REMEMBER WHEN BJ STOOD SILHOUETTED against the window, squinting at the narrow plastic strip in his hand. A little cross on one end glowed bravely red, confirming what I had known all along—I was pregnant! The test was more for him than for me. Change had begun in my body, and I sensed it with every fiber of my being.

It may surprise you to know that there is a test, like an EPT test with its skinny strip sporting a positive and negative sign on either end of it, which confirms matters of faith. As a consistently accurate assessment of where I truly stand on everything, especially spiritual matters, this test is foolproof.

What test am I speaking of? It is the words that come out of my mouth. They betray me far more than I realize and are an accurate reflection of my heart, mirroring with outstanding precision exactly what I believe as opposed to what I *think* I believe!

Words that flow ceaselessly without much forethought are powerful. They either confirm or negate spiritual realities in our lives. Words, to which I once didn't pay much attention, are like dynamite: seemingly harmless and yet with the ability to transform the tangible landscape around us either favorably or with sorry consequences. We know that words can amuse, inspire, incite, wound, or heal. Yet that list only captures a fragment of their power.

God taught me that words also have the power to shape my future. If I want my tomorrows to be different from today, then I must apply my words with the precision and deliberation with which I apply paint to a work in progress. This principle may seem absurd, but I can demonstrate that it is sound. As a Christian artist, if you determine to master this principle, you are guaranteed the kind of success that only God can impart.

"I am pregnant!" I joyfully proclaim to the world. There is no outward indication of it besides the little red positive cross indicator on the EPT

strip. My stomach is taut and flat, betraying no visible sign of cells multiplying at a furious rate, taking on the form, personality, and characteristics of my soon-to-be firstborn son, Johann. My words excitedly state this event as a factual reality to anyone who cares to listen. Yet it is a reality that will only manifest nine long months later.

God's promises begin as words for my mouth with the power to birth a future totally unlike my present reality. He stands as the guarantor of the things promised, but only if I believe and continue to believe until they manifest. Resolutely believing without wavering, despite all evidence to the contrary, manifests the promise.

Strangely enough, the best indicator of whether I truly believe is what I say—not in prayer, but at other times when my circumstances don't bear the faintest resemblance to the fulfillment of the promise.

Proudly sporting the maternal label, I am now an "expectant" mother. Every act is colored by that thrilling fact, from the foods I choose to eat or eliminate from my diet to the amount of rest I treat myself to each day to the clothes I acquire. Yet all I have as proof this far is a little red cross, a slowly swelling belly, and a few other incidental symptoms. Without the confirming test, I could easily assume that I was merely gaining useless weight. My faith is based on the test and the collective wisdom of generations of pregnant women and their described symptoms. There is nothing that can shake my conviction of the impending arrival of my baby. My mouth never betrays me. It would be inconceivable to say, "*If* I have a baby . . ."

Jesus promises us that "What things so ever ye desire, when ye pray, believe that ye receive them, and ye shall have them" (Mark 11:23). I ask God for many things all the time. For example, wisdom is a frequent request. When I pray, I don't doubt that God has heard my prayer. According to the Scripture, I am to believe and then receive, or take (which is a more precise meaning, in Greek, of the word translated "receive") what I've asked for.

Yet, in the moment of prayer, I experience nothing and have no sense of being any wiser, or smarter, than when I first asked. Although I do believe God, I find myself asking others to pray for me. I talk as if the required

wisdom is something that God *may* bestow on me in the future, if I ask Him often enough or have other people ask for me as well. Words slip out like, "I don't have a clue about how to do it" or "I am really not that smart" or "Please pray that I'll know what to do." These words of my mouth expose my skepticism. Yet if you ask me if I believe the promise, I will passionately affirm that I do. Christians do this all the time, fervently affirming that they believe God yet in their casual speech confirming that they are far from taking Him at His Word. I am no different. My words don't merely indict me; they erect an impenetrable barrier around my eagerly coveted promise, keeping me from ever enjoying it. That may sound harsh, but the Bible states that no outcome is all I can expect:

> *But let him ask in faith, nothing wavering. For he that wavereth is like a wave of the sea driven with the wind and tossed. For let not that man think that he shall receive any thing of the Lord.*—JAMES 1:6.7

I am now overwhelmingly conscious of the words I permit to leave my mouth. It never ceases to amaze me how fickle I really am! God's promises are believed with passion one moment and just a short while later completely negated by what I say, which of course stems from what I truly believe. For one as chatty as I am, I quickly discover that it is safer to say less! If I refrain from speaking too much, I have less to regret and less to correct.

So how are we to speak? If what I pray for is granted the instant I believe it, then it is mine whether I perceive it right now as a tangible reality or not. If that is so, then isn't thanksgiving to a great and generous God for hearing my prayer and granting my request the *only* appropriate response?

It's not really a whole lot removed from telling the world that I am pregnant. Every mother-to-be makes that declaration in a tense that defies definition—present continuous stretching into a happy future and assuming the reality of a lively bundle of joy as its ultimate reward. No one expects the baby right away. The sense of expectancy is not considered odd, as it often is when we declare answered prayer as fact when there is no evidence of it.

I used to balk at speaking as if my requests were already granted when everything seemed to scream that it was not so. It somehow felt false. Yet God showed me that those words spoken in agreement with His promise, in the past tense as if it were already granted, affirm my faith in His Word far more than any other form of piety. His words are truth that supersedes physical reality. When spoken in faith, they are containers of power that take from the spiritual world and manifest into our material world the very things that we are praying for.

Respect for others is best demonstrated by simply taking them at their word. So my words spoken in faith, affirming God's promise rather than my currently viewable circumstances, honor Him and unfailingly manifest my answer.

Praying over and over for the same issue, asking others to join with me, begging God with tears . . . these are actions that may appear pious, yet they betray my skepticism and a dependence on my natural assessment of the challenge rather than faith in an already stated promise of God. At the root of such religiosity is the stubborn refusal to take God at His Word and believe His many wonderful promises, which cover, provide for, and reverse just about every issue of need common to man.

The simplicity of trusting Him is only authentic when my speech backs it up. This, I discover, is where the battle is decisively won or hopelessly lost. I must only speak words that affirm that my prayers have been answered as promised. Contrary words are to be swiftly and decisively reined in. When the answer takes considerable time before being made manifest, it proves to be a test of discipline that is certainly not for the wimp but for the stubbornly persistent. Thankfully, faith has a way of snowballing. Choosing to remain unmoved by contrary circumstances, while a Herculean act of faith at first, usually develops a momentum of its own as the Holy Spirit empowers me to stay true.

Even so, I cannot pretend that practicing this has been anything short of overwhelmingly challenging. My mouth is consistently rebellious, wanting to whine, moan, mumble, complain, find fault, wallow in misery, and state every challenge and obstacle. When I decide to just shut up, like any

addict I experience severe withdrawal symptoms, finding it an excruciatingly painful exercise. Yet slowly I gain ground and see the fruit of my carefully spoken words in the results—predictable answers to prayers. I discipline my mouth to speak only the faith-filled words of God's specific promises to me. What happens as a result often leaves me speechless with gratitude! I enjoy tangible, specific answers to my prayers which cannot be dismissed as inevitable or freak coincidences. I know that they were birthed in the face of impossible odds.

Thank You, God, for always providing me with all that I need as and when I need it is a frequent prayer of mine, based on Philippians 4:19: "My God shall supply all your need according to his riches in glory by Christ Jesus." When I am asked, "Can you have two large canvases ready for a show next month?", I may respond, "Yes, I can," as I sense that God desires me to do so, even while my mind struggles with how to accomplish it. I may be low on time or supplies, yet thanking God for foreseeing my need and providing for me miraculously reaches into the spiritual realm for the provision and makes it mine. God is always faithful to His Word to perform it. Carefully studying His words, making them mine, speaking His promises repeatedly in faith, and reining in other contrary words with deliberation and precision, will require a lifetime of practice.

Yet I can attest to the fact that with each victory won, it becomes just a little bit easier. I struggle less. The gap between the words spoken and the answer received also narrows. Each answer builds in me an unshakable confidence in the power of the promises in the Bible and the faithfulness of God who honors them when I do my part to believe.

*"Study to shew thyself approved unto God,
a workman that needeth not to be ashamed, rightly dividing
the word of truth."* —2 TIMOTHY 2:15

Study to Shew Thyself Approved

*Words flow in ceaseless, furious streams
In currents, eddies, gullies, and dreams
Gushing, urgent, in rapid excess
Boasting and bragging, but not to bless*

*Strain the dross examine the rest
Cherish the pure and speak it best*

*Study to show thyself approved
Vain or empty words removed
Words of power don't dare ignore
From the Book to sieve and store*

*Study to learn, then apply to grow
Your words matter more than you can know*

When I was pregnant, I saw pregnant women everywhere I looked. The whole world seemed to have become pregnant with me! Now I am acutely conscious of the words spoken all around me. Having experienced the power of consistently wielding God's Word from my mouth, I have become conscious of its potential to reverse hopeless circumstances. Sadly, I also witness the devastation of negative words spoken. When I hear people mindlessly slinging words about, I cringe, certain that they would never do so if they only knew.

For a long time whenever I spoke about my art, I would say, "I am the quintessential starving artist!" and then joke about BJ being my "Theo." For those of you who are unfamiliar with Theo, he was the generous brother of Vincent Van Gogh. Theo supported Vincent by providing him with a continual supply of canvases and paints. Vincent's "Dear Theo" letters of requests for supplies are now famous as a poignant reminder of both the tender bond of brotherhood and Vincent's unrelenting poverty and help-lessness. Theo kept him sane and producing art when Vincent did not have the means to do either. History records Vincent's dismal circumstances, making him the best poster boy for the label of "starving artist."

I recoil now at having been so foolish as to repeatedly apply that label to myself, but I knew no better. It was an excuse, a cloak behind which I hid. If no one had any expectations of me rising above that label, then I had none either. True, they were words spoken in jest; I really was not starving at all. But that was only because of the grace of God! His kindness eventually exposed the folly of poor speech and the power of speaking His Word instead. His intent was never for me to be a starving artist, but a prosperous one. His words consistently spoken by my mouth carry the power to manifest that reality. This is a consistent spiritual law. No one is to be my "Theo" but God. He will keep me abundantly supplied, no matter how much, or how often, my earthly circumstances may change. I take Him at His Word, thanking Him often for my prosperity. I guard my lips from contradicting myself.

I'll admit that this discipline is a constant challenge, not because I am poor, but because of a persistent, foolish habit of joking about art that I am trying to kick. I tend to treat conversations about my pursuit of art with a

levity that cloaks the seriousness with which I truly view it. I find it uncomfortable to reveal much, simply because it exposes the very heart of who I am. It is equally unsettling to write this book. I do it in obedience.

I am truly thriving, more alive with each passing day than ever before, only because of the vitality of my relationship with Jesus. Mine is not merely a prosperity in worldly riches, although that is certainly included, but the ability to enjoy His blessing in numerous areas of life that I had never considered before. I abound in a wealth of experiences, relationships, and friendships; in insight, understanding, and peace; in a wealth of joyful moments and opportunities for influence; in health, energy, time, efficiency, and favor. I acknowledge, with gratitude, that this experience of wealth is included in His covenant, not just for the distant heavenly future, but also to be enjoyed here and now. He purchased it for me at such great cost and so faithfully watches over enforcing its terms that to deny any aspect of it is to dishonor Him and His gift. I discipline myself to not only expect prosperity, but to demonstrate my expectancy by speaking it. All of my expectation can be yours too, if you also choose to trust Him.

"But thou shalt remember the LORD thy God: for it is he that giveth thee power to get wealth, that he may establish his covenant which he sware unto thy fathers, as it is this day."
—DEUTERONOMY 8:18

"A man shall be satisfied with good by the fruit of his mouth."—PROVERBS 12:14

The Sower

My lips can bear the fruit of good things
That satisfy and make my heart sing
Or heinously evil, mouthing sinful talk
A potent choice that makes me balk

That my words so uncaringly spoken
Cruel or thoughtless, are a mere token
Of hidden power, bearing seed
Able to affect my thought and deed

I desire a garden, yet heedlessly toss
Seeds of tares, dry and thorny weeds
Then stand surprised at my dismal loss
Why seek not then for the best seed?

Prepare the soil and sow with care
Remove from my lips the reckless air
Of unheeding speech and sinful talk
Then eagerly expect the fruitful stalk

The Word divine is the choicest seed
My harvest sure, my seed increased
Promises sworn by my great Creator
For today, tomorrow, and forever

So boldly now my lips declare,
"Of the King Immortal, I am an heir
I can do all things, He strengthens me
For He'll never leave nor forsake me."

This then the garden I long to grow
To share His abundance with all I know
Of luscious fruit and fragrant bloom
As for a great harvest, I'll make room.

The Final Wash

A FINAL WASH OF TRANSPARENT COLOR FLOATS over the painting, tinting it daintily, completing it like the last trailing note of a symphony. It unifies the whole, tying all the colors together by a thin veil into a cohesive visual statement.

I've had to carefully choose what to include in this book. God has been so gracious, and I've experienced much that I know has borne His fingerprint, but not every experience specifically pertains to this testimony of understanding and walking out my destiny as an artist. I've had to be judicious in my selection. There have been struggles that I could have dwelt on, but I chose to avoid them—not to deny them, but rather because I overcame them by practicing all that I have already written about: by believing God's promises, receiving (taking) them, and unwaveringly speaking them into existence.

I've experienced the loneliness of exhibiting art in hostile environments only to be strengthened and emboldened by Jesus with a stubborn persistence to simply endure. I've been more than adequately compensated for my discomfort by His sweet presence. Learning not to look for affirmation from others has been slow going. Yet when I wane, He unfailingly sends me encouragement like a breath of fresh air.

Like a painting that is almost complete, only lacking that final wash, perhaps my account thus far has only brought you to the threshold of daring to trust Him with your future.

This then is my final wash.

Living as a Christian artist in the way that I've described is a worthy adventure. It will engage you completely, yet fruitfully. With each passing year, instead of being spent, you will be renewed and energized. Too numerous to recount are the instances that can only be described as divine appointments.

Whenever they happen, I understand another aspect of my mission as an artist in His service. Yet I sense I have only scratched the surface.

Art encourages, elevates, inspires, and educates. I have found that in God's service it does more; it gives me an opportunity to touch hearts and minds in unpredictable ways. How else can you explain the comfort that one of my sculptures brought someone whose wife had just miscarried? It eludes a simple explanation. I have stood mutely overwhelmed while a woman who was a complete stranger embraced me in tears, thanking me for another work which "spoke" to her. I neither understood the tears nor the embrace. That work of art was my conversation with God. He had rewarded me long before she took the work home. It was, and still is, more than I could grasp.

These and numerous other similar responses to my art were not for technical skill or ability. My work frequently elicits an inexplicable response, not because it is so remarkable, but because it somehow sparks either a yearning for or a touch of the divine in someone God has specifically intended it for. I know that for this I have been created. Each event, full of grave import, feels as if something ordained eons ago has been satisfactorily concluded. They are "God moments," as my Christian friends love to say, moments when the presence and joy of the Father are acutely felt. Once tasted, like an addict, I crave them more and more. Yet they occur on a timetable not of my making, but rather of His. Their savor is the incentive that keeps me pressing in for more.

One such event gave me a taste of another dimension of this sacred calling as a Christian artist. It is so unusual that I debated long before choosing to include it here. I do so because it touches on facets of possibility that I don't yet grasp but which beckon me like mysterious distant shores viewed blurrily through a mist.

Late one Saturday evening at the conclusion of an eventful conference where I had a booth displaying my art, I had an unforgettable, indescribable encounter with a woman named Althea, her sister, and her best friend. They were strangers to me, and I may never meet them again. They stood silently in tears before a painting I had painted earlier in the year. As I

walked over and began to talk to them, I became acutely conscious of the presence of God like I never had before. They asked me to tell them about the painting, and I could barely get the words out—God's presence was so tangible. Hard as it is to describe, I testify that what I write is no exaggeration but the truth. I am all too conscious that I will have to answer to God if I embellish anything in my written account!

In the magical moments of that encounter, I gathered that I had painted a vision God had given Althea one dark night in a season of her deepest sorrow. Somehow, in unbelievable detail of symbolism, color, and visual imagery, I had captured what she had seen when in an instant God comforted her and reassured her of His blessing in the dark of night. She shared the experience with her best friend and sister. Months later they stood before my painting as mute witnesses to what she had once described to them in minute detail!

Her e-mail to me much later may better capture the incredible beauty and mystery of what happened:

> Last year, just about this time in late September, I was in deep grief over the death of my husband, Timothy. He died on May 16, 2011, from a stroke he had on December 15 from which he never fully recovered. We had been married for thirty-four years; he was everything to me. His birthday was on September 9 and mine on October 22. I remember how sad I was for his birthday, and now mine was approaching without him to celebrate it with me. Not only had I lost my best friend, but I had also suffered great financial loss. I was not feeling real good about turning fifty-five years old. Then the Lord, who carried me through this whole ordeal as only He could, spoke to me. Things got a little tougher; I lost my home and my job. I am also an event planner/decorator, and my business had dropped off. The Lord is my strength and I am a fighter, but this season of my life was the hardest and darkest I ever had to go through. I cannot say that I ever felt abandoned by God, because I did not. He always

kept wiping away my tears and telling me to look up and move forward.

Then in January 2012, I began to wake up between 3:00 and 6:00 a.m. I thought at first that it must be menopause (smile). Then of course, I realized that it was God. So I began to journal what He was showing me. This happened continuously from January through April. These experiences with God began to change my life.

On one such night, she saw the vision that I had painted.

In her letter, Althea went on to describe the details of her vision and the circumstances that preceded her coming to the conference and finding my painting. The details I had unknowingly included in the painting were remarkable. "How could you have known to paint this?" she asked me. I had no answers, only a sense of awe at what had happened. Somehow, well before the actual event, on an ordinary day in my studio, I had painted a painting that captured a vision which would only be given to comfort and encourage a grieving widow months later!

"He used you to show me the season that I had been in and that He was bringing me out," Althea said. There was so much more in the e-mail, details that boggle my mind. In a crazy jumble of time and circumstance, God in His precise and inimitable way made perfectly sure that the events surrounding the whole episode were so unarguably impossible that never again would either of us question His love and care for us. He assured Althea that she was not forgotten, that her future was still in His hands and that it was blessed. Strangely enough, He also satisfied my deep need and hunger for significance for the art I create with my limited skill and ability. "If you have ever doubted that your work is a ministry," she wrote, "please know that it is." I was unaware of the subtleties of what I painted when I painted it. In the hurried packing of the paintings for the show, this one could easily have been left behind. My selection of art for an exhibit is usually on a whim and rather haphazard. Althea, from her story, sounded like she had just barely made it to the conference. Our paths might never have crossed, and may never cross again. You get the picture!

I only mention these incidents because of their strangeness. They leave me with a palpable sense of purpose and satisfaction, yet I am filled with the mystery of not fully comprehending their import. Some things, I think, will only be grasped in their entirety on the other side of life, when we have passed through the thin veil of time into the promised beyond.

I do not want to leave the impression that my work is always, or even usually, received favorably. My journals have pages of complaints to God about being ignored and for the art languishing in the back of my closets! There have been long, arid seasons of wondering if I was crazy to persist in what seemed a completely unrewarding pursuit. I've winced at disparaging comments made by others about my art and frequently tasted the frustration of being misunderstood. I have also cried a lot for simply being overlooked when my art was a baring of my soul.

"These things I have spoken unto you, that in me ye might have peace. In the world ye shall have tribulation: but be of good cheer; I have overcome the world."—JOHN 16:33

Black

I felt alone and all but forgotten
A victim of naught I had begotten
Misunderstood, beaten, and lacking a friend
Forlorn season without glimpse of an end

In bleak darkness, I struggled for sight
If I only knew how, I'd put up a fight
Blinded, I swallowed the bile of despair
My cries echoed thinly in thick black air

Impenetrable black quelled not a voice
Softly He told me that I had a choice
"In darkness when blinded, heed my Word
Obey my voice, act on all that you've heard"

"Look at how overpowering the odds
Speak the strong word, since you are my Lord
This awful, dense darkness is here to stay
I have not the clout to chase it away"

Spoke the voice, now firmer still
"You have the power, t'was bought on the hill
I took your darkness and your black despair
Breathing My last in the sin-soaked air

"Swirled around Me every foul foe
Demons of despair, sickness and more
Wave upon wave of despicable vice
Polluted My flesh and exacted a price

"Overcome your trouble, no matter how bleak
My Words of triumph you must boldly speak
Darkness will flee, as you resist despair
Earnestly expect a change in the air"

Heart scrambled with fear, I did as He bid
Feeble within, yet with mouth intrepid
A pinprick of light flooded the gloom
Black took to flight, as hope filled the room

Long I lingered His words to ponder
When spoken in faith, with power they thunder
No debt of despair, I'm in the black
He paid it in full; I'm not taking it back

I was once an avid reader of marketing information for artists. How do I stand out? What sort of promotional materials must I create? Which are the best shows to strive for entry into? How do I build my portfolio? I wanted these questions answered, and others like them. They are asked by all aspiring artists. Concrete answers, however, are hard to come by. Many professional artists are tight-lipped about their paths to success, refraining from freely sharing information, afraid of the competition. Besides that, being an artist is a fickle profession, and there are no sequential steps to take to achieve a universally acknowledged measure of success.

The art industry, like so many things in this world, is part of a system that, without the partnership of God, is fiercely competitive, rooted in fear, and fed primarily by the passion for a sale, fame, and monetary success. Once liberated from it, I am no longer bound by its norms.

I too strive for excellence. In my quest for accolades and rewards, I press for excellence in obedience and faithfulness to the One who understands all my needs, including my craving for a "Well done!" He promises to make me superb at whatever He deems best.

How grateful I am for quick and continual access to the wisest promoter of all! Unexpected opportunities have come my way, events that are rich and multidimensional, opportunities not measured only in sales, fame, or accolades, but in growth in ways that defy description. The more I seek Him, the less I feel compelled to seek them out. He will make sure to bring them to my attention, persisting even when in my blindness I do not immediately perceive them. His ways are usually contrary to anything conventional. I remind myself frequently that it is critical to trust Him. By taking the time to turn to Him, I am assured of the kind of success that is worth striving for.

> *But thou, when thou prayest, enter into thy closet, and when*
> *thou hast shut thy door, pray to thy Father which is in secret;*
> *and thy Father which seeth in secret shall reward thee openly.*
>
> —MATTHEW 6:6

I like open rewards, don't you? I have discovered that God's rewards are thrilling in so many dimensions, surprising me constantly for their sheer ingenuity and ability to fill me with joy—not just with the happiness that a worldly reward might bring. Joy bubbles up and spills over, infectious, unstoppable and uncontainable. Joy is the inevitable quality of a reward of God.

I've learned much, not merely academically but by personal experience, in lessons I have not always sought yet which have been vitally necessary. Seasons change, often dramatically. After just two years, I was nudged out of another area of comfort. At the Lord's prompting, I released the studio at the Victory Arts Center and moved my supplies back home. Johann graduated high school and moved into an apartment close to college. My new holy ground is his room that I now use as my studio, with a large window facing the western sky with its brilliant sunsets. It was a seamless transition.

A studio no longer defines me. I am, and always will be, a Christian artist, a witness to God's goodness and faithfulness, until I am called to my eternal home. I pray that I will be an irresistible witness to a life that would be impossible without God and is compelling only because of Him.

I exhibit wherever He leads me. As a partner along with other artists at a wonderful gallery, I stay busy. Jesus has been an ingenious mentor: gentle, yet firm, and sometimes delightfully humorous. I learn slowly, make many mistakes, and yet remarkably make definite progress. I know there is much beyond the radar of my scrutiny that is also growing and prospering. It is as it should be, consistent with God's expressed desire for me. His desire is the same for you.

Beloved, I wish above all things that thou mayest prosper
and be in health, even as thy soul prospereth.—3 JOHN 1: 2

Even as I eagerly scan the horizon for adventures yet to come, I look back in awe. God's infinite patience has kept me this far. My hand, which is firmly to the plow, is more skilled than it has ever been, and the field, which grows ever larger with my faith, is mine. I am no longer ambivalent about the fact that God has assigned it to me until I am called home.

I sought God and found life, *zoe,* joyous and free. Yet we would never have met had He not sought me; and for that I'll be eternally grateful. Although tomorrow is shrouded in mystery, I am secure. How could I not be? I am never alone.

"Know therefore that the LORD thy God, he is God, the faithful God, which keepeth covenant and mercy with them that love him and keep his commandments to a thousand generations."—DEUTERONOMY 7:9

The Promise

I read again from well-thumbed pages
A word for me from the God of Ages
His oath I dated and brightly underlined
I remember it well, a thrilling find

Cherished more than a lover's note
Imparting strength to boldly go forth
Flooding hope and quelling fear
Quiet peace chasing fretful tears

I searched for signs like a lovesick lass
That the pledge may quickly come to pass
God spoke to me His words so true
Dawn to dawn, they're as good as new

Strode weary days unhurriedly by
Confusion infused my frequent sighs
The search seemed futile and all in vain
To turn my delight to baffled pain

Pages were turned and the promise set aside
Life ever marched on with its ebbs and tides
Somehow prevailing with strength for each day
Dimmed the memory of that thrilling day

Sometimes I turned to that page underlined
As in reading I dared not fall behind
Faithful to maintain my goal to complete
The Bible in a year, my annual feat

Years slipped by and the markings paled
Other vows fulfilled, His love never failed
Yet that one promise stayed just out of reach
In its incompletion, a lesson to teach

His faithfulness is not measured in time
His promise is true the day I make it mine
The answer then only awaits my loyalty
To trust in my Maker and His honesty

Lined and marked with notes of all kinds
Someday, I'll leave my Bible behind
And when you read the last date on a list
Know I received all He promised

My final wash makes the finishing stroke on this account, yet I am uncertain that this work is complete. Knowing when to stop is a skill slowly learned as an artist; there is nothing worse than an overworked painting. I daresay it is the same with writing.

I pray that what I have painted in words is sufficient, giving you adequate impetus to step into your own adventure in art, or life, with God. He will not disappoint you.

As for me, tomorrow beckons, filled with promise . . . another day of conversations with God. Will they be in paint or clay, on paper, board, or canvas? I am eager for strange and meaningful encounters that I cannot orchestrate, for abilities and skills I do not yet possess and for hopes and aspirations that only the Holy Spirit can birth and complete in and through me. Oh, and I press on for joy, unspeakable, inexpressible, unstoppable joy that seems to be the hallmark of walking in step with Him; joy that only seems to grow with each passing day!

I conclude with the words of Paul:

"I count not myself to have apprehended: but this one thing I do, forgetting those things which are behind, and reaching forth unto those things which are before, I press toward the mark for the prize of the high calling of God in Christ Jesus."
—PHILIPPIANS 3:13–14